D1587174

To be

Theatre's Heterotopias

Contemporary Performance InterActions

Series Editors: Elaine Aston, Lancaster University, UK **Brian Singleton**, Trinity College Dublin, Ireland

Editorial Advisory Board: Khalid Amine, Bishnupriya Dutt, Mark Fleishman, Janelle Reinelt, Freddie Rokem, Joanne Tompkins, Harvey Young

Theatre's performative InterActions with the politics of sex, race and class, with questions of social and political justice, form the focus of the *Contemporary Performance InterActions* series. Performative InterActions are those that aspire to affect, contest or transform. International in scope, *Contemporary Performance InterActions* publishes monographs and edited collections dedicated to the InterActions of contemporary practitioners, performances and theatres located in any world context.

Forthcoming titles include:

Nobuko Anan
CONTEMPORARY JAPANESE WOMEN'S PERFORMANCE AND VISUAL ARTS
Playing with Girls

Stephen Farrier and Alyson Campbell (*editors*)
QUEER INSTRUMENTS
Local Performance Practices and Global Queernesses

Sarah French
PERFORMING FEMINISMS
Sexuality and Gender Politics in Contemporary Australian Performance

Charlotte McIvor
MIGRATION AND PERFORMANCE IN CONTEMPORARY IRELAND
Towards a New Interculturalism

Des O'Rawe and Mark Phelan (*editors*)
POST-CONFLICT PERFORMANCE, FILM AND VISUAL ARTS
Cities of Memory

Contemporary Performance InterActions
Series Standing Order ISBN 978–1–137–35987–2 Hardback
978–1–137–45593–2 Paperback
(*outside North America only*)

You can receive future titles in this series as they are published by placing a standing order. Please contact your bookseller or, in case of difficulty, write to us at the address below with your name and address, the title of the series and one of the ISBNs quoted above.

Customer Services Department, Macmillan Distribution Ltd, Houndmills, Basingstoke, Hampshire RG21 6XS, England

Theatre's Heterotopias

Performance and the Cultural Politics of Space

Joanne Tompkins
University of Queensland, Australia

palgrave
macmillan

First published 2014 by
PALGRAVE MACMILLAN

Palgrave Macmillan in the UK is an imprint of Macmillan Publishers Limited, registered in England, company number 785998, of Houndmills, Basingstoke, Hampshire RG21 6XS.

Palgrave Macmillan in the US is a division of St Martin's Press LLC, 175 Fifth Avenue, New York, NY 10010.

Palgrave Macmillan is the global academic imprint of the above companies and has companies and representatives throughout the world.

Palgrave® and Macmillan® are registered trademarks in the United States, the United Kingdom, Europe and other countries.

ISBN 978–1–137–36211–7

This book is printed on paper suitable for recycling and made from fully managed and sustained forest sources. Logging, pulping and manufacturing processes are expected to conform to the environmental regulations of the country of origin.

A catalogue record for this book is available from the British Library.

A catalog record for this book is available from the Library of Congress.

Typeset by MPS Limited, Chennai, India.

This book is dedicated to my nieces (Teagan West and Tasmin West) and nephews (Myles Hudson, James Hudson, Evan Hudson, and Rhys Hudson) in the hope that they also find a place that captivates them and continues to provide them intellectual inspiration.

Contents

List of Figures

Acknowledgements

I have been lucky enough to have a series of excellent research assistants without whom this book could not have been written: in order of their employment Neal Harvey, Sarah Holland-Batt, Sarah Thomasson, Bernadette Cochrane, and Alan Lawrence. I remain most grateful for their dedication, incredibly astute analyses, speed, and intellectual and personal thoughtfulness.

This research was completed with the help of the Australian Research Council's Discovery Scheme project DP0877316, and I very much appreciate the support. I was fortunate enough to spend a semester of study leave in 2008 at the Department of Drama, Queen Mary, University of London as a Distinguished Visiting Fellow. This period was invaluable in researching and formulating the book and in enabling me to immerse myself in a wide range of theatre and performance. I am deeply grateful to the staff there for their hospitality, intellectual engagement, and friendship. Thanks in particular to Matthew Delbridge, Maria Delgado, Bridget Escolme, Jen Harvie, Dominic Johnson, Michael McKinnie, Nicholas Ridout, Catherine Silverstone, and Martin Welton. On that visit, I also visited the School of Theatre, Performance, and Cultural Policy Studies at the University of Warwick where I presented a very preliminary paper on what eventually became this book. The feedback I received was extremely useful (even forcing me to completely rethink my approach); thanks to Jim Davis, Milija Gluhovic, Susan Haedicke, Silvija Jestrovic, Baz Kershaw, Janelle Reinelt, and Ed Scheer. Closer to home, thanks to my colleagues (professional and academic) in the School of English, Media Studies and Art History at the University of Queensland, especially Frances Bonner; and Sarah Evans, EMSAH's Liaison Librarian.

My four-and-a-half-year term as Head of School during administratively and financially difficult times slowed the progress on this project. Many colleagues and postgraduate students at UQ and elsewhere continued to remind me of the importance of at least *thinking* about the book, if not writing it. I am extremely grateful for their assistance. Chief among these minders/reminders is Helena Grehan,

who believed in the book and me far more than I did. Julie Holledge let me talk through ideas. Others who read chapters include Michele Sanz Nicholson and Joanne Zerdy, and my UQ Drama colleagues: Stephen Carleton, Sean Edgecomb, Tim Keenan, Diana Looser, and Rob Pensalfini. The book has benefited so much from all my readers' suggestions, prodding, and picking up conceptual slippages and confusing syntax. Outside academia, I owe thanks to Mark Bayley, Nancy Bikson, Shaktiprem Blaschke, Catherine Fenn, Marion Kreder, and Jeff Pittam.

Other forms of assistance came from Fred D'Agostino for a discussion on Foucault and for the reference to *Cradle Will Rock*, plus encouragement at a difficult time. Mónica Farías and Stephen Young were helpful in providing me references to more of David Harvey's work on heterotopia. Thanks to Kim Solga and Laura Levin for inviting me to keynote at the 2006 Canadian Association for Theatre Research (CATR) conference where I first explored heterotopia. Thanks too to Susan Bennett and Ric Knowles.

Various people have assisted with the actual research. Thanks to Caroline Newall and the National Theatre of Scotland; Victoria Northwood and Jordan Landes at Shakespeare's Globe; Ian Crawford; Emily Hoare at Royal Opera House; Andrew Sanders; the MAIPR Students at the University of Tampere, Finland in 2008; other colleagues from Finland including Hanna Korsberg, Pirkko Koski, Riku Roihankorpi, and Hanna Suutela; my Ortelia colleagues Matt Delbridge, Lazaros Kastanis, Darren Pack, and Sarina Hobbin; and Ros Merkin and Gary Mitchell who assisted with *Suitcase*.

I published an article on an earlier phase of my thinking about heterotopia in *Nordic Theatre Studies*. I am grateful to *TDR* (which published an earlier iteration of the work on *Suitcase*) and to *Theatre Journal* (which published a version of my research on *And While London Burns*) for allowing me to reprint parts of the following papers in this volume:

Joanne Tompkins, 'Theatre's Heterotopia and the Site-Specific Production of Suitcase', *TDR/The Drama Review*, 56.2 (Summer, 2012), pp. 101–112. © 2012 by New York University and the Massachusetts Institute of Technology.

Joanne Tompkins, 'Site-specific Theatre and Political Engagement across Space and Time: The Psychogeographic Mapping of British Petroleum in Platform's *And While London Burns*', *Theatre Journal*, 63.2

(2012), pp. 225–243. © 2011 The Johns Hopkins University Press. This article was first published in *Theatre Journal* 63.2 (2012), pp. 225–243. Reprinted with permission by Johns Hopkins University Press.

Paula Kennedy has had faith in this project from my first mentioning it to her many years ago. I thank her for her patience and her support, while the anonymous reviewer of the proposal provided especially helpful feedback.

Finally, thanks to Alan Lawson who put up with what seemed like an endless project. I am very grateful for his assistance and support, now that he has much more time on his hands.

Introduction: Theatre, Space, and World-making

In *Theatre's Heterotopias*, I isolate and examine space in performance. 'Space' might include the imaginative setting created with and through a narrative, the scenic space of a production's design, the contribution to meaning that the architectural, cultural, or historical surrounds of a venue might offer, and/or the efficacy of an unconventional venue. I seek to provide a specific interpretational means by which we can analyse the space of performance, not just in its own immediate performative context but also in relation to its physical and historical community: I propose the concept of heterotopia for this project. Heterotopia (related to utopia, the better known aspirational 'topos') is a location that, when apparent in a performance, reflects or comments on a site in the actual world, a relationship that may continue when audiences leave a theatre.[1] It may even act as a foil for how we understand spaces and structures beyond a performance. I chart the ways in which theatre can create what Kevin Hetherington calls 'spaces of alternate ordering' (1997, p. viii). Heterotopias are alternative spaces that are *distinguished from* that actual world, but that *resonate with* it. Heterotopias have the capacity to reveal structures of power and knowledge: a potential outcome of a study of heterotopias is, then, a more detailed examination of locations in which cultural and political meanings can be produced spatially.

One of my many starting points for this study was reading about the premiere of Katherine Thomson's 2003 play, *Wonderlands*, which was performed in the regional centre of Albury-Wodonga, located on Australia's Victoria and New South Wales state borders; I found the

1

set and location extremely resonant, but I could not find a satisfactory way to investigate it critically. Dealing with the fraught issue of indigenous land rights in Australia, *Wonderlands* maps the attempts by Edie, an indigenous woman, to secure a 'land claim' to her ancestral land, entitlement to which was lost over the course of the white settlement of the country. The white farmers, Lon and Cathy, whose family has farmed Edie's ancestral land for almost a century, are anxious about what a legal decision in Edie's favour will mean to their 'ownership' of what they consider to be their land. The set for HotHouse Theatre's production at the Butter Factory Theatre, designed by Ralph Myers, consisted of 'a packed red-earth floor, with a gumleaf-encrusted curtain snaking across the space' (Thomson 2004, p. xiv), drawing attention to the all-important landscape and, in the staging, to the possibility of simultaneous occupation of the land, since both parties take up space on the same stage.[2] At the conclusion of this production, 'the rear doors of the theatre opened, and Edie and Cathy walked out together into the night, towards the (actual) trees and the river beyond' (Thomson, 2004, p. xiv). As the audience left the theatre, they were encouraged to see the direct relationship between the play and the landscape on which the theatre was built (even though the explicit geographical setting for *Wonderlands* was several thousand kilometres away in central Queensland). The audience could take their intellectual responses to the land rights issue and their affective experiences of the production back into their world, following the characters' exit from the theatre into the landscape outside. Some might interpret this relocation of the play outside the theatre as a lack of faith in the imagination of the audience to make the connections themselves, but the evocative connection in this play between the theatre and the world beyond it stayed with me both in aesthetic terms and because it articulated a need to both dramatize and critically account for the spatial complexity of *Wonderlands*.[3]

I wanted a mechanism to analyse exactly how space and place in plays like *Wonderlands* – and performance more generally – came to generate meaning. I wished to engage with the actual and imaginary landscapes of performance, particularly those that extended beyond the theatre venue and the performance experience, but I could find no language to investigate theatre in such a way, even though space offers so much in narrative terms and in articulating the argument

of a performance visually. This absence prompted me to seek a different way to determine and communicate the theatrical function of staged space and what the socio-political implications of that setting might be. My previous book, on the spatiality of theatre in Australia, *Unsettling Space*, explored the multiple ways in which space on the stage enacted moments of the repressed and the uncanny that define Australian political and cultural history but, as I discovered, there were many other spatial figurations that required scrutiny; heterotopia emerged as one option but I did not have the opportunity to explore it sufficiently there.

As I develop it here, heterotopia accords with what Howard Barker terms a 'braver theatre' that 'asks the audience to test the validity of the categories it believes it lives by. In other words, it is not about life as it is lived at all, but about life as it might be lived, about the thought which is not licensed, and about the abolished unconscious' (1993, p. 52).[4] In this book, I offer a conceptual process for charting that complex movement between 'theatre' and 'life' in spatial terms. Of the myriad ways in which Barker's braver theatre might be achieved, I focus primarily on the often subliminal spatial ways in which theatre can make us think, rather than on plot, corporeality, or other elements of performance.[5] Theatre provides an experimental zone in which different 'worlds' can be constructed and tested, or, as Barker explains above, it delivers a glimpse of 'life as it might be lived' but it is still difficult to imagine how one might enact this process. The spatial aspects of such experiments afford a fundamental basis for this reimagining in a way that language and other elements of performance can't quite replicate. As I argue, heterotopia rehearses the possibilities of something else, something beyond that which the theatrical art form generates. The productions in my case studies realize this spatialized 'something else' in a key way: they demarcate locations that offer an alternative to the status quo. They present an opportunity for characters to inhabit a zone that has a relationship with the workings of the actual world, but that is distinguished from that world.[6] While all theatre achieves this at one level, theatre that is heterotopic depicts other possible spaces and places live in front of an audience, and it offers spectators specific examples of how space and place might be structured otherwise. It points to the potential for cultural impact to be reframed. Spectators need not personally inhabit a heterotopic zone: watching it transpire in

multidimensional form is sufficient because the performance of even the semblance of such spaces can have significant potency. While they may not occupy the heterotopia physically, spectators witness a depiction that is real, at least temporarily, in the confines of the theatre. Or, as some of my case studies illustrate, the absence or the withdrawal of such a location that has been constructed as 'possible' can be equally meaningful.

I am often disappointed that the spatial worlds created in the performances I see miss the opportunity to 'do' more with spatiality; I hope that artists might find my approach productive to increase the potency of their work. Nevertheless, like Jill Dolan who explains in *Utopia in Performance* that 'every [theatre] ticket I buy contains a certain promise' (2005, p. 5), I retain an anticipation that the next performance I attend might be characterized by spatial dynamism. This study aims to identify a means of analysing such spatial invention. The Introduction defines heterotopia (which is explained in greater depth in the next chapter) before I briefly explore its place as both interpretational strategy and object of analysis. I then contextualize the role of space in theatre and outline the shape of this volume.

Heterotopias

The spatial relationship of heterotopia was first popularized by Michel Foucault and has been further developed by the cultural geographer, Kevin Hetherington. Foucault singles out theatre as an example of a heterotopia because it is 'capable of juxtaposing in a single real place several spaces, several sites that are in themselves incompatible. Thus it is that the theater brings onto the rectangle of the stage, one after the other, a whole series of places that are foreign to one another' (1986, p. 25). Examples of the heterotopic potential that Foucault outlines at 'just' the level of plot and/or structure could include the isolation of the world of Tom Wingfield's memories in Tennessee Williams's *The Glass Menagerie*, or the Moscow for which Chekhov's eponymous three sisters yearn, or the temporary alternative court in the Forest of Arden in Shakespeare's *As You Like It*. These plays articulate geographical and abstract heterotopias as separate locations on stage (or, in the case of the importantly absent Moscow, off-stage), but Foucault suggests that all theatre is heterotopic. While this may be true at a superficial level (the activity on stage being

separate from the outside world but juxtaposed with it), Foucault's formulation assists little either in analysing theatre or how theatrical space comes to represent potentialities.

Heterotopias, once identified, do not remain heterotopic forever, and Hetherington argues that art galleries, a significant example of heterotopia for Foucault, no longer comply, 'at least not any more. Only when new sites, alternatives to these ones, emerge within their respective fields, offering alternative and new orderings of science, politics or art, do we see examples of heterotopia' (2001, p. 52).[7] Hetherington wrote this in 2001 at a time when galleries and museums had already begun considerable rethinking of their engagement strategies with their venues, contents, exhibitions, and patrons. It would be possible to argue that many galleries and museums – and particularly specific exhibitions within them – could continue to operate heterotopically. In other words, the entities in themselves may have lost the heterotopic appeal that Foucault found in them, but their internal workings are capable of producing heterotopic relationships that are in fact more rewarding. I place 'theatre' as a generalized medium in the category of no longer being inherently heterotopic. But given the profound engagement with space that performance often enacts (as I argue in the next section), there is scope for a more enhanced form of theatrical world-making and for analysing in heterotopic terms what transpires spatially therein. In other words, calling theatre itself heterotopic as an art form (in its relation to the outside world) contributes little to our understanding of it, but isolating and developing a stronger means of theatrical world-making (and how such world-making takes place) can be incredibly dynamic. The heterotopic strategy that I propose in this book is, then, distinct from the perception that a traditional form of theatre itself may be heterotopic. Its conceptual role is to engage far more deeply with spatiality in performance (and the analytical effects of that engagement) than has been possible and than Foucault's original delineation of theatre enabled. The effect of this engagement is a deeper exploration of the structures of power and knowledge. The method that I delineate begins with Foucault's heterotopia but incorporates refinements that others have made to the concept and that I in turn develop in the next chapter. My version of heterotopic analysis facilitates an interpretation of theatre that participates very differently with its contexts, an approach that is as appropriate for

performance studies, multimedia, postdramatic, and posthuman performance, as it is for 'traditional' theatre.

Heterotopic spaces can be difficult to define and Foucault's description is cryptic, leading others to use the term in vague and divergent ways, as I outline in Chapter 1. The concept can nevertheless be very productive in generating what Derek Hook terms the 'potentially transformative spaces of society from which meaningful forms of resistance can be mounted' (2010, p. 185). This resistance suggests that heterotopias in performance can be constructive sites for identifying and analysing the possibility of theatre intervening in its culture. A heterotopia, then, does more than simply mark politics or ethics or conscience: it is a technique for exploring theatrical space that enacts a 'laboratory' in which other spaces – and therefore other possibilities for socio-political alternatives to the existing order – can be performed in greater detail than Foucault's conventional definition of theatre as heterotopic. This enactment of space in performance has the capacity to demonstrate the rethinking and reordering of space, power, and knowledge by locating world-making spaces and places tangibly, albeit transiently. Such rethinking ties in with Robert Topinka's argument that a heterotopia has the capacity to 'creat[e] an intensification of knowledge that can help us resee the foundations of our own knowledge' (2010, p. 70). It is in this 'intensification of knowledge' that heterotopia can be distinguished from what theatre already achieves. Through this intensification, heterotopia functions as a conceptual means of analysing concrete and metaphoric space; from there, the conclusions one might make from such world-making may affect our understandings of cultural impact and our interpretations of the actual world.

Yet a heterotopia cannot directly intervene literally in the actual world. Rather, it affords glimpses of what might be; the transitoriness of such glimpses matters little.[8] Space's engagement with time through the notion of transience is an undercurrent in this study, and even more overtly, the staging of what does not appear to be 'there' (such as the 'gaps' in place and space). A staged heterotopia enables audiences to discern some hint or inkling of another world, even one that is otherwise invisible. Heterotopia provides the potential for spatializing in performance both visible locations and, paradoxically, invisible locations (those which we know and those which we imagine).[9]

What might we learn from the generation of heterotopia in performance and/or its analysis? As my case studies illustrate, when audiences perceive heterotopia in theatre, they are presented with a sample of what spatial, structural, and political options might be tried out for evaluation, whether or not they are accepted as actual possibilities. Even rejecting selections affords the opportunity for audiences to decide which options are a step too far. Heterotopic theatre that is engaged politically – and aesthetically – offers a model for (re)fashioning the present and the future.

Space and theatre

There are two main reasons for giving priority to spatiality among the many dimensions of theatricality. Most importantly, as Henri Lefebvre argues in *The Production of Space*, '[e]very space is already in place before the appearance in it of actors [...]. This pre-existence of space conditions the subject's presence, action and discourse, his [sic] competence and performance' (1991, p. 57). Later he notes that 'every social space has a history, one invariably grounded in nature' (1991, p. 110). David Harvey develops Lefebvre's arguments to insist that '[h]ow we represent space and time in theory matters, because it affects how we and others interpret and then act with respect to the world' (1989, p. 205). A second key reason for focusing on spatiality is the substantial role that space plays in performance. That is, space *structures* theatre since there can be no performance if there is nowhere for it to take place.

Analysing space is not without its problems, in part because of its magnitude. Two difficulties in studying 'space' are its scope and its terminology. Space is particularly difficult to evaluate because we are always already implicated in 'it', whether as a theoretical concept or a specific example; it is all but impossible to generate the customary critical distance that conventional analysis usually requires. Secondly, the potential definitions even for 'space' and 'place' – let alone the host of other words that may seem to be synonyms – are numerous.[10]

In terms of theatre, David Wiles captures the relationship between space and theatre with his argument that '[t]heatre is pre-eminently a spatial medium for it can dispense with language on occasion but never with space' (1997, p. 3). Such a space may transform in nature:

in my final chapter, I address virtual theatre space. Whether virtual or not, theatre space refracts to encompass several additional dimensions beyond the building that houses bodies in real space; it accommodates the imagined (and performed) place(s) that those bodies occupy. The 'place' of space in theatre production and analysis is impossible to encapsulate briefly.[11] Rather, I identify six aspects of theatre's spatiality that are core to the development of my argument that theatre, more than other art forms, offers the opportunity to experiment spatially with the depiction of possible worlds in performance (Figure I.1).[12] Many items on this inevitably partial list are obvious and the distinction between some may seem minor, but they clarify my larger spatial approach.[13]

First, a theatre venue encompasses an infinity of places in that it holds the potential of all the spaces that theatre can conjure, depict, and contain. But at the same time, these locations are grounded in illusion since the locations established for a performance will be dismantled at the end of its run. Audiences accept the former in the light of the latter, no matter how realistically established some locations are in performance. Second, a single space on a stage is capable of presenting multiple meanings either in turn or simultaneously. More than merely a receptacle for the current production, theatre represents a multifaceted geography in which the all-but impossible can occur. For instance, the two principal locations in Shakespeare's *Antony and Cleopatra* – Rome and Alexandria – are brought together to essentially the 'same' place, the stage on which the play is performed, in a manner in which the two cities could never coexist otherwise. Third, 'traces' of places established on stage can remain 'in performance' even if they are no longer physically present or relevant.[14] Likewise, the venue itself provides traces of what has gone before. The contribution that a venue makes to the spatiality of a performance cannot be underestimated, but neither can we overlook the power of performance that takes place outside a conventional venue.[15] Fourth, the setting for staged worlds may be congruent with the original setting for a play, but they may incorporate vastly different geographies, such as a 2012 Royal Shakespeare Company production of *Julius Caesar*, directed by Gregory Doran, which was set in a somewhat generalized west African nation. Fifth, these spaces, multiple or singular, do not have to be 'realistic' locations. They may be imaginary, psychic, fictional, or even places that are impossible to realize

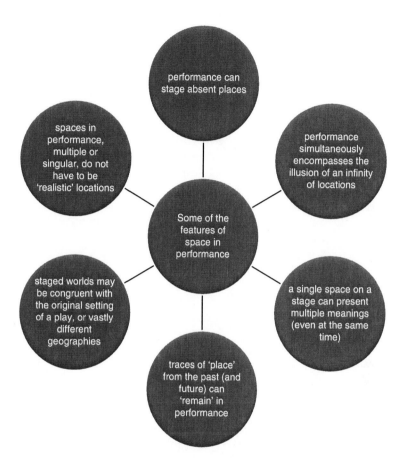

Figure I.1 The potential for space in performance, 2014
Source: © J. Tompkins, Brisbane.

anywhere *but* in a theatre, and they may nevertheless intersect and interact on the same stage with more realistic locations, even simultaneously. Further, the use of space in theatre facilitates all types of illusions so that a character can occupy more than one reality, time, or place without questioning the bounds of theatrical possibility. As such, spaces may intersect in ways that defy the rules of geographical or chronological logic that operate elsewhere. Sixth and finally, as

I alluded to earlier, theatre has the capacity to manipulate the 'gaps' that absent places can, paradoxically, stage. As Gay McAuley argues, 'theatre is constantly playing with the possibilities of revelation, with the relationship between the shown and the not-shown, the shown and the partially shown' (1999, p. 75).[16] As many of the examples in this book demonstrate, a heterotopia not only isolates and enacts space: it can even make visible the invisible. None of these spatial features of theatre is in and of itself heterotopic; the next chapter details the relationship between theatre as a generic medium, and theatre that engages with heterotopia wherein spatiality acts and reacts more explicitly with its context.

These matters are usefully enhanced and complicated by the work of the set designer. A designer may propose perceptions of space, geographical locations, psychological states (and how they might be staged) that differ radically from previous productions or from the spatial realm in a pre-existing script. Bruce Bergner describes his role as a designer as being 'responsible for materializing a living world, a space that fosters life [...] [to] supply the event with a motivational mechanism, helping to move the action forward' (2013, p. 11). My study is keenly interested in what designers create on stage in conjunction with a script.[17] I aim to present a means to analyse performance that achieves a heterotopic effect, but I also maintain that heterotopia is an excellent strategy for theatrical production wherein alternative engagements with spatiality might also be achieved. It is a separate (if complementary) project to consider in detail heterotopia's potential as a trope for design. Such a project would reinforce the scope for a more complex spatiality to explore in performance what options there might be to influence what takes place in the actual world, thus pushing the possibilities of spatial meaning well beyond Bergner's 'materializing a living world'.

Theatre's heterotopias

There are few critical means of noting when 'performed' space is communicated productively (or even when it fails to contribute effectively to the meaning of a production). To address this, Chapter 1 outlines in depth my method for deploying heterotopia. A heterotopia opens up the opportunity for a detailed examination of the layers of spatiality (the concrete spaces of architecture and both the concrete and

abstract spaces of performance), as well as enabling overlap between and among these layers. In analysing spatiality in performance more directly, I examine the elements that contribute to a heterotopic reading of these works, including: the physical location of theatres; the company or venue structures that attempt to connect theatre and the community for which it is produced; and the fictional space(s)/place(s) of selected theatre productions which attempt to elicit a response from an audience that encompasses more than 'mere' applause at their conclusion. Such an investigation can yield an assessment of the ways in which a production might contribute to a rethinking of spatio-political structures in cultural practice at large. The presence of a heterotopia provides a chance to interpret theatre space and spatiality as a key aspect of cultural production. A heterotopia enables the better understanding of the concrete space(s) of performance amid the social context in which such a performance is enacted.

Chapter 1 explains the potential of heterotopia by charting its connection with the concept of utopia and discussing heterotopia as a bridge between theatre and cultural politics and practice. The chapter then maps the capacity for theatre to continually present in performance possible worlds that can intensify the art form's relationship with the actual world. It makes the case for heterotopia as a form of socio-politically contextualized cultural production, and presents the methodological underpinning of the project. Four case-study chapters then follow. Two are structured by genre (site-specific and multimedia performance) and two by interpretations of a particular company or venue (the National Theatre of Scotland and Shakespeare's Globe Theatre). Each chapter adopts a different perspective on heterotopia and space while also developing the methodology through its application. The performances discussed herein establish a specific relationship between theatre space and the social and spatial context beyond the venue. I isolate examples of heterotopia to provide theatre practitioners, scholars, and audiences with a map, as it were, of how to imagine and mobilize the glimpses, snapshots, or brief indications depicted in performance of how spatial structures might be different.[18] This work has relevance beyond theatre and performance studies to cultural materialism, performance art, and other disciplines or art forms that claim an impact on our social, cultural, political (and spatial) world(s).

ment!

Comp to NSC + Gollancs argument

Chapter 2 begins with site-specific theatre since this genre is the most closely related to the world 'outside' a performance space. I analyse two productions that generate heterotopic worlds that cannot be marked on a map but that have the capacity to significantly alter our understandings of and responses to the events of the narrative and the site-specific location where they take place. These are *Suitcase*, which took place in a train station, and *And While London Burns*, an audio-walk. *Suitcase* exploited the ambience and architecture of the historic location of the action, invoking recollections of presence through the immediacy of the present; *And While London Burns* uses a pre-recorded blend of music, sound, and dialogue to propel the individual audience member around a consciousness-arousing exploration of central London.

The third chapter highlights the National Theatre of Scotland whose motto in its early years was 'Theatre Without Walls'. The National Theatre of Scotland (founded in 2004) engages with its constituents very successfully by choosing not to have a fixed venue and to play in various types of venues and halls, contexts that are appropriate to the subject matter and to the community for which it is made. Since its inception, this significant theatrical force has performed all over Scotland (and beyond). Chapter 3 addresses how the 'theatre without walls' metaphor enables a strong engagement with both theatrical and socio-political spaces.

Chapter 4 maps the physical and metaphoric 'place' that Shakespeare's Globe Theatre takes up in London. Rebuilt near the original site of the Renaissance equivalent, the theatre was designed to recreate the theatrical culture of Renaissance England in modern London. The productions that succeed in looking beyond the history embedded in the venue – and engaging with the world outside the Globe's stage – suggest the strength of spatiality in regenerating worlds on and off this well-known stage.

In Chapter 5, I explore heterotopia's relevance to performances that either deploy a high degree of multimedia or are heavily digitized in nature. Each case study spatially exceeds the 'frame' of performance. The expansion of 'space' in such a context challenges not just heterotopia but also the limits of performance itself. The book's Conclusion suggests ways in which heterotopic theatre might be deployed in the future.

This analysis of heterotopia focuses on contemporary theatre since the millennium. There is a structural reason for this narrow window:

heterotopias are time-bound in that what pertains to a cultural context from even twenty years ago may not be meaningful today. Equally, that which works heterotopically today in performance will likely not operate in the same way in the future. I thus concentrate on productions in and around the late part of the first decade of this century: specifically, theatre in and around 2008 when I had the opportunity to see over fifty productions in a short time and to begin to understand which ones held my attention and why, and which were less compelling. This effective 'immersion' in theatre (including professional, traditional, site-specific, fringe, and festival performances) enabled me to investigate how 'space' was being staged in many different venues and contexts and to test out possible variations on a heterotopic model. Further, this was also the time of the Global Financial Crisis, when events of the outside world necessarily had an impact on the arts (and the funding of the arts), and would continue to do so for years to come. My perspective is western in focus. The productions that I have chosen have been performed in England, Scotland, and Australia; many were touring productions. I am, then, addressing heterotopia from a western theatre and performance context. The concept extends beyond a western framework but the cultural specificities and generic particularities of non-western theatre would require additional detailed attention that I cannot provide here. This book has an international but not a global focus.

Before turning to Chapter 1 and a detailed account of heterotopia, I mention two significant theatrical concepts that are adjacent to space but that I cannot cover here: time and the body. As noted above, a study of space invariably overlaps with an account of time, even if there is insufficient scope to discuss the latter in any detail. The different spatial locations that a heterotopic interpretation isolates are inevitably temporal as well as spatial. One of the qualities of heterotopia is its fleeting nature; it is an event that is almost always understood *after* the fact. Equally, concerning the body, Gill Valentine notes Adrienne Rich's argument that 'the body is the geography closest in', while she quotes Maurice Merleau-Ponty's insistence 'that there would be no space without the body' (1999, p. 49). I encourage readers to make the connections between space and time and corporeality, as well as the other key elements of theatre and performance; the intersections between them would make for fruitful discussion.

Claire MacDonald notes the significance of theatre as an experimental form: '[t]heatre remains for me a space of praxis [...] a space where things are made sense of, where the known world is reorganized into the unknown and tried for size' (2002, p. 63). I provide a reading strategy to demonstrate conceptually how we might interpret events in the actual world in and through theatre, but also how theatre might continue to offer the necessary venue to 'try things out for size'. I describe theatre from which I have been able to discern a connection between what happens spatially in performance and what might happen beyond a performance venue. *Theatre's Heterotopias* examines one means of exploring how theatre matters in its articulation of actual and potential worlds, its isolation of locations that are otherwise invisible, and its generation of 'world-making'. It has confirmed my desire to continue to seek a fully engaging theatre experience; I retain a hope that the next production I see confronts my perceptions of the possible.

A note on photographs: I would have liked to have incorporated more photographs to illustrate my argument, but few suitable images emerged, despite extensive searching. Most available photos of the productions discussed in the book were close-ups of actors; images that depicted the set, staging, and other such matters proved rare. Unlike late-nineteenth-century and early-twentieth-century photography (or even eighteenth-century engravings) that frequently depicted actors in a fuller *mise-en-scène*, modern photography focuses on faces and bodies. This is an interesting illustration of my argument: other theatrical elements, particularly corporeality, continue to be much more of a focus than space in contemporary criticism. I hope that my descriptions will set the scene, as it were, for readers.

1
Theatre and the Construction of Alternate Spaces

In her nuanced analysis of Christopher Marlowe's *Dr Faustus*, Ruth Lunney argues for the greater understanding of how space and performance interact:

> The connecting space within its [theatre's] 'landscapes' is always potentially refractive, setting repeatedly before the spectators images that challenge or distort the 'vertical and antithetical balance' that other elements of staging reflect. These images offer them alternative perspectives on the action, confronting them with the interconnectedness of experience. (2002, p. 181)

While Lunney turns this discussion to *Dr Faustus*, her observations are also relevant for understanding performance and spatial relationships in the contemporary world. Further, her investigation connects the world of the stage with the world in which that theatre is situated. My project also accounts for the refractive, challenging, and distorting nature of theatrical space. I explore the ways in which space in performance can instigate a significant interaction between theatre and the culture in which it enacts its meaning when it rehearses locations that may have resonance with the actual world. While this may seem to be the function of theatre already, the method of heterotopia that I offer extends the spatial reach – and its meanings – more than occurs in the genre naturally, as it were.

Specifically, I argue for the efficacy of heterotopia as a means of rendering more palpable both the spatial and the socio-political possibilities that theatre presents. It is also a useful production tool

in that it helps generate different orders of space in performance. I explore heterotopia in detail later in this chapter, but I summarize it here as a space generated via performance that enables us to better understand the theatrical experience; it may comprise the concrete space of the theatre venue, the imagined locations depicted in that venue, and/or the social context for the performance. Heterotopias, which Hetherington succinctly defines as 'spaces of alternate ordering' (1997, p. viii), offer a means to articulate and extend theatre's role in its socio-political context, especially in an age when theatre competes more than ever with the entertainment pleasures of cinema, television, and internet-based social networking communities, among many other possibilities. The core of this project is a combined and sustained relationship between space and performance.[1]

In this chapter, I construct a theoretical understanding of the role that heterotopia can play in creating and analysing theatre and performance. I introduce the term – which has been deployed more fully in cultural geography – into theatre studies and provide the 'map' to justify my approach (while also demonstrating the rigour required in interdisciplinary borrowing). I review the discourse on heterotopia because I believe it to have been inadequately deployed in many cases, particularly in its limited application in theatre. To lay the theoretical groundwork for this means of analysing spatiality in theatre, I furnish a genealogy of heterotopia that hasn't been undertaken since Kevin Hetherington's 1997 *The Badlands of Modernity: Heterotopia and Social Ordering*. It charts heterotopia's origins from the concept of utopia, through Michel Foucault's initial explorations of the term, to Hetherington's recasting of it, and finally, to how I argue for its potential in theatre. The second part of the chapter conveys the method that I have developed and introduces its application to theatre and performance to discuss heterotopia as a bridge that connects theatre with cultural politics and practice.

Following this theoretical section, I map how theatre's continual presentation of 'possible worlds' in performance can intensify the art form's relationship with the actual world beyond a venue. Such 'worlds' have meaning in themselves, in the context of the theatre experience, and in the connections we make between them and the worlds that exist outside a theatre or site-specific performance venue. Heterotopias open up the opportunity for exploring in detail the possibilities that such connections present; they have the capacity

to occupy a deeper 'place' than theatre already offers. They demonstrate how the layers of spatiality – both the concrete spaces that architecture provides as well as the abstract spaces and places that a specific production creates – articulate meaning in their own right, let alone through overlap between and among these layers. In so doing, they attend to spatial ordering, leaving open the chance to reveal and rethink existing structures of power and knowledge. The next section, on utopia, contextualizes studies of topoi generally.

Utopia: imagining and framing culture

Underscoring the popularity of utopia, Oscar Wilde quipped, '[a] map of the world that does not include Utopia is not worth even glancing at, for it leaves out the one country at which Humanity is always landing' (qtd in Neville-Sington and Sington 1993, p. 33). Before examining how heterotopia works, I briefly discuss its antecedent, utopia, to distinguish one from the other. Heterotopia requires an understanding of utopia, the more commonly described term, but they diverge from each other. Since 'utopia' was coined in 1518 by Sir Thomas More in his foundational narrative that is named for the word, it has been considered either topical or antiquated by turns, and sometimes even both at the same time.[2] Its enduring presence leads Angelika Bammer to argue that 'utopianism has been a staple, if not bedrock, of the western cultural tradition' (1991, p. 1). Its attraction is, Lucy Sargisson argues, its focus on 'spaces free from constraint, limited only by imagination' (2000, p. 153). Fredric Jameson also addresses the relationship between utopia and imagination: 'utopia as a form is not the representation of radical alternatives; it is rather simply the imperative to imagine them' (2005, p. 416). Traces of abandoned utopias remain in the cultural and historical landscape, reinforcing the form's currency in contemporary culture (see Pinder 2005).

A short description of utopia will help distinguish it from heterotopia. More's *Utopia* describes a society and its location in which life is ordered for the benefit of all by limiting the freedoms of the individual in favour of the greater good. *Utopia* satirizes the society of its time, contrasting the inequalities and injustices of sixteenth-century England with the egalitarianism of its fictional society. From a twenty-first-century standpoint, the satire takes on a compelling

edge, suggesting certain of the regulatory measures recalled from the more extreme twentieth-century experiments in egalitarianism. While More was clearly criticizing the values in his own society, he ironically questioned the relative values of freedom and equality. But a fundamental quality of this fictional 'elsewhere' – this impossible place – was precisely the fact that it was elsewhere.

By contrast, heterotopia offers a functional and reflective agency for change or commentary in contemporary society. Heterotopia retains the quality of otherness in a way that utopia does not. It is the operation of the 'alternate ordering' that provides the means that 'looks to how society might be improved in the future' (Hetherington 2001, p. 51). Heterotopia exists within the present time and place, an internal organ of its community, affording it a direct, functional relationship to that time and place. Heterotopia had originally been used to describe the medical situation in which an organ is displaced from its usual location or position in the body (*Concise Medical Dictionary*).[3] Like the anatomical abnormality of its etymological origin, heterotopia can work from within, albeit occurring where we may least expect it. Since a lengthy reading of utopia is outside the scope of this study,[4] I have narrowed the remainder of this section to its manifestations in and applications to theatre.

Jill Dolan's *Utopia in Performance* is the most prominent of these; although she engages in a different project, she has comparable expectations of theatre and performance to mine. She suggests that theatre can provide – however fleetingly – the means to change perceptions.[5] It is helpful to my argument on heterotopia to address Dolan's work briefly. We both recognize the potential of the 'glimpse' of the topos (whether utopia or heterotopia) and that such a glimpse has the power to transform interpretation and understanding. She seeks in theatre the moments that she calls the 'utopian performative', which is a 'complex alchemy' (2005, p. 8) that 'lifts everyone slightly above the present, into a hopeful feeling of what the world might be like if every moment of our lives were as emotionally voluminous, generous, aesthetically striking, and intersubjectively intense' (2005, p. 5). She articulates the fleeting nature of utopia, which for her, is determined by affect. This feeling has the capacity to prompt us to achieve what is otherwise thought to be impossible. Dolan's formulation is valuable for the possibility, however transitory, that something 'better' might be generated, even though her exploration of

utopian performatives through affect leaves little room for a spatial analysis. While she explores only one component of utopia's spatial possibilities – the 'no place' that is part of the meaning of the term (2005, p. 7)[6] – she usefully situates how the potential that she sees in affect-driven utopian performatives can be realized in performance: '[u]topia is always a metaphor, always a wish, a desire, a no-place that performance can sometimes help us map if not find', whereas performance 'is not a metaphor; it's a doing, and it's in the performative's gesture that hope adheres, that communitas happens, that the not-yet-conscious is glimpsed and felt and strained toward' (2005, p. 171). This formulation that combines the metaphoric with the concrete 'doing' is central to the way I discuss heterotopia. Utopia is, in its strictest sense, not a place at all. It is a geographical impossibility that cannot be marked out by a set of global positioning coordinates, yet it nevertheless takes up 'space'.[7] As Dolan establishes, it can be revealed by performance: mapped onto a stage, it can be made into a reality of sorts, even if temporarily.

For Dolan, the affinity between performance and utopia is close: 'performance always exceeds its space and its image, since it lives only in its doing, which is imagining, in the good no-place that is theatre' (2005, p. 13).[8] Theatre, then, has an alliance with utopia in that both describe fictional locations that resist mapping onto a particular place (except in site-specific performance) but both can intervene in the shaping of their cultures. My project moves in a different direction in its attempts to institute this potential spatially, since, as Hetherington notes, '[u]topian experiences are inherently spatial in character' (2001, p. 49).[9]

If utopia is deemed to be satiric, another related topos, dystopia, is equally so.[10] Dystopia 'satirizes both society as it exists, and the utopian aspiration to transform it' (Ferns 1999, p. 109). Dystopian worlds are a reification of disaster. For Dragan Klaić, '[d]ystopian drama frightens us with its vision but at the same time reawakens utopian instincts and urges the rejection of dystopian threats, similar to tragedy, which brings catastrophe but most often some sort of reconciliation and healing as well' (1991, p. 188). Dystopia in theatre also points to the ways in which the diegesis of a performance works to trouble our understanding of the worlds established through performance and, importantly, to make strong connections to the construction and operation of worlds beyond the theatre as well. While

comparable to heterotopia's function in performance, it, like utopia, fails to exploit spatiality as much as it might.[11]

This brief summary of utopia and its dystopic relative reinforces the idealistic nature of utopia and the ways in which the generation of alternative worlds (whether actual or imaginary) continues to captivate humans. This background is essential for my study, which argues that heterotopia, ironically unlike utopia, has the capacity to actually build the foundations for making what Hetherington terms alternate orderings of spatial structures. Heterotopia describes the relationship between performed worlds and the actual world beyond the theatre, holding the potential to spatialize how socio-political relationships might work differently beyond the stage. To illustrate heterotopia's function in theatre, I explore the concept itself, beginning with Foucault's interpretation of the term.

Foucault's heterotopia

Foucault popularized heterotopia, introducing it first in 1966; in addition to recounting a genealogy of the term, I articulate the most important features from his version of the term, and extend it by drawing attention to how it 'unsettles'.[12] I then combine this understanding with Hetherington's development of the concept before laying the groundwork for my own intervention, which applies heterotopia to theatre and performance studies. These disciplines have yet to properly engage with the term, an oversight that I seek to correct. Finally, this chapter turns to theatre, proposing it as an ideal art form for heterotopic analysis.

Foucault's explanation of heterotopia in 'Of Other Spaces' has provided its widest citation in the humanities. In cultural terms, heterotopias are

> real places – places that do exist and that are formed in the very founding of society – which are something like counter-sites, a kind of effectively enacted utopia in which the real sites, all the other real sites that can be found within the culture, are simultaneously represented, contested, and inverted. (1986, p. 24)

While they are culturally specific, they exist 'probably in every culture, in every civilization' (Foucault 1986, p. 24). His examples of

heterotopias suggest that they have discrete units of meaning, rules, and existence: churches, theatres, museums, libraries, fairgrounds, barracks, prisons, brothels, and colonies. His three most significant heterotopias are the cemetery, the garden, and the ship, each of which presents a world of its own, related to the actual world, but in some form separated from it. Most importantly to Foucault, heterotopias must have some relevance to the space and place outside them, a relevance that takes one of two forms:

> Either their role is to create a space of illusion that exposes every real space, all the sites inside of which human life is partitioned, as still more illusory [...] [or] their role is to create a space that is other, another real space, as perfect, as meticulous, as well arranged as ours is messy, ill constructed, and jumbled. (1986, pp. 25, 27)

In both cases, heterotopias for Foucault operate as 'counter-sites' or 'sites of resistance'. In using 'counter-sites' to describe heterotopias, he provides a means of distinguishing actual life from these other spatio-temporal sites. Russell West-Pavlov pursues this difference between the actual and the heterotopic by insisting that Foucault's concept be understood in the context of 'fault-lines' such that '[h]eterotopias emerge at moments when the conceptual bedrock is shifting, at places where the social and semiotic fabric is fraying [...] [where] primordial space is undergoing change and can no longer be taken for granted' (2009, p. 138). Diana Saco takes this in a slightly different direction, arguing that a heterotopia 'is a kind of in-between space of contradiction, of contestation: a space that mimics or simulates lived spaces, but that in so doing, calls those spaces we live in into question' (2002, p. 14). Such fraying or contestation is core to Foucault's heterotopia. In *The Order of Things*, he notes that heterotopias

> are disturbing, probably because they secretly undermine language, because they make it impossible to name this *and* that, because they shatter or tangle common names, because they destroy 'syntax' in advance, and not only the syntax with which we construct sentences but also that less apparent syntax which causes words and things [...] to 'hold together'. (2002, p. xviii; original emphasis)

This is the point about Foucault's heterotopia that is most frequently overlooked: that heterotopia is disturbing. It *unsettles* the world as we know it, a quality that will come to be key in its use in theatre.

Heterotopia is usually either applied ineffectively or dismissed, possibly as a result of Foucault's imprecision. Both Benjamin Genocchio (1995, pp. 38–9) and Robert Topinka (2010, p. 57) critique Foucault for a lack of specificity in describing the concept.[13] Hetherington defends Foucault against these claims, arguing that '[t]he power of the concept of heterotopia lies in its ambiguity' (1997, p. 51). Nevertheless, Genocchio's criticism comes down to a rhetorical question implying that Foucault's interpretation is simply too wide-ranging: 'what cannot be designated a heterotopia?' (1995, p. 39). Certainly Foucault's many examples do suggest that the possibilities are almost endless, and frequently attempts to deploy the term serve only to render it so broad that it is emptied of its usefulness and complexity. My own formulation in this study endeavours to keep it more focused.

David Harvey has argued most strongly that heterotopia not be used simply to mark the presence of other worlds, spaces or places but that it be connected with what might be called a political function, such as the attempt to articulate the potential for social change, however that may be conceived (2009, p. 111). He objects to a simplistic application of heterotopia that fails to account for its critical, disruptive, political point. Edward Soja understands Harvey's reservations but appreciates that 'Foucault focused our attention on another spatiality of social life, an "external space", the actually lived (and socially produced) space of sites and the relations between them' (1989, p. 18).[14] Soja argues that heterotopias are not 'just "other spaces" to be added on to the geographical imagination, they are also "other than" the established ways of thinking spatially. They are meant to detonate, to deconstruct, not to be comfortably poured back into old containers' (1996, p. 163). Heterotopias, then, require an intersection with the cultural context of which they are a part, rather than a narrow metaphoric application.

As I explained in the Introduction, Foucault singles out theatre as an example of heterotopia, but it is not a concept that has gained traction with many theatre scholars, several of whom contest heterotopia's value to the form. David Wiles finds it passé: 'Foucault's idealization of alternative (hetero-) spaces seems a little dated. To

opt out of globalization and inhabit an "alternative" culture seems more problematic than it did in the sixties' (2003, pp. 8–9). The term retains for me much more possibility than it does for Wiles, as I explain shortly. Arnold Aronson believes that any opportunity for heterotopia to have purchase in theatre has waned with the advance of multimedia in theatre: '[t]he stage, which by definition is a framing of space, creates an impression of itself as one unified space. Technology, however, has found a way to present multiple sites or locales simultaneously: video' (2005, p. 110). As my final chapter argues, such a strict generic division between *either* theatre *or* video is increasingly unlikely. Further, the co-existence of video (among other multimedia forms) within a theatrical environment could be said to challenge traditional modes of thinking about genres such that it *extends* performance and specifically spatiality.

Heterotopia has not been widely or effectively used as a critical framework in theatre. Various theatre scholars refer to heterotopia, but rarely in detail.[15] Among the very few exceptions is Michal Kobialka who provides a detailed analysis of Foucault's heterotopia in the context of Tadeusz Kantor's work and subject formation (see Kobialka 1993, pp. 310–12, 360–1). For Kantor, heterotopia can be located within the 'space' of the self. Kobialka argues that Kantor used heterotopia to push the potential for theatre 'beyond the physical aspects [...] in the direction of metaphysical theatre' (1993, p. 339). He quotes Kantor that this pressing of theatre's potential should extend to the 'final limits where all categories and concepts lose their meaning and right to exist' (1993, pp. 339–40). While my work pays more attention to the specifics of space, Kantor introduces a useful troubling of the notion of space or rather, what can be interpreted *as* spatial.

Finally, in Foucault's system, heterotopia is necessarily relational, but it is not simply an inversion of reality or the actual world beyond the theatre's walls. For instance, I do not consider plays that simply replace one world for another as heterotopic. Peter Shaffer's 1965 *Black Comedy*, in which the action takes place during a blackout (but where the lights are extinguished for only the scenes before and after the blackout occurs), creates an alternate world, but there is no resistance or disturbance to the actual world. Likewise, Richard Brome's 1636 *The Antipodes*, in which one character engineers a 'cure' for another's malady by convincing him he has travelled to the

Antipodes where the customs are reversed from English ones, satirizes the times but fails to challenge spatial politics and practices.[16] Rather, there needs to be more spatial development that marks heterotopia as different from the function of theatre itself, as I articulate and develop in the next section.

Attempts to apply Foucault's concept have generally been less productive than one might hope, but Hetherington's version of this 'imaginary' spatial context, to which I now turn, provides a means to better understand the spatial possibilities of theatre and performance.

Hetherington's heterotopia

Hetherington's interpretation of heterotopia more than answers the criticism of Foucault's admittedly vague delineation of the term; further, it extends it in such a way that it can be productive for theatrical application. Hetherington's development of the concept shifts it slightly, though: whereas heterotopia for Foucault is a counter-site of resistance (1986, p. 22), Hetherington sees it as not quite oppositional. Instead, for him, heterotopias 'organize a bit of the social world in a way different to that which surrounds them. That alternate ordering marks them out as Other and allows them to be seen as an example of an alternative way of doing things' (1997, p. viii). Heterotopias, then, do not need to be obviously resistant to operate successfully (although many of them are oppositional). This modification to the resistance that Foucault stipulated broadens the comparative function of heterotopia and extends its relevance in theatre. Heterotopia for Hetherington retains an 'unsettl[ing],' ambivalent 'effect of making things appear out of place' (1997, pp. 49–50), thus distinguishing it from the more categorical examples that Foucault outlined. Unsettlement remains a key aspect in my extension of heterotopia for the interpretation of theatre and performance.

In order to understand Hetherington's contribution to heterotopia, I must return briefly to utopia, or more specifically, utopics, which is a term that Louis Marin coins for 'a play between imagined sites and ideas about the good society' (qtd. in Hetherington 1997, p. 56). It is via the work of Marin that Hetherington derives his extension of Foucault's concept. For Marin, utopics is not a synonym for utopia. Hetherington summarizes Marin's argument that utopics takes on

broader social practices whereby the utopian ideals that a society has are expressed spatially. He calls this utopics a spatial play and we see examples of it in such things as town planning, modernist architecture, landscape gardening, prison design and civic building. In these forms of spatial play we witness a modernising utopics put into practice in which future-oriented ideas about order, improvement and development were expressed through certain kinds of planned social space and the discourse surrounding them. (2001, p. 51)

The relationship between utopics and heterotopia is closer than that between utopia and heterotopia, because utopics *produce* heterotopia (Hetherington 1997, p. 56).[17] The spatial play between the actual world and other possible worlds interests Marin most. Following Marin, Hetherington returns to More to locate heterotopia: '[w]hen Thomas More first coined the term *Utopia* [...] he collapsed two Greek words together: *eu-topia* meaning good place and *ou-topia* meaning no-place or nowhere' (1997, p. viii; original emphasis). To explore the sense of 'play' in the utopic act, Marin separates the two terms (or, strictly speaking, the homophonic prefixes More attached to 'topos') that form the word 'utopia'. Hetherington sees heterotopia residing in the space that exists between the separation of 'eu-topia' and 'ou-topia'. Hetherington builds on Marin's project by examining the nature of the chasm between the 'good place' and the 'no place': it is in this considerable conceptual gap that Hetherington sees heterotopic space situated in a location that differs from the actual world. It may appear that a 'no place' cannot be located anywhere in the strictest geographical terms, but as Dolan outlines, a no place can be enacted and realized *in performance* (2005, p. 13).[18]

The arguments that Marin and Hetherington advance make possible a more substantive exploration of alternate spaces and places through a metaphoric 'extension' of space and/or an identification of 'another' dimension to spatiality. Heterotopias do not simply exist in the delineation of such an alternative space: rather, their power is derived from being read *against* a context of a real or actual world. Hetherington investigates the chasm between the poles of 'good space' and 'no place' that Marin identified (the components of More's utopia that Marin pries apart) because it is against this chasm that he finds a productive point for comparison for the actual world.

Significantly, this other location gathers its strength in contrast with the 'real'. Thus, a heterotopia without such an actual point of comparison is meaningless. For Hetherington, heterotopias are not necessarily the fixed locations or entities that they are for Foucault (see Hetherington 1997, pp. ix, 22–49) and equally, Marin notes that 'utopic discourse "works" as a schema of the imagination [...]. It is a discourse that stages – sets in full view – an imaginary (or fictional) solution to the contradiction' (1984, p. xiii; see also p. 10).

Further, importing this concept to theatre renders 'location' slightly more fluid since in performance, 'space' straddles the borders of 'real' and 'not real': space in performance is 'real' for the duration of the performance but in its transience, its unreality is limited by the stage set that must be built for the next production to occupy a particular venue. To clarify, a theatre venue is obviously real even if what is staged within it is not. Many of the locations that are created on a stage are real in that they are, in, say, naturalistic theatre, made with wood and objects that are recognizably 'concrete'. Yet they are also unreal in that they do not exist beyond their function in a performance and they will be destroyed or repurposed when the production closes. Still other locations are generated almost exclusively imaginatively in that we do not see their boundaries or their materiality on stage, even if we accept their presence and, for the intention of the performance, their existence in context. Following on from this, heterotopias might be abstract locations, as much as representations of actual geographical locations. They must, at the very least, be anchored in space on the stage or in a production's diegesis. It is their spatiality that provides them meaning.

Heterotopias may, then, be actual or imagined spaces/places (or spaces of the imagination) in dialogue with 'real' locations (although it is important to note that real and non-real places are not equivalent to the 'good place' and 'no place'). Hetherington's more nuanced figuration of heterotopia as an imagined space – which I interpret to be created, depicted, and/or enacted in front of us on stage – provides a literal and metaphoric basis to the spatial analysis of what might be possible in theatre and beyond.[19] In the next four chapters, I explore how imagined places and spaces relate to what exists beyond the theatre walls or the theatrical experience. Before I proceed to the case studies, I set out some of the parameters for the heterotopic reading strategy in theatre and performance (see Figure 1.1).

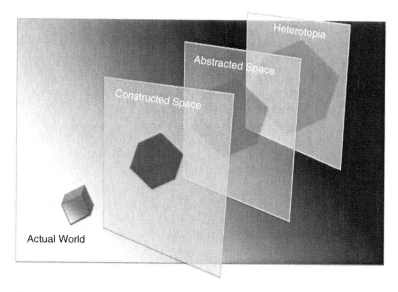

Figure 1.1 Heterotopic space, 2014
Source: © Alan Lawrence, Brisbane.

Interpreting theatre heterotopically

This section provides an overview of how one might enact a heterotopic interpretation of a production, including a short account of an 'anti-heterotopic' production. Before I embark on describing this method, I articulate the significance of applying heterotopia to theatre and performance. The productions that I investigate in Chapters 2–5 deploy heterotopias to renegotiate and r*eplace* literal and figurative locations in terms of a given diegesis. They rehearse the spaces of possibility in performance in such a way that the audience is encouraged to make connections between 'imaginative' locations and the actual ones that they inhabit and traverse to get to the theatre. Heterotopic spaces act as experimental zones for possibilities to be tried out. Crucially, heterotopias also have the capacity to influence an audience's understanding of the relationship between the theatre and the world outside its walls, such that theatre can continue – and extend – its function of both shaping and contesting its cultural context. I explore heterotopias not to refuse or refute other

interpretations but to extend them by providing a more systematic means to analyse theatre spatially.

By exploring spatiality at a greater level of detail than is usual, I look beyond the imagination and stage magic that make theatre work for so many audience members to the actual space(s) and place(s) that theatrical productions depict, imagine, create, and develop. I examine particularly those spaces that have multiple meanings and interpretations, and even more, those spaces that connect to off-stage actions, events, and feelings that are relevant to contemporary audiences. It is not possible to describe a theatrical heterotopia out of context: given that the existence of a heterotopia depends on the intersections of an actual place and the poles of 'good place' and 'no place', it is not an entity that will always be depicted by a list of pre-existing qualities. It is clear, however, that heterotopias do, for the duration of the theatrical production in which they are produced, take up space. Like the art form of theatre itself, they may appear at some times to be tangible, definable spaces or places whereas at other times they may generate more of the 'feeling' of an ethereal space or a 'world' picture that is created by an entire production, in conjunction with the 'world' beyond performance. Heterotopia opposes the real in some cases while offering a means of 'alternate ordering' in others.

Theatre has long been characterized as a 'window into other universes'. As a result, audiences frequently take for granted the ability of theatre to construct and generate recognizable locations – global, national, and local geographical places, as well as public and private places. A generalized relationship between the setting of a play and an extra-theatrical parallel universe is usually part of critical analysis; for instance, the 2012 production of Shakespeare's *Timon of Athens* at London's National Theatre staged the London base of the Occupy Movement to remarkable effect, as well as presenting an initial scene set in a large exhibition hall of the National Gallery. Spectators could make the links, and reviewers inevitably also drew their readers' attention to these connections.[20] Yet rarely is a specific examination of the nature of theatrical space/place effected in a thorough analysis of performance: few studies outline the significance of spatiality in theatrical analysis. In *Theatre's Heterotopias*, I respond by interpreting 'place' not just through the action that occurs on the stage in the worlds that are created there, but also through the relationship

between those locations and the social experience outside the theatre. Such an approach to the workings of cultural production encompasses the manner in which abstract theatrical space takes 'physical' form and meaning; it picks up on Lefebvre's discussion of how space structures social contexts (rather than the reverse).

Heterotopic theatre may not in itself directly create political change (theatre almost never has that capacity), but it is possible that a performance might affect audiences significantly by demonstrating how change for the social good (however incremental) might take place off the stage. The value in heterotopia is actually witnessing in performance how else space and place might be constituted: it is the point of comparison of what *does occur* against what else *might transpire* such that the 'unreal' spaces that comprise a theatrical experience have the capacity to elicit concrete effects beyond its walls.

The method

My analysis takes into account a combination of the following spaces, which intersect and interact to generate heterotopic locations: the theatre venue in which a performance takes place (or, if it does not take place in a conventional venue, the location in which it is staged); the narrative space(s)/place(s) that the playwright establishes, which are generated in the venue or even referred to beyond the limits of the performance space; and the layers of design and direction that are added to the first two types of space and which continue to accrete (and in some cases challenge or subvert) meaning. These contexts are not all equally relevant in every production where heterotopia is discernible; as well, space and place are not always depicted, aligned, or engaged similarly, in performance or beyond. Sometimes a heterotopic space becomes apparent only for a short time, whereas in other instances it may be staged for a much more significant part of a performance.

Heterotopia begins for me with the potential that the next production holds. A detailed examination of the spatiality of a production is the first step. In addressing whether or not a production might exhibit heterotopic features, I investigate the design of a production in the context of its venue and, from there, ask myself a range of questions, beginning with what types of places/space are presented in performance, and to what end? I may be alerted to the potential for a productive heterotopic analysis through reviews,

posters, promotional material, the nature of the playwright, director, designer, and/or company, but such advance warning may not have occurred. Heterotopic theatre tends to take risks with theatrical space and with the effects of such decisions, so some theatre companies may be more likely to produce it than others. A heterotopic experience is more likely to emerge and affect an audience member when that person remains attentive to and welcoming of the theatrical – and other – conditions taking place and being generated around them. It requires effort, as does any thorough interpretational reading frame.

The questions I might ask of a specific production include: what space(s) and place(s) contribute to a production's diegesis and how are they operating? Do they overlap and intersect to suggest the potential for collapsing time and space? Do the locations in performance require disentangling to even identify (since theatrical worlds often intertwine, sometimes in very confusing manners)? Or do they create rigid contrasting zones? What is their function *vis-à-vis* contemporary social or cultural politics? Do these spaces and places provoke connections for their audiences to other possibilities, whether implicit or explicit, or do they simply reproduce the social and political norms? In addition to strictly spatial considerations, I also address how such spaces intersect with (or contradict) the actors' embodiment(s), the dialogue, the narrative, the sound. What is the role of the venue in which the performance takes place? Do the production's locations 'fit' in this venue? What is the potential for an alternative and/or resistant reading of the spatial practice in this performance? Heterotopia thus requires a spatio-centric analysis, but it also accommodates and incorporates other theatrical elements of any production. This range of questions is what might be described as background work, like the mathematical figurings in long division. The answers to such questions do not in themselves determine whether a production is heterotopic: rather, they provide information about how space operates, from which an interpretation can be built about the worlds that a production establishes, as well as the crucial relationships between those worlds.

My interpretational reading frame helps connect spatiality more explicitly to the social/political contexts of the production. Following such questions, I enumerate the various 'spaces' or 'worlds' that a production constructs, regardless of how nebulously or briefly

they appear on stage. At first, the list often looks incomprehensible, until patterns emerge; I then consider possible ways to configure the poles of utopics that Marin describes and whether there is 'room' for a heterotopia between them. It may be more useful to consider the poles as different representational systems or even different vantage points, since they may not be opposites, and equally, there is no hierarchy between them. This form of analysis may frequently require the shifting of the interpretational lens, looking at the spatial realms through different prisms; similarly, not all productions will be capable of producing such an interpretation. This description may appear to be amorphous, but a fixed checklist approach is impossible: the interpretational strategy needs to leave room for the possibilities that a production brings with it.

Particular locations created for performance may communicate a heterotopic relationship with a socio-political context outside the theatre for the duration of a production or only in a moment's fleeting execution. It is possible to bring this heterotopic reading strategy to bear in the busy set of a naturalistic production and in the spareness of a minimalist set; one may find it in a new play as well as in the adaptation of a classic text. It is somewhat easier to investigate the spatiality of a familiar play (as is the case with any interpretation), but new plays also offer promising territory for analysis. It should work with verbatim and documentary theatre. Heterotopia may be embedded in the narrative of a text, but it is more likely to be enhanced by a production team of designer, director, actors, composer, lighting technicians, and so on. Of course one person's perception of the heterotopic may not 'translate' in the same way to another. Certainly many audience members already implicitly piece together this information as they interpret a performance in a manner that communicates to them on, for instance, aesthetic, affective, political, and/or cultural levels.

Terminology

I find the system that Hetherington identifies for locating heterotopia between the prised-apart poles that form utopia very engaging but I am less captivated by Marin's reliance on the foundational terminology of a 'good place' and a 'no place'. It is too easy for the adjectives – 'good' and 'no' – to acquire unintended value judgments. Further, while it is possible to discern multiple locations in the

theatrical examples, the terms fail to capture the nature of these zones, often obscuring their functions. I retain the structure but I have modified the terms to 'constructed space' instead of 'good place', and 'abstracted space' instead of 'no place'. By 'constructed' I mean the spatial environment that one usually confronts as a production begins, whether determined by a venue/location, its (initial) set, by expectations, and/or by the setting(s) required by the narrative/action. 'Abstracted' space that is produced by the other dimension of utopics is a sometimes oppositional but certainly contrasting spatial environment that may be located in a geographically determined place; it may take on more of an abstract quality (a state of mind/being) that is nevertheless rendered spatial in performance. Abstracted spaces may not necessarily be abstract per se.

I have also elected to use 'space' instead of 'place' since the relevant locations developed on stage are, even in the case of constructed space, often described less by geographical coordinates than one might assume. One of the two poles is often a more figurative location than the other, but not always. The two poles may be oppositional but they do not need to be. The resistance that Foucault outlined is between the heterotopia itself and the formation of utopics, not between these two terms themselves.

Heterotopia

Between the two locations of constructed and abstracted space, it is possible to discern a heterotopia, a zone or realm that can be located physically in performance and that suggests an alternative to the status quo. This experimental zone provides a means to test out spatial alternatives that might prompt audiences to think (and act) differently about matters outside the context of performance. Given the complexity of the various spatial locations that this process requires, it is perhaps not surprising that the emergence of a heterotopia may be transient, but it is the fleeting nature of heterotopia that is often its initial attraction, especially if we seek more of that moment. Since space structures social order, alterations to space have the potential to be far more effective in generating change than other qualities (in theatre, elements such as language, narrative action, music, among others, and even performance itself). The identification of heterotopia takes some investigation, but that work reveals the depth of the spatial relationships.

Structure

There are echoes in this method with other interpretational strategies that could be applied to performance, from the Hegelian dialectic of thesis-antithesis-synthesis to Edward Soja's concept of 'thirdspace'. A more recent proponent of a tripartite system of analysis is Jacques Rancière's 'emancipated spectator' who 'overcome[s] the gulf separating activity from passivity' (2009, p. 12) through what he calls the 'pensive', or 'a zone of indeterminacy between [...] activity and passivity' (2009, p. 107).[21] Rancière outlines the effect of such an approach, which resonates with mine:

> [t]here is no straightforward road from the fact of looking at a spectacle to the fact of understanding the state of the world; no direct road from intellectual awareness to political action. What occurs instead is a shift from a given sensible world to another sensible world that defines different capacities and incapacities, different forms of tolerance and intolerance. [...] Such breaks can happen anywhere and at any time. But they cannot be calculated. (2009, p. 75)

In her analysis of art and performance, Claire Bishop favours Rancière's avoidance of 'the pitfalls of a didactic critical position in favour of rupture and ambiguity' (2009, p. 29). The popularity of a tripartite structure in assisting with 'rupture and ambiguity' is undeniable, and politically much more functional than a binary. My heterotopic model extends the three component parts (constructed space, abstracted space, heterotopic space) to account for what this might mean in a cultural context beyond performance. In the Conclusion, I return to the nature of the interpretational method, following its substantiation in the case studies.

Anti-heterotopia

I have discussed what heterotopia is and might be, and the next four chapters explain how it operates. A brief example of a production that I found to be the antithesis of heterotopia might help, ironically, to anchor my method. While it was staged in a thoughtful and entertaining way, *A History of Everything* was quite static for me because of the absence of hope and the absence of any 'forward motion'. The ninety-minute co-production between the Belgian-based company, Ontroerend Goed, and Sydney Theatre Company unfurled the

history of the world for audiences. Directed by Alexander Devriendt, *A History of Everything* began with the arrest of South African sprinter, Oscar Pistorius, and other events that had occurred on the actual day that I saw the production. It moved from there back 3750 million years to the big bang that formed the earth, and much further to 13,750 million years ago. It travelled from the events of 15 February 2013 back through the movement of tectonic plates and the formation of planets, well before the dawn of life. To capture more recent history, the play was performed on a stiff, white matt floor cloth cut in the shape of a Mercator world map laid on the stage. It came to resemble a large military strategy board with events of history placed on top of it, including flags, signs of war or trademark symbols, horses, the Yen, and boats travelling across the Atlantic. The seven actors depicted all events (including their own births and back much further to the generation of the first cell, by which time the floor-cloth had been rolled up into a ball and then disappeared). It was enjoyable to pick the cultural and historical references in a witty production. Yet, while it was imaginative in terms of its setting and staging, the focus on the past without any agency for the present or future provided no hook, no means of thinking beyond an inevitable absorption into the past. I found it oppositional to the notion of heterotopia, though, because its wholly backwards glance left no opportunity for experimentation or consideration of even the present, let alone the future. Such a 'replay' of what happened in the world's history wasn't 'productive' theatre, except perhaps in the marvelling about the past. That wasn't its point, so I am not criticising it per se (I applauded as loudly as the rest of the audience), but its absence of any scope for heterotopia was stark for me, and it isolated the potential power of this trope. In the absence of even the prospect of trying out anything new, *A History of Everything* simply retraced paths, leaving no room for choices; it presented the future as a teleological inevitability, whereas attention to the future permits and necessitates choice. Other examples of performance unlikely to be heterotopic include re-enactments of historic events on the actual sites, or adaptations concerned solely with a connection to original text(s) and genre, or classics where there is an apparent attempt to preserve an erstwhile 'original'.

Not all productions (even those that are forward-looking) will produce a heterotopic reading, particularly if little attention has been

paid to careful staging.[22] Inevitably, there are many reasons why one play might operate in this way and many others not.

Yet other spatial realms

Heterotopias can be literal or abstract spaces. They may be generated through the (textual) spaces of soliloquies or choruses or the more scenic rendering of places and concepts. In order to understand their specificity (and their relationship to their contexts), I acknowledge another form of space to outline the potential for analysis and interpretation that heterotopia raises: the absences and gaps that paradoxically might produce clarity about actual locations. One of the ironies that I have discovered in this analysis is the fundamental significance of an 'absence' of space. That is, investigating heterotopias often reveals the unseen, the absent present, or an obvious gap. While heterotopia provides a specific location in performance, at times that place is one of 'absence', or quantifying what is not there. It is particularly appropriate that such a state be explored in theatre that not only stages those places or states that are difficult to pinpoint in the actual world, but it also makes things appear on stage *because* they refuse to appear in 'real' life.

There are two variants on absence that I raise here. Theatre facilitates their analysis because of its propensity to enact spaces that are otherwise unreal. The geographer, Yi-Fu Tuan, discusses mythic space. In theatre, playwrights, actors, and designers generate a fictional space/place that is often related to perceptions of contemporary space/place in the world outside the theatre. The audience's receptivity to that fictional space comes about because of our understanding of mythical space, which Tuan defines as 'a conceptual extension of the familiar and workaday spaces given by direct experience. When we wonder what lies on the other side of the mountain range or ocean, our imagination constructs mythical geographies that may bear little or no relationship to reality' (1977, p. 86). Mythical space is set apart from what Tuan calls 'pragmatic and scientifically conceived spaces' because it does not necessarily follow the rules of pragmatic or scientific space. Tuan's mythic space translates naturally to theatre, of course, which is also metonymic: a very limited range of signs (props, lighting, gestures) can generate in performance a kingdom or a particular time and space, or even 'history' itself.

A further variation, what I term psychic interiority, evokes the work of Gaston Bachelard, perhaps the best-known commentator of

interior spaces. He coined the term, topoanalysis, which relates to the 'topography of our intimate being' (1964, p. xxxvi). According to Bachelard, we retain the memory of our childhood home, 'our first universe, a real cosmos in every sense of the word' (1964, p. 4). Those memories continue to affect our lives in ways that often emerge as surprising or unexpected. They have a material reality in space and time. Ed Casey interprets Bachelard to mean that 'a topoanalysis of the house demonstrates that psychic places are not merely diffuse or formless. To the contrary: they possess their own precision' (Casey 1997, p. 292). The intimate space of our memories must intersect with the exterior 'world space' (Bachelard 1964, p. 203), and each is immense in its own way.[23] Bachelard's value to my argument is his articulation of the significance of particular locations that might otherwise be considered ephemeral or even meaningless. Further, topoanalysis identifies that such locations take up material space, something that is a given in theatre but that is often taken for granted. Gaps and absences structure a significant portion of this analysis, but I do not discuss mythic or psychic interiorized space in any depth in their own right; rather, they provide a foundation for the analysis herein, *vis-à-vis* world-making and abstraction.

The potential of heterotopia

As I noted in the Introduction, this is a hopeful book: I continue to put stock in the next production I see staging space and place in ways that encourage me to shape arguments about cultural formation and cultural change. I hope to address how the spatial alternatives these productions present are worth exploring, debating, developing, and even adopting beyond the space of performance. Like Dolan, who believes that '[u]topian performatives, in their doings, make palpable an affective vision of how the world might be better' (2005, p. 6), I am confident that theatre as a medium can provide a glimpse into options that can make a difference. I am proposing, ambitiously, that heterotopic theatre can facilitate what Margaret Kohn terms '[t]he transformative potential of space [that] lies precisely in the possibility of suspending certain aspects of reality in order to intensify others' (2003, p. 156). It may result in a very small action, but as Bachelard reinforces, '[b]y solving small problems, we

teach ourselves to solve large ones' (1964, pp. 134–5). Dolan quotes Herbert Marcuse who claims, '[a]rt cannot change the world, but it can contribute to changing the consciousness and drives of the men and women who could change the world' (2005, p. 20). The isolating of spatial models can contribute more definitively to that change of consciousness.

Space in theatre can function not just at the level of an individual audience member's reactions but also in terms of a larger community response. Theatre assumes and builds on the connection between space and the collective experience in which its world-making takes place. Theatre's ability to play with an infinite number of spaces in front of a collective audience makes it an ideal context with and through which to examine heterotopia. The potential existence of a paradoxical world on stage wherein both the actual and the 'conjured' locations coexist offers the opportunity to practice – to 'rehearse', as it were – potential socio-political alternatives to the larger space-time reality. This relationship has been explored in specific periods in theatre history where the notion of theatre as a microcosm is well acknowledged. D.J. Hopkins has investigated this connection in detail in the theatre of early modern London, where he traces how the world – particularly London – has been compared to a stage (2008, pp. 25–31). This is also the ethos of applied theatre and community theatre that uses theatre as a proving ground for cultural change.[24] Augusto Boal, perhaps the exemplar of applied theatre, notes:

> [o]nly humans are capable of observing themselves in action. By observing myself in action, this dichotomization allows me to change my way. That's why culture is possible: because we humans are capable of looking at ourselves in action [...] and say[ing], 'If I am here I can go there. If I have done like this, I can do like that.' (qtd. in Prendergast and Saxton 2009, p. 203)

Boal's intervention sought direct and immediate social change. The analyses I pursue in this book essentially seek the same, but I acknowledge that measuring 'success' in such a venture is difficult. A heterotopic moment or production is not going to transform the world but I believe that it can prompt a rethinking, however minor initially, or a personal reaction to a larger social issue that can foster

changed attitudes and responses. The chapters that follow analyse performances that attempt (and in most cases achieve) the feat of locating what is staged in the context of that which surrounds – and contextualizes – the theatre venue. Each chapter provides a different perspective on how heterotopia might operate in theatre.

As with all other components of theatre, heterotopia cannot communicate on its own. Rather, it offers an additional, material method for theatrical analysis. It operates with the assistance and (given the heterotopic capacity to unsettle) even the resistance of other theatrical sign systems, such as dialogue, music, costume, gesture and all the aspects that the performing body brings to the stage, not to mention the role that spectators play. I demonstrate the importance of accounting for space, acknowledging that for the purposes of this study, doing so requires me to take attention away from other equally significant aspects of the theatrical experience.

Even though this methodology focuses on a spatial analysis, it is not possible to cover every aspect of space: I have thus prioritized some matters. Yet even in these necessarily partial accounts, I have been able to generate a richer interpretation of the selected productions and of spatiality in theatre than I would have yielded otherwise. *Theatre's Heterotopias* aims to connect theatre practice and criticism to social history and geography with a view to more fully articulating theatre's role in its culture. A heterotopic reading strategy enables us to better understand the concrete space(s) of both theatre and its social context, not to mention the performative relationship between them. To some extent, this is a function of theatre itself, but as embodiment and, increasingly, multimedia, work with other elements of performance (in this situation, space), my argument seeks to reposition the role of spatiality more prominently among theatre's other major components.

Ultimately, heterotopia helps rethink theatre's function in its social space, however widely we may choose to define that context. As Soja describes, heterotopias provide a way of investigating a context '"other than" the established ways of thinking spatially' (1996, p. 163). Theatre is a particularly appropriate medium to match with heterotopia because of its spatial foundation and its capacity to encapsulate many different resonant locations in (usually) a (relatively) small space. Topinka's observation that '[h]eterotopias, by juxtaposing many sites in one space, reveal the extent to which

knowledge relies on spatiality' (2010, p. 67) reinforces theatre's role in communicating the value of that spatiality in our cultures. The method that I outline for analysing heterotopia suggests a renewed potential for investigating the role of theatre and performance in shaping cultural formation and cultural change. This study offers ways of interpreting spatiality on the stage beginning, in the next chapter, with performance that is situated amid the culture for which it is created: site-specificity.

2
Heterotopia and Site-Specificity

David Wiles argues in his influential study of theatre spaces that '[t]heatre architecture turned out to be one of modernism's greatest failures, flexible, versatile theatres stripped of social messages proving a conceptual impossibility' (2003, p. 22). Conventional theatre buildings need not be as gloomy as Wiles suggests of modernist venues (or the late twentieth century's flexible spaces), but many theatre buildings do tend to curtail the potential for engagement with the world beyond their walls. Subsequent chapters address how such seemingly restrictive venues can nevertheless facilitate the production of heterotopic effects, but here I discuss performance that rejects conventional venues, instead exploring locations that have the capacity for a heterotopic relationship with a community.

Site-specific performance is an ideal topic for heterotopic analysis because of its focus on space, but ironically, Sally Mackey insists that there remains 'a lack of clarity about the *particularity* of place-based performance' (2007, p. 181; original emphasis). If site-specific performance aims for a convergence between site and performance to create something new, a heterotopic reading of such work provides more 'placed' speculation about the organization of social and political spaces. Heterotopia is, arguably, easier to explore in site-specific performance, which is more directly intertwined with the social context, because it takes place outside what might be considered the 'mediating' architecture of a theatre building.

This chapter analyses two productions that engage with otherwise non-theatrical space.[1] The first barely appears to intrude spatially on the city and can continue to be performed well after its premiere,

yet it delves far beneath the surface of the urban context. Platform's audio-walk, *And While London Burns*, increases the complexity of site-specific performance in its location in London against moving temporal and spatial markers. The second was performed against quotidian events in a train station. Ros and Jane Merkin's *Suitcase* took place at Liverpool Street Station in London on one significant day in 2008. These examples engage with their cultural contexts while they also destabilize the familiar to (simultaneously) foreground the regenerative. They demonstrate some of the ways that heterotopia invites speculation about how to address (and redress) cultural and social quandaries and even impasses that are space-based. They indicate the room for personal agency instead of maintaining inherited assumptions about the power to change things always residing elsewhere. This chapter's heterotopic readings push the potential meanings of sites and events, intensifying site-specific performance's already-strong relationship with social, historical, political, and aesthetic contexts. The heterotopic moments from one production occasionally echo the other, but in each case, they articulate an additional space generated by and between the specific relationship between site and performance. They thus provide a more explicit means of spatial analysis than other interpretational possibilities. Before I turn to the case studies, I interrogate in greater detail some of the spatial components of site-specific performance and tie their analysis to the cultural historical and geographical contexts in which they exist.

The value in exploring heterotopias in theatre and performance generally is the opportunity to connect theatre much more directly with the social and political world in which it takes place, expanding the possible frame(s) of reference and the effects of the performance and the ideas it elicits. Whether concrete or metaphoric, heterotopias provide the building blocks for creating something different: the opportunity to try out – on stage or in another type of space marked out for performance – what else might take place. In this way, heterotopia can generate spaces of promise, even of hope. A heterotopia may even provide a counter-example: that is, it may perform what option(s) are unlikely to take hold, simply to rule them out. This chapter's examples demonstrate the prospects for heterotopia to effect a change (however subtle) in the consciousness of audience members. It seeks to make audiences think, without prescribing *what* to think or anticipating immediate action per se. As Chapter 1

detailed, a heterotopia does not exist on its own: it operates between the two poles that structure utopics, what I call 'constructed space' and 'abstracted space'. When it is apparent, a heterotopia resides between – or somehow in relation to – these two locations. This tripartite configuration affords an alternate ordering of the real world, a way to engage with other ways of thinking, other ways of structuring space in performance. Once we see how these alternate orderings might work for performance, it is possible to conceive of them operating beyond a performance location as well.

This opportunity for an alternate ordering is particularly achievable in site-specific performance. Site-specificity has experienced a resurgence in popularity since about the 1990s, whether because venues are too expensive, or they are perceived to limit imaginative scope, or performers seek other ways to engage with their communities. Site-specific performances that compare an actual world location with the immediate narrative context can generate a relationship with a social space more easily than performances that take place in conventional theatre venues.[2] Simply taking a performance out of a theatre venue, however, does not in itself create site-specific performance. Many productions that take place outside conventional venues do not succeed in engaging as fully with the site as one might wish (see McKinnie 2012). Neither is site-specific performance inherently heterotopic.

There are many ways to frame site-specific performance: some critics trace site-specific performance to site-specific art installations (see Kaye 2000, pp. 91–105; Kwon 2002, p. 1); others see its genealogy in environmental performance in the 1960s (McKinnie 2012, p. 22) while still others claim that the interest stems from the spatial turn (Eaket 2008, p. 30).[3] Mike Pearson and Michael Shanks's definition covers most of the conditions of this form, which is

> conceived for, mounted within and conditioned by the particulars of found spaces, existing social situations or locations, both used and disused [...]. [Such performances] are inseparable from their sites, the only contexts within which they are intelligible. [...] The multiple meanings and readings of performance and site intermingle, amending and compromising one another. (2001, p. 23)

Heidi Taylor deploys astronomical metaphors in describing the potential effects of site-specific performance, bolstering Pearson

and Shanks's encapsulation, and indicating the additional spatial dimensions inherent within this kind of performance:

> When a performance is created specifically for a site, it resonates because of the way it places observing and performing bodies in relationship. It creates not a world but a universe, with its orbits and gravitational pull, constant movement, explosions and black holes. Other worlds exist in a universe. This exploded view of theatrical space often has a higher quotient of randomness. The unscripted *texts* (the sounds of the traffic, the industrial equipment, the shoppers) demand dramaturgy, or their implicit cultural significance will drown out the scripted elements of the play. (2001, p. 17; original emphasis)

Such a metaphoric 'explosion' provides a platform for heterotopias that can delineate additional spatial dimensions that help to shape social context(s).

The kind of site-specific performance which Pearson and Shanks discuss engages with actual sites, but a heterotopic interpretation can accrete further spatial layers that may or may not be apparent to performers or to spectators initially. Further, it may or may not be concrete. Heterotopias provide a means of identifying more finely the function of space and place in site-specific performance, facilitating a stronger argument for the efficacy of this form, both on the site of performance and in its social world. This is perhaps not far removed from conventional responses to site-specific performance, since Nick Kaye points out that site-specificity 'is defined precisely in these ellipses, drifts, and leaks of meaning, through which the artwork and its place may be momentarily articulated one in the other' (2000, p. 57). Cathy Turner figures it slightly differently: '[s]ite-specific work frequently treads a line between the play-world and reality, sometimes provoking conflict, sometimes providing moments where the two seem uncannily coincidental. It looks for the chance intrusion that becomes the chance discovery' (2004, p. 382). A heterotopia can take shape – and occupy space, as it were – in these in-between zones: it can inhabit Kaye's 'ellipses, drifts and leaks of meaning' or walk Turner's 'line between the play-world and reality'. It has the potential to extend the spatial interpretational frame for site-specificity and performance itself, and to strengthen the relationship between

a performance and its context. Heterotopias have the capacity to build on the geometric dimensions and metaphoric resonances of a particular place/space and to uncover more nuance than 'just' the ellipses or drifts, or leaks between site and performance.

Site-specific performance 'carries' what Sacha Craddock terms 'the "advantage" of ready-made atmosphere' (1998, p. 198) through both planned and random sounds, activity, and interventions, although the form holds more potential than just atmosphere (and random activity can, of course, detract from a performance). It has the capacity to affect deeply our understanding of place. In an urban context, site-specific performance 'changes our relationship with the city, our appreciation for it, and changes "what a city is for"' (Eaket 2008, p. 44), or at least it has the capacity to do so. Yet no methodology for analysing site-specificity appears to exist, despite a recognition of its importance. This heterotopic interpretational strategy attempts to fill this gap, affording a reading lens for analysing and evaluating the socio-political efficacy of such performance through its engagement with site. The examples that follow encourage us to think differently about the potential function of public space, the generation of safe space, and the spatial machinations of big business against the mapped realities of global warming. By investigating the spatiality of the literal and metaphoric contexts they provide, we have the chance to discern, through performance, the existing social and political realities that structure our lives and to chart alternatives to them. These productions unsettle the familiar to address how the socio-political milieu in which a performance takes place might work differently. Understanding the effects of space and place in these case studies contributes to a stronger means of developing and interpreting site-specific performance generally. This chapter foregrounds the methodology to assist readers in understanding heterotopia more fully.

And While London Burns

Platform's widely acclaimed audio-walk, *And While London Burns*, is an unusual site-specific performance in that it continues to be available since its 2006 premiere because it is a recorded production where actors do not need to be paid per live performance.[4] What is lost in income for actors and other creatives (and in the immediacy

of live performance) is gained in the number of participants who can experience it through a time span that can mark changes to the landscape. The audience's experience of the performance in a bustling city provides a version of the 'liveness' that we associate with theatre but a version that is placed against a mobile setting of a non-theatrical venue. *And While London Burns* marks out an alternative map of London against the backdrop not just of the city but also of the oil company, British Petroleum (BP), the largest company on the London Stock Exchange. We learn in *And While London Burns* that as BP 'moves, in growth or decline, a whole economy swings with it'.[5] One of the world's largest companies of any type, BP dominated headlines in 2010 following the explosion of the Deepwater Horizon oil rig in the Gulf of Mexico, which killed eleven workers and spilled millions of barrels of oil.[6] It is relatively easy to target BP, especially in the environmental wake of oil spills, but the demise of a company that holds 8 per cent of British pension funds income (Kayha 2010) would clearly have negative consequences. BP provides substantial financial support for a range of arts companies as well as research on the mapping of seabeds, which in turn benefits various types of non-oil-based research. We are told in *And While London Burns* that these are the 'costumes' of sponsorship that companies like BP 'wear'.

Platform has explored the workings of many oil companies in order to expose the effects of this industry on global warming in particular. *And While London Burns* specifically rethinks issues of power and authority through space, as my heterotopic reading illustrates. Before I can describe the heterotopia, I must outline the constructed and abstracted spaces that support it, since heterotopias have little meaning without this framing structure. The constructed space is the city as backdrop in this example (and in *Suitcase*). The city replaces a traditional venue. The abstracted space maps onto this same urban venue with a very different interpretation and 'location', that of the carbon web, which I explain shortly. Between these two spaces, *And While London Burns* generates a heterotopic zone of hope and change in the face of the catastrophic consequences of climate change. This heterotopia is a less concrete location than in other examples in this book but it is anchored in the spatiality that the constructed and abstracted spaces shape.

I derived this analysis by undertaking the audio-walk, listening to the narrative several more times, investigating more of the narrative

detail (regarding the carbon web and climate change), and taking the walk again on another occasion. The audio-walk produced more spatial narratives and metaphoric and concrete spaces than I could initially apprehend. I found intriguing the production's exploration of multiple places and spaces that I couldn't reconcile initially; they seemed inherently connected to social/political contexts, which made them all the more worth charting. They failed to map onto meaning easily (at least initially) and spilled over the bounds of the various map and interpretational 'shapes' I tried to match to them. I have come to understand that when the spatial dimensions of a performance attract my attention in this way, there is a good chance that applying a heterotopic interpretation will provide some lucidity while also revealing much more than I would have otherwise discerned. I begin first with a brief outline of the audio-walk and then with fuller accounts of the constructed, abstracted, and heterotopic spaces. This interpretational strategy facilitates a detailed reading of the production and a more profound understanding of the effects of its various types of concrete and metaphoric space.

Participants download *And While London Burns* (for free) onto a portable music device.[7] Written and directed by John Jordan and James Marriott (2006), it begins whenever a participant arrives at 1 Poultry Lane, near Bank tube station, and pushes 'play'. The fund manager, Morley's, is located here; it employs the unnamed trader who plays a major role in the narrative. Part love story gone wrong, part politics and economics lesson, the audio-walk proceeds through London's financial district for about seventy minutes and is structured by three acts, each of which is characterized by an element: fire, dust (a combination of air and earth), and water. The history of London is prominent, even before the walk's conclusion at the Monument, Sir Christopher Wren's 1666 Great Fire of London memorial, but it is not the history of London's fire that is at the walk's core; rather, the piece is structured by the future, shaped by the imminent threat of the flooding of the Thames River, an inundation that the production forecasts will be catastrophic to the city. The fire of the past gives way to the dust of the present that will contribute to the devastating floods of the (near) future. *And While London Burns* makes a plea for the future of the planet against the excesses of finance and industry. Through its intricate narrative and theatrical experience, *And While London Burns* maps a heterotopia

closely associated with the urgency of climate change. Billed as an 'operatic audio tour', or what Ed Crooks calls an 'innovative hybrid of guided tour, radio drama, opera and political lecture' (2007), *And While London Burns* blends Isa Suarez's haunting musical score with the narrative of the trader whose partner, Lucy, has left him, her job, and London. He eventually receives a postcard from somewhere in Cornwall, suggesting that she is happy now that she is 'off grid'. A second voice is that of the guide: she directs us, reminds us to cross safely at the crosswalks to which she leads us, and points out what takes place in buildings that we pass.[8] Her audible footsteps also lead us to other indicators of space and power, especially what she calls the 'carbon web', which marks out the network of oil companies and supporting industries and that, the production contends, provides an alternate London map, a version not covered by the *A–Z Directory*. This production uses the same 'venue' throughout, although the participant moves through the City of London as the piece proceeds. In the process, this setting changes meaning quite significantly, which is the point: we are encouraged to rethink the city – and our roles in it – from its history through to its present and future.

Constructed space[9]

As outlined above, the constructed space for site-specific productions could generally be the extra-theatrical location in which it takes place (although this is not necessarily a given). It is the case with *And While London Burns* where the constructed space is the historical square mile of the City of London, the area we navigate. Incorporated into this city-as-backdrop are London's history, its buildings (old and new), and its activity. The city continues to operate around the participant so the performance is different each time it is undertaken, the city's own contributions always altering. The audio-tour suggests at first a particular type of experience: a narrative context that will be mapped against the buildings that we walk past and through, with a little more detail than one might derive from a pop-up street directory. The guide's helpful instructions contribute to the structuring of the piece and what we anticipate will occur. Our traversing the city appears not to stray too far from expectations, from history, and from what we know of the city – how can it if we are walking in the city which the production is powerless to change physically? Or can it? Can we? It becomes clear quite quickly that

the constructed space will not remain intact for long, as is often the case: an additional location comes to compete – and even take over from – the relatively conventional, site-specific city-as-backdrop. *And While London Burns* completely re-maps the city as we navigate it: through urban, national, and international business and politics, and through the personal. The carbon web that links these locations forms the domain of the abstracted space; the production spends most of its time mapping it for us overtop of the conventional city. The constructed space continues to be visible, but it loses some of its prominence to the all-encompassing carbon web. As later chapters illustrate, the identification of constructed space can often be more complicated than it tends to be in site-specific performance.

Abstracted space

The abstracted space in *And While London Burns* introduces us to the much broader geographical and political dimensions of the complex, spatially realized carbon web that this audio-walk identifies and maps. This space is not as tangible or as geographically determined as the constructed space, and that is both its fascination and its danger. Other accounts of abstracted space in this book are not as lengthy as this one, but in *And While London Burns*, it is complicated to delineate and describe and, as will become clear, it has significant implications for the production and the participant.

 This abstracted space is another layer of spatiality that is connected with the city we traverse. The buildings that we pass no longer simply provide the skyline and a recent or distant urban history of London. They now propose more consequences, of a greater magnitude. The audio-walk's scope becomes much larger than simply 'London': as we pass firms entangled in the carbon web in the wider world, the guide suggests that '[i]f you look closely at the fumes, you can see the geology of other countries disappearing in thin air'. Jordan explains that 'the tour links firms in the Square Mile [of London] to overseas activities that aren't included in their annual reports. It's absolutely key to know what's going on in the City because that's where decisions get made, and yet it's invisible to most people' (qtd. in MacDonald 2007). The performance's mapping of specific buildings in London extends from local to global to take in oil production in Nigeria, mine construction in Bangladesh, a West Papua pipeline, and a burned-out Siberian forest the size of Italy. As these examples

indicate, the carbon web is an ideal abstracted space because its enormity and amorphousness cannot be mapped in any conventional or cartographic way but it can be encountered as a 'performed' space. This complicated carbon web 'map' helps participants understand the effects of climate change physically, historically, economically, and viscerally, and to think passionately enough about global warming to take part in political and cultural change.

The 'space' that the carbon web occupies is clearest when it is compared to the constructed space; that is to walking the streets and anticipating a traditional interpretation of the city of London. It is seldom ever possible to entirely disentangle all the discrete locations in a production, and that is particularly true of this tightly imbricated one. Its carbon web is laid over a map of the 1666 fire, which is marked on a very rough guide to the walk, the only aid provided to participants (also downloadable from the website). Participants are to supplement these intertwined maps with the conventional markers of street signs and the visual and experiential ones of historical landmarks. As Nick Kimberley's review notes, '[i]t is not opera as we know it, but an ingenious way of reanimating this monstrous city, showing some of what lurks in its shadows' (2006). We are urged to listen to the announcements at Bank tube station (those recorded as part of the 'opera for one' and audible through the headphones, as well as the ones in real time); the recorded announcements take on an increasingly urgent tone as tube safety reminders give way to cautions about the drastic climate-changed future to which Londoners can look forward. The heightened state of security that is evident in the recorded messages urging calm (prominent in 2006, following the July 2005 London-transport terrorist attacks, even if neither year is specifically cited) soon merges with the imminent disaster of global warming. The increasingly frantic pace of the dialogue is mirrored by the guide's quicker footsteps, the urgency echoing through our ears to our own inevitably quickening physical action.[10]

The carbon web is built on oil but it is held together by money, and the chorus's refrain reminds us of this by singing 'more and more, more money, give us more and more' when we are directed to walk through the Royal Exchange, an institution predicated on wealth creation. This building, the centre of London's commerce from 1565 to 2001, is now a luxury brands shopping complex, underscoring the wealth that the carbon web yields.[11] The audio-tour's guide

continues to point out buildings (some architecturally or historically spectacular, some nondescript), mapping the vectors between them; for participants who know London, the tour provides an alternative view of familiar territory.[12] This form of 'corporate mapping' of who works with whom and what takes place where is rarely charted in such detail. One building we visited is the Swiss Re building, better known as 'The Gherkin' (and sometimes by its address, 30 St. Mary Axe), which we are directed to circumnavigate twice, one turn after the other. Swiss Re is 'the insurers of the insurers', the second largest such firm in the world; Lucy worked in this building and the couple's first date was in the restaurant at its base. In the time it takes for us to walk around this building twice, we come to understand the extent of the carbon web as a viable map (of sorts) and the sizeable chasm between it and the 'real' of our perceptions of London and companies like BP.

The trader's narrative and the guide's discussion of the carbon web compete for attention until they merge at the Swiss Re Building, when everything shifts: the trader has a change of heart and decides to quit his job – not to flee like Lucy, but to try to make a 'difference'. At this point in the narrative, it is possible to chart the heterotopia, which is being played out in the same space as both the constructed space of the urban backdrop and the intricate carbon web of the abstracted space, even if participants may not be able to discern it in such terms yet. These various zones inevitably intersect and overlap; their separation into units for discussion sometimes appears rather artificial. Suffice it to say that just as the carbon web is mapped out for the participant, so is the potential for a more generative space that provides options for addressing global warming. It aims to change participants' relationships with the city on several counts, beyond 'mere' refamiliarization. *And While London Burns* offers what is, eventually, a hopeful message but it requires a shift in behaviour that in itself is as unsettling as the abstracted space that helps to produce it. But before I can turn to heterotopia in more depth, there is another aspect of the abstracted space that I wish to develop.

The final aspect of abstracted space to address is the significant effect on London (and elsewhere) that the carbon web will produce. While the history of the Great Fire is the backstory to the production, and the line of fire is even drawn on the piece's sketchy map, there is another line that becomes apparent in its absence from the

map: the trader talks of a 'line of water', which has much more seri-
ous repercussions, well beyond the narrative itself. *And While London
Burns* outlines that the devastating 1666 fire will be rivalled by the
inundation of the Thames when the temperature rises only a few
degrees more as a result of global warming. We experience first-hand
what the city will look like in the not-too-distant future, post-flood.
This spatial telling of the future is extremely profound as we walk to
the flood line that the Thames water will reach, which the trader esti-
mates to be at Lime Street. We walk over land that will be underwater
when the river's walls are breached. The trader's 'decision' to take
the participant to Lime Street, which is at a considerable distance
from the current riverbank, is a significantly more effective means
to explain the extent of global warming's effects on London than if
we had merely heard about or even witnessed a flood map. Not only
is it significantly far from the current line of the Thames, but we
also walk past buildings, businesses, and flats that will be inundated.
Most of South London will be underwater, he explains, as we prepare
to mount the Monument to observe from a different perspective the
vast tracts that will be submerged and hear about the next disaster
at the site of a previous major urban crisis. The extensive abstracted
space in *And While London Burns* structures the past and the future,
the metaphoric and the actual, thoughtfully intersecting with the
constructed space of the city. The dire predictions are, however,
balanced to an extent by the heterotopia to which I now turn.

Heterotopia

From this large (if unconventional) map of London generated by
both the constructed and abstracted spaces, the performance turns
to a more personal map that marks the heterotopia. The trader's nar-
rative – and his familiar spaces in the city – come to be much more
important: he also takes over narration from the guide as the drastic
effects of carbon web-producing climate change begin to become
clear. The mood of the music shifts from sombre to somewhat
brighter, as if the trader sees hope in his decision. The impending
flood of the future can yet be halted, even though the line of the
flood that global warming will generate is generally kept hidden. He
demonstrates that there is power in the individual's choice to pro-
duce change, and that the bastions of influence that the carbon web
represent need not determine the future. The heterotopia is the space

of the individual to intervene and respond to the events around us. In this section, I describe how the audio-walk fashions such a hopeful, personal space, and what its effects are.

The most important new context that the heterotopia introduces is an extension – in a different dimension – to the street maps and the locations elsewhere that the carbon web conjures. This extended location takes up space in the visceral, physical body of the participant. This spatial environment produces actual results that have the capacity to affect the participant profoundly: at first, this layer of personal mapping appears to be simply an existential crisis, but the narrative is carefully constructed to engage directly with the participant. At the beginning of the piece, the trader needs to escape the office: he 'takes' us to the Temple of Mithras, circa AD 300, near his building, introducing layers of history.[13] Now located on Queen Victoria Street, it was moved from nearby Walbrook Street shortly after its 1952 discovery, following the clearing of a site bombed in World War II. The all-encompassing cult of Mithras is equated to the trader's finance work by his exclamation: 'everything was sacrificed to the cult, everything!' The ruins are nevertheless contrasted with the contemporary world, implying that it is unlikely that remnants of contemporary architecture will be around for walkers 1700 years hence. While this location may appear to be more appropriate to the piece's constructed space, the narrator reveals at this sacrificial altar why he is so distracted: operating on just three hours' sleep because of his heavy workload, he has learned just how low his sperm count is, a result of the city's 'toxic soup' (of pollution – the dust, air and earth of the second act's title) and the petroleum industry's contribution to it. He compares himself to a polar bear, directly introducing the global-warming theme that underscores the performance. The dust of the second act is generated by the wind tunnels created by the skyscraper, Tower 42, and, more sinisterly, carbon dust: the 'fine toxic excrement' that is everywhere, including being 'lodged in my lungs'. If there is toxic matter in the trader's lungs, there is in mine too as I traverse the same streets.

The audio-walk's multiply-defined city frames another space, a psychic location that becomes more physical as the 'space' of the heterotopia comes to occupy the participant's mind. The auditory function of the audio-walk means that this crisis rages not just within the narrator's head, but also within *my* head, between *my*

ears. Peter Salvatore Petralia explores the effects of aurally enhanced performances where '[t]he closeness of the amplified sound to the body requires our hearing systems to embrace the apparatus as an extension of our natural hearing systems, to often-hypnotic effect' (2010, p. 100). He argues that the process continues such that sounds from the 'outside' diminish and even 'fall away' (2010, p. 100). This is not quite what happens in *And While London Burns*, because real-time traffic noises and tube announcements, for example, continue to be an integral aspect of the performance, especially because this soundscape differs for each participant. Indeed, to fail to notice these unique aspects to the piece's landscape and set would be to risk one's safety. Nevertheless, unlike a conventional performance, we are not watching action played out by a human who is disconnected from us; in *And While London Burns*, the trader practically merges with us, *in* us, immersively. His crisis necessarily becomes our crisis, which also parallels the carbon web's infiltration of the human condition. This connection, among others, ties us to the narrative, to the trader (if not the guide), to the city, and to the crisis; it aims to force a response from us, because it affects us personally and viscerally as we come to be immersed in the piece in so many ways, culminating in the infiltration of the participant's subjectivity. It changes the nature of not just how we listen, but where 'here' is.

I identified this personal space as the heterotopia when it became clear to me how much more 'space' the audio-walk shaped than 'simply' the numerous external locations, whether concrete or metaphoric. Further, the features that associate the trader with us – the earphones experience and the effects of polluting oil in our bodies – are deeply disturbing and coerce a reaction regarding environmental, historical, political, and financial problems that extend well beyond the individual. That reaction is a main point of the audio-walk, but it is difficult to understand its impact without appreciating the layering of different forms of spatiality. The individual and the collective implications of the carbon web space are clarified in this immersive moment. Tom Stevenson notes in his review that the performance caused him to take personal action: 'I was challenged to make the connection between my investments and their consequences' (2006). In addition to investigating climate change, BP, and ethical investments, I found myself inspecting the cultural patronage that large corporations use to contribute some of their fortunes to 'social good'. While Stevenson's

resistant act and my own inquiries do not in themselves form substantial change, small-scale personal interventions can, combined with other such contributions, amount to significant efforts. Participants are encouraged to intervene in their surroundings and redress traditional forms of power and authority; the disturbing aspect of the heterotopia outlines alternatives to the norm even if achieved in small measures.

And While London Burns concludes at the Monument, which, the trader reminds us, does not actually commemorate the fire, but rather the making of a new city, an idea reinforced in one of the final choruses: 'we could build a new city, not on oil and gas but on the wind and the sun'. The trader and the lyrics echo talk of new possibilities, even as we witness just how much of South London will be underwater. The satisfaction of achieving the summit of the Monument (up 311 steps; there is no elevator) contributes to a strange sense of hope in the participant. The walk astutely capitalizes on the positive feeling that can result at the end of physical exertion. I was also aware then how my own location in this piece was complicated: I was both a walker within the performance (whose footsteps did not add to the carbon web) and an international traveller (who arrived in London by contributing to it through air travel). This moment of climbing towards the sky brings both activities together, implicating us in the problem, as well as, one hopes, in the solution. Even recognizing these complexities begins to disentangle the web.

And While London Burns encourages the participant to contribute to a collective solution, rather than giving up in the face of the overwhelming odds of the tipping point of a two-degree temperature change. This hopeful conclusion that the heterotopia structures is supported by a palpable sensory awareness: the participant takes on the same sense of calm that the once-harried trader now bears, no doubt assisted by the satisfaction of having mounted the Monument's top step. For Marriott, Platform 'catapults the climate crisis from the cold realms of science and economics into the emotional world of culture' (qtd. in Minton 2007). Through this location of historical hope, *And While London Burns* illustrates the specifics of its heterotopic space: not just how much of the city will be affected by flooding but what some of the options for change are, including reducing the effects and extent of the carbon web, investing in wind and sun energy, and working to avoid reaching the all-important temperature tipping point.

Whatever temporal frame forms the backdrop, *And While London Burns* leaves the listener with a view of the city that can be rebuilt with, as the chorus sings, 'hope and possibility'. The performance concludes with a layered map of the city showing present, past, and future landmarks, complete with who does what and where in the city, and what the effects of these actions are around the world. It embraces politics and names names, drawing its participants into its own web. The layering of different mapping projects illustrates the implications of what happens in these buildings, here and elsewhere, and our complicity in these actions and decisions. This performance makes us aware of events of the past as they continue to surface and transform in the present and future; it also signals an absence of ethics in many modern acts, as it marks out how the carbon web connects regions of the world both financially and geographically. That we might do something is left up to us; that we must take these issues seriously is very clear as the production provides us with the alternate ordering to the events that shape our world.

My experience of the audio-tour in 2008 required me to turn off the player for about ten minutes to renegotiate my route at Tower 42, because some remodelling had occurred since 2006. The guide's reluctance to use street names made this somewhat difficult but not impossible.[14] This rerouting reminded me of the shifting of traversable 'geography' that the inundation of the river will necessitate. Further, my introduction to the audio-walk in November 2008 meant that I was even more inclined to accept the urgency of the global-warming message and the breadth and strength of the carbon web, since the prediction about the 'recession or other financial collapse' had been proven true in spectacular form;[15] further, little progress (locally and internationally) in halting moves toward the tipping point of two degrees heightened the production's impact. My own response accorded with Jordan's aim for the production: '[w]e know the numbers, graphs, models and terrifying predictions of the climate catastrophe that faces us, but until we are truly moved to feel the scale of the crisis, then there is little hope our society will go beyond the cataclysmic scenario of business as usual' (qtd. in Hopson 2007). This emotional response was, if anything, increased in the time-lapse between the production's origin and my first experience of it. *And While London Burns* continues to capitalize on both current events and historicity – not just, as it may appear at first,

site-specificity. The production's heterotopia provides a fuller reading of the effects of place and space in the participants, in London, in a global context, and in the carbon web.

What I interpret to be the heterotopia in *And While London Burns* is marked out in space deliberately for the participant, if not in so many words. I began with this example because its heterotopic context is, to some extent, the most straightforward since it is embedded not just in space and place but also in the narrative itself. This is unusual, though: few productions are as complex as this and have integrated the form and function of their spatiality so well with the political purpose of the piece.

Suitcase

The heterotopia in *And While London Burns* merges various forms of large-scale maps of London with the personal to generate a new civic and socio-political map, but the next heterotopia emerges from a more focused point in the same city. *Suitcase* staged how audiences came to perform the various temporal and political locations and dimensions of history in a train station. Kaye argues that 'site-specific art frequently works to *trouble* the oppositions between the site and the work' (2000, p. 11; original emphasis), and *Suitcase* is a good example of how this 'troubling' takes place to generate an active response to the 'site' in performance as well, thus lending itself to a heterotopic reading. *Suitcase* was performed, for free, only three times (10:30 am, 1 pm, 7:30 pm), all on 2 December 2008, for capacity audiences at London's Liverpool Street Station, a busy bus, train, and tube interchange in the north-eastern corner of London's central business district.[16] I contextualize the production before interpreting it and identifying its effects. It is less its location in London's geography or a generalized history of this train station at issue here.[17] Rather, it is what took place exactly seventy years before: the performance commemorated *Kindertransport* (or 'children transport'), the 1938 arrival of the first train carrying hundreds of unaccompanied children whose parents hoped that they would escape the events that Kristallnacht (9–10 November 1938) presaged in Germany and other countries soon to be under German control in World War II. Only one child in ten would reunite with even one parent (Gooderham 2008), their families likely perishing

in concentration camps. The gravity of this historical moment was constantly at play in *Suitcase*.

Directed by Ros Merkin, produced by Jane Merkin, and based on memories of *kinder* (one of whom was their mother), *Suitcase* marked the history and legacy of trains that brought almost ten thousand children to London from 1938 to 1940. Ben Macintyre explains that

> late in 1938, a delegation of British Jewish leaders appealed to the Prime Minister, Neville Chamberlain, to permit the temporary admission of child refugees. After a debate on November 21, the British Government agreed, provided a bond of Pounds 50 was posted for each child 'to assure their ultimate resettlement.' (2008)

British Jewish groups paid the children's train fares, with trade unions, private individuals (Macintyre), and churches including the Quakers (Gooderham 2008) also contributing. The US Holocaust Memorial Museum website notes that '[p]arents or guardians could not accompany the children. The few infants included in the program were tended by other children' ('Kindertransport' 2013). Not all children met with happy experiences in England; some were even interned as 'enemy aliens' ('Kindertransport' 2013) whereas others later served in the British army.[18]

The heterotopia marked out by *Suitcase* repositioned this historical moment from the lead-up to World War II back into contemporary public memory; this production begged a reassessment of whether or not such an event could take place again, here or elsewhere, and what the scope would be for comparable large-scale humanitarian ventures today. As with *And While London Burns*, a heterotopic interpretation provided a deeper reading of the relevance and potential of the political and historical context of its site. The extra-theatrical site-specific location of the train station circumscribed the whole piece: the train station presented a substitute venue, the location of which was essential to understanding the piece. The train station accommodated multiple spans of time, but it was not the workings of a train station per se that were the focus here. *Suitcase*'s constructed space was the train station in 2008 and its 1938 narrative. It focused on transforming the function of the station socially, politically, historically, and geographically – even if fleetingly. Through this production, the train station altered in historical scope and scale, taking

on more than it normally contained or represented. The abstracted space was a spatial representation of the alternative to such actions as *Kindertransport*, or the location of other train stations that did not signal the way to peaceful destinations. It was also the failure to provide shelter or safety at all, the absence of asylum. Between them, the heterotopia established a space in which we could imagine endeavours such as *Kindertransport* happening again. The heterotopic space called on yet other 'spacetimes' (Harvey 2006, p. 125) to encourage humanitarian action. Beyond the location of the actual performance and the diegetic place(s) it recalled, the additional sites that were evoked produced a profound understanding of history and the possibility of reproducing *Kindertransporten* in the present and future. In this location, we could re-read the politics of rescue (and more) as *Suitcase*'s heterotopia looked less to the stops on a train line than to stops in history and the future.

I briefly outline how I arrived at such a finding. It was not something I was able to discern in detail as I saw *Suitcase*, but I could tell as the performance continued that it was raising for me very provocative spatial (and political) concerns that had the potential to reveal more than a 'conventional' relationship between site and performance. In investigating further when the performance was completed, I was able to itemize a series of locations, some of which were concrete and others metaphoric; a set of patterns emerged, as this analysis outlines. Several scenes were uploaded to YouTube, assisting me in revisiting them. From mapping out and piecing together these locations, I could establish the nature of the production's various sites and then the effects of this performance on a scale well beyond the hour's engagement on a Sunday, or a relatively straightforward commemoration of events from the past.

This itemizing of the spaces of engagement is a first step towards defining heterotopic potential: what spaces are identified or identifiable, and what might they be representing or signifying? Further, how are they intersecting or even clashing? From there, the larger effects of the relationship between site and narrative (however loosely defined) may begin to become visible. It might be convenient to define one pole as the 2008 station and the other as the 1938 station (in the same way that site-specificity might suggest a division of 'site' and 'performance'), but my initial analysis of the production kept throwing up other spaces that could not be accommodated in

such a structure. The format I have adopted here better housed the greatest number of locations in the most fruitful manner.

Constructed space

As outlined above, the train station established constructed space in *Suitcase*, a not uncommon site-specific performance location for its suggestion of motion and journeys (among other things). Audience members were positioned from the beginning in and between a doubly constituted train station of 2008 and back to 1938. Yet *Suitcase* deflected a familiar characteristic of site-specific performance whereby one might examine the specific real-world architecture or spatiality of a site seldom visited (or seldom visited in this way): there was too much going on – in the station and in the performance – to appraise the site's actual and structural nuances, as we were hustled from one place to another. It was not at the architectural or generalized historical level that *Suitcase* intervened in the potential for a renewed understanding of its venue: it was the 1938 train station that we entered and occupied.

Suitcase began in some sense of confusion, even though the 1938 narrative was established immediately. Ticketholders were directed from the Hope Square entrance to Liverpool Street Station into a passageway next to what appeared to be a Salvation Army band (actually, the Trans-Siberian Marching Band). Participants were grouped on an upper concourse, according to numbered and coloured-coded packing tags on strings that we were instructed to wear at all times: as such, audience members were immediately interpellated as *kinder*, somewhat confused in and by the vast station. As we gathered, the actors (14 students from Liverpool John Moores University) wearing larger numbered labels walked by.[19] Each carried a suitcase or knapsack: these bewildered *kinder* mingled with us and with oblivious station patrons. The performance began when two 'adult' actors arrived to take charge, including Mrs Hilton who sounded a whistle that introduced a note of authority that overlapped with the real train whistles in the background. Her presence thus reinforced the connection between the actual site and the fictional narrative. She discovered some 'ungrouped' children – the actors – who each described the contents of their bags and what they left behind;[20] they also expressed their incomprehension of what was taking place. Once Mrs Hilton led the ungrouped children away, audience

members were guided to the locations within the station where the scenes took place; each group saw eight three- to five-minute pieces in a different sequence.

Meanwhile, the active 2008 station also remained palpably present: bins were emptied, trains departed, and delayed arrivals were announced. At times, we were out of place in both the narrative and, increasingly, in the station itself as we experienced the clash of times and spaces. Occasionally we waited for the workings of the 2008 station to finish before we could witness a 1938 scene. The noise, the confusion, the smells, the draughts, and the distractions contributed to and overlapped with the production. Some passers-by were interested (even joining the audience), but others were annoyed when their paths were impeded, while yet more remained unaware of what else was happening in the station. The constructed space accommodated various contemporary locations and historical spaces at Liverpool St Station.

The scenes were simple: on a pedestrian overpass, a girl tended a baby whose basket was pushed through the departing train's window. She dealt with her fear – and her confusion about what's wrong with being Jewish – by caring for the baby. Other scenes were played for humour: the new 'parents' of one child reached the pick-up point at the main arrivals board, horrified to learn that the boy they had 'ordered' was actually a girl.[21] Some children already had a preternatural sense that they would not see their parents again. Against this knowledge, we were also required to take on a number of uncomfortable 'roles': specifically a tearoom scene in which we heard one woman's overtly Anti-Semitic views (even adding her disgust for the Spanish who had also escaped from war).[22] The variety of locations and narratives that formed *Suitcase* transformed the station and expanded our subjective viewing positions.

Abstracted space

The multiply-configured constructed space was quickly contrasted with abstracted space, or train stations from World War II that pointed to less safe destinations. Other associated moments that did not take place in this train station crowded in: I became acutely aware that the space of the Liverpool Street Station in 2008 was 'growing' in signified potential because it needed to accommodate numerous parallel historical train stations from which Jews – including the

families of the *kinder* – would be transported to concentration camps. Other locations became apparent (metaphorically) as well, including additional examples of racism layered through history well beyond 1938, whether related to the Holocaust or other anti-Jewish pogroms. The labels which we wore to identify us as *kinder* combined with the historical significance of other trains that we all inevitably recalled; our identification numbers were a macabre echo of our knowledge of the tattooed numbers on the arms of concentration camp prisoners. From the Holocaust, my mind moved to other crisis points since then that were related to public transport, like the segregation that was a part of the American South pre-civil rights or the systematic approach to apartheid in South Africa; and to broader racist wars of the Balkan States and Rwanda in the 1990s, to name just a few; and to the ones that we will inevitably come to know in the future. The spatio-temporalities of 1938 and 2008 cross-referenced each other in performance and generated a specific spatial context laden with loss and injustice, even if most conflicts moved from Europe to, in 2008, numerous fragile states in central Africa, among other zones. The overwhelming presence of sites that held an *absence* of safety took up as much 'space' as the relative security of the *Kindertransport* of 1938 and its commemoration in 2008.

If *Suitcase* hadn't taken place *in* a specific train station, this abstracted space would not have been as well developed or quite as easily conjured. It would have been less likely to contribute to the articulation of the heterotopia. The performance's construction of war zones, even if in their absence, clarified the enormity of the task of *Kindertransport* and what the outcome would have been if the remarkable rescue mission hadn't taken place.

Heterotopia

The heterotopia in *Suitcase* extended the combination of the actual, contemporary train station and the place of the 1938 narrative, against the abstracted space of aggressive action or the failure to act at all. Its location was only possible to 'see' through performance. Commuters or casual visitors to the train station would not have been aware of it, unless they joined the performance. It rested in this potential for rescuing children from war zones (in the past and in the future); it appeared in multiple forms, sometimes through specific scenes, and sometimes in ephemeral moments. Through

such moments, *Suitcase* asked how we could make the space for such humanitarian actions to occur again. *Suitcase* commemorated one such opportunity in history but the performance pointed to the means by which it could take place in the actual world again. In her review of *Suitcase*, Lauren Krotosky writes of 'commuters' being 'hijacked by [the] history' of the *Kindertransport* (2008), but London in 1938 was only part of what was conjured here at the heart of the play's heterotopia.

I explain this by examining several scenes that each stage in different ways how we might think about creating the context of an equivalent *Kindertransport* in future. One attempted to merge 1938 with 2008 deliberately and directly: a Czech boy, Stephan, approached a passer-by who was not part of the audience. On a very narrow pedestrian overpass, Stephan proposed that this young, annoyed 2008 station patron might hire his highly educated mother as a cook, to rescue her from the danger that he perceived her to be in. The moment the uninterested Liverpool Street Station patron shook off Stephan was quite startling: this distressed boy was seeking to save his mother, but the passer-by refused to engage at any level. The temporal disjunction of present and past poignantly disrupted the illusion of theatre to demonstrate how the narrative's events related to an outside world. The refusal of the passer-by to engage at all with Stephan prompted the audience to speculate not on the passer-by himself but on questions such as, what if I were in Stephan's situation? What could I do/have done to help Stephan and his mother? How does this pertain today? This moment illustrated how the beginning of the hope that heterotopia can hold could be realized, that performance could productively engage with the public audience to create the potential for an alternative space of, in this case, rescue and asylum. This incident prompted me to speculate about how the scenes from 1938 intersected more overtly with the actuality of 2008, specifically the hope that the production engendered about the scope for rescue missions now. The young man Stephan approached was not the only 2008 non-audience patron of the train station to respond with irritation or, perhaps worse, apathy (see Figure 2.1). Ros Merkin recalled that in one scene, a distressed boy (actor) was left alone next to a platform: in rehearsals, occasionally, if a train arrived at the right moment, commuters walking up the platform might watch him, but no one inquired if he needed help

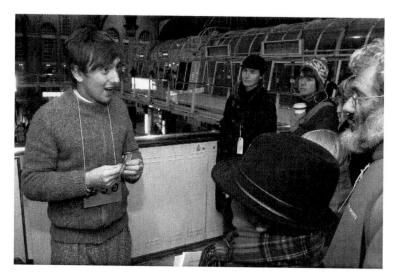

Figure 2.1 Kyle Blears as Stephan attempts to encourage the audience to help rescue his mother in *Suitcase* at Liverpool Street Station, London, 2008
Source: © Gary Mitchell, London.

(personal correspondence 2011). Some scenes were viscerally difficult to watch: young children struggling to cope with and understand the circumstances in which they found themselves, against a tide of indifference.

The heterotopia that *Suitcase* presented was, however, more positive than this may appear, as in the next scene where it engaged directly with the users of the 2008 station to reinforce *Suitcase*'s heterotopic potential. An actor playing a station porter appealed for donations to support the original scheme; he interpellated us as a 1938 audience but, by implication, he encouraged our 2008 selves to assist analogous causes.[23] We listened to him explain to our 1938 selves why we should contribute to such an appeal, and how he had been persuaded to fundraise for this cause (despite his original scepticism about the *Kindertransport* endeavour). He rehearsed the spaces of possibility in performance in such a way that the audience speculated about how *Kindertransport* might be possible again, today, or in the future. He showed us, in the venue of a particular train station, how it was achieved in 1938. More importantly, the scene subtly reinforced that

there are many more global conflict spots where children are not as fortunate as the 9500 *kinder*, where trains (or their equivalents) continue to come and go, but not all to safe havens. Through the porter, *Suitcase* established the possibility for inverting conventional structures of power and authority: a collection of 'ordinary people' worked together to save thousands of children from almost certain death.

There is one other element of this production that reinforced the generation of a more nuanced heterotopic spatiality for sanctuary in the future. Perhaps the most significant expansion of multiplied spatial possibilities in *Suitcase* was the presence in the audience of people who had actually travelled through Liverpool Street Station in 1938 as *kinder* on the very trains that we were now remembering. These audience members reinforced the effects that the alternate spaces of *Suitcase* produced. There were two *kinder* in my group, and through discussion with them as we moved from one scene location to another, I learned that one had arrived in London at three years of age, the other at six. The younger woman became overwhelmed by events that the performance conjured for her and she left, not to return, during the second scene. This piece, performed just outside the station master's office, next to what appeared to be a remote and disused platform, portrayed siblings who were about to be separated; the older sister understood what was happening, but her brother could not grasp the effects of the decisions being made around him. The girl was required to join her new family, leaving her bewildered brother literally on his own, on an unoccupied train platform in a strange country; his sense of loss was much more palpable in this vast and physically remote (all but deserted) location in the station than it would have been in a theatre venue. While the sister could understand what was occurring, it was beyond her capacity to explain the events to him. The presence of *kinder* witnessing this scene of 'chains' of separations resulted in multiple points of action and reaction such that other members of the audience began watching at least three 'performances', each of which took up its own space: the actors, the reactions of the passers-by, and the reactions of the *kinder* in the audience. Such reactions inevitably affected our own.[24] The production's implications were thus profoundly unsettling and moving: that it was too much for one of the *kinder* emphasized the refracted impact of what was 'taking place' in this train station in 2008. The presence of the *kinder* substantiated the

heterotopic moment such that these adults who were so differently invested in the events than the rest of the audience came to help define the performance for us all.

The now-elderly *kinder* unwittingly occupied the metaphoric space of the chasm between the constructed space of the train station that represented refuge as well as the abstracted space of what was left behind: the almost certain deaths of their families and their proximity to the same outcome. They demonstrated the potential for the expansion of these terms that form the utopics which Marin and Hetherington explore. The in-between 'space' of heterotopia was adjacent to – even overlapping with – the space that other participants occupied, but it accrued a more significant experience in our understanding of the production. Further, their embodiment in *this* space of the larger train station and the narrative scenic space suggested a more substantial intersection with the actual world outside the performance.

The presence of *kinder* provoked audience members to consider the treatment of refugees and those trapped in conflict zones around the world.[25] In the interim, the profound effects of the act of faith and compassion from 1938 prompted me in 2008 to donate to children's charities in several war zones around the world, an attempt to address (in 2008) the injustices of 1938. This small act wouldn't have saved many children, much less the thousands of children involved in *Kindertransport*, but each contribution to a children's charity helps some children at least in some ways. Further, *Suitcase* embedded the practice of donating to schemes that may, like *Kindertransport*, make a material and political difference. This act could be said to have emerged most directly from the scene with the porter who was canvassing for donations, but the performance overall accumulated a reading that explored the capacity for audience members to support and advocate for future charitable projects where necessary. This intensification of meaning of the various types of spaces that the *kinder* helped identify is part of the heterotopic space of *Suitcase*.

Suitcase provided an alternate ordering to the quotidian workings of Liverpool Street Station and to humanitarian crises. It concluded outside the station, as if the station was no longer large enough to house the literal and metaphoric occupants that the piece signalled and conjured. We left the station to assemble in Hope Square just outside the station, heavily laden with history and locations

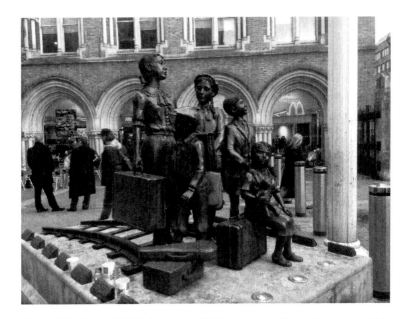

Figure 2.2 Frank Meisler's statue, *Kindertransport*, Hope Square, outside Liverpool Street Station, London, 2014
Source: © Alan Lawrence, Brisbane.

described by loss. This path reinforced that what we had learned through the performance could be translated into the city beyond the station. Here, in a final scene with all the actors assembled, the children we met in the prologue explained what they had made of themselves following the war, most remaining in the UK, and confirming that they never saw their families again. The final scene took place in the middle of Hope Square around Frank Meisler's statue dedicated to the *Kindertransport* (see Figure 2.2).[26]

This concrete link between the past and the present contains

[t]he names of the cities on one side of the statue [which] conjure up a (partially) vanished world: Danzig, Breslau, Prague, Hamburg, Mannheim, Leipzig, Berlin, Vienna. The bronze statue itself consists of five children, smartly dressed, arriving off a train. They do not have much luggage with them. The younger boy has a violin case, while a girl sits on a suitcase clutching her teddy. Just

an ordinary-looking group of nice young people, gazing around expectantly at their new surroundings. (Stern 2008)

Meisler, who, Stern notes, 'is himself a beneficiary of the Kindertransport rescue', added words from the Talmud to his statue: '[w]hosoever rescues a single soul is credited as though they had saved the whole world' (2008). *Suitcase*'s conclusion here pointed to the future, not just for the children who were rescued, but also to where other children might require – and receive – such assistance. The trains (metaphoric or actual) no longer come from Germany, but the need remains to assist in comparable rescues, despite national security issues, immigration quotas, governmental distraction, the financial burden of transportation, or compassion fatigue.

Suitcase's heterotopic dialogue with the Liverpool Street Station of the past and the present provided the room to think about the very real effects of such a transportation, and both the loss and rescue of children. The presence in the audience of people whose lives had been saved by the *Kindertransport* made palpable the effects of *not* participating in such rescues. It thus generated an alternate ordering to the real world, wherein the memories, historical events, and present evocations that it produced offered a different way of thinking about *this* station for the audience and even for some passers-by. *Suitcase* repositioned this historical moment from the 1930s back into public memory in a way that encapsulated the urgent need to assist those trapped in conflict zones around the world now. The heterotopia here was the collection in the station of refracted additional historical layers associated with rescue. More than simply the event being commemorated, it also incorporated the what-ifs and the if-onlys of this moment of rescue, the most-likely permanent separation from family, the sheer courage of parents to relinquish their children in the hope that they would find safety, and the generosity of the foster families. The heterotopic spaces in *Suitcase* made the prospect of such a rescue happening again possible – not merely a symbolic moment in time and space – by demonstrating *how* it happened in the past, in the very venue in which we were gathered, and in such a way that the audience could perceive how it could happen now. It was through the delineation of different types of spaces (both concrete and metaphoric) that the heterotopia became apparent to me. There was more taking place than I would have been able to ascertain in an

interpretation of *Suitcase* as a site-specific piece. Further, history's horrors were relived in a way that would not have the same effect had the production been performed in a conventional theatre because of the reality of the historically laden train station and its oblivious patrons.

Suitcase demonstrated the possibility of extending theatre's role in its socio-political context in two ways: by producing in Liverpool Street Station a venue that accounted for more than simply the activities of the present, and by exemplifying the potential for reprising rescue missions like *Kindertransport* today. The people who made *Kindertransport* happen in 1938 were by and large, independent, caring members of the community, not representatives of government agencies. These multiple worlds have meaning in themselves, as well as the connections we make between them and the worlds that exist outside the production. Interestingly, the remounting of *Suitcase* in 2013, which marked the 75th anniversary of the historical moment, relied on crowdsourcing of funds (crowdfunder.co.uk), that is, on the collective actions of individuals.

There is scope for heterotopia to be brought to many other forms of site-specific performance, whether urban or rural/regional in setting. It matters little if, like the productions discussed here, the performance rests lightly on the site, or if they make lasting and literal marks on their communities. Heterotopia is much more likely to be transitory than an indelible feature in a landscape; it usually manifests as a fleeting possibility, as opposed to a place ringed with permanent stone walls. This chapter presents ways to understand site-specific space – metaphoric and concrete – as instrumental in rethinking not just spatiality but the authority and structural power that are associated with it. Further, it helps identify the efficacy of the use of space and place, something that has been absent in much analysis of site-specific work. *Suitcase* and *And While London Burns* demonstrate the potential for marking spatial alternatives to conventional social orderings. This investigation of heterotopia has delved beneath the surface of history, geography, politics, economics, and formulations of the self to uncover and rethink constructions of power, authority, and agency. I have provided lengthier accounts here than I do in subsequent chapters to illustrate the method and just how extensive the heterotopic argument enables analysis to be.

As I outlined in the previous chapter, heterotopia is defined by fault-lines: these disruptions can suggest how we might change the nature of the actual world. The value of a heterotopic interpretation here is the opportunity to achieve a greater understanding of site-specific performance and the potential for rethinking social space. In spite of the effort it may take to identify it, heterotopia reaches a higher degree of particularity regarding space/place performance than other reading methods. It also articulates both function and effect (and even affect) of spatiality in performance in greater detail. Heterotopia does not generate a utopian world where things work better than the actual world; rather, it facilitates a means for rethinking and potentially reconstructing the spatiality in and of specific communities. Heterotopia's 'alternative orderings' place a responsibility on the audience to witness the spaces marked out in and by performance and then to choose to take up, extend, or reject those options. This efficacy requires an engagement of some sort with the experience once one leaves the venue.

The productions examined in this chapter establish a strong sense of affect, to use Erin Hurley's formulation of the term, to conjure a form of regeneration, whether local (either community/civic change or personal development), or international (climate change and a shared responsibility towards assisting children caught in war zones). Each asks, in its own way, 'what if?' What if another humanitarian intervention like *Kindertransport* were possible? What if the carbon web could be disentangled and the crisis of a two-degree change in climate averted? Possible answers to these questions are performed, and it is in this performance that heterotopia becomes fruitful as a proving ground for social, cultural, and political ideas.

Mackey notes that '[p]lace-based performance [...] assumes a strongly specific site but expects more from its participants' (2007, p. 181). This extra effort is perhaps clearest in site-specific performance that intersects with heterotopia and, by direct connection, where performance can exemplify the possibility of generating and realizing new social and cultural structures. The spatial dimensions that are produced in these performances are unique to them, but my discussion is relevant for analysing comparable site-specific productions that engage in an 'expansion' of the spatial realm(s), well beyond the diegetic worlds of the production. This heterotopic spatial sphere offers, to return to Soja, a way '"other than" the

established ways of thinking spatially' (1996, p. 163). Site-specificity is, then, inherently amenable to the creation of heterotopias while heterotopias also expand our understanding of site-specific performance by extending the spatial vocabulary available to their analysis and by particularizing the ways in which space and place might come to enact meaning.

From this consideration of site-specific performance, I move to theatre that takes place indoors, although it maintains a firm grasp on connections with the actual world: the National Theatre of Scotland relates directly with its communities in a significant spatial and cultural manner.

3
Heterotopia, the National Theatre of Scotland, and 'Theatre without Walls'

Heterotopia may be relatively easy to identify in site-specific performance (where the creation of a 'constructed space' that is a necessary precondition is fundamental to the genre), but it is also an effective interpretational tool in performance that takes place in theatre buildings. Whereas the previous chapter explored performance that spoke directly to a community by situating it amid its social context, by-passing a traditional theatre venue altogether, the remaining chapters present different approaches to possible heterotopias, examining them in various generic, social, and historical contexts. This chapter focuses on the National Theatre of Scotland (NTS), a company that has side-stepped being identified with a specific, flagship theatre building. NTS lives by the motto that it used widely in its early years: 'Theatre without Walls'.[1] While the company no longer advertises itself this way, it continues to build on this ethos.[2] The rejection of a fixed venue has enhanced NTS's success to the extent that the National Theatre Wales has adopted a version of this model.[3]

NTS inevitably foregrounds space in their work, precisely because they do not occupy a fixed venue: the performance site changes for just about every production.[4] The productions I address here – *Black Watch*, *Aalst*, and *365* – deploy stage space strategically to investigate alternative ways to configure on-stage and off-stage locations (both concrete and metaphoric). The multiple award-winning and internationally touring *Black Watch* stages the regiment's final tour of duty in Iraq before it was amalgamated into a single Scottish regiment; *Aalst* is about a couple who murdered their children; and *365* deals with young people in state care. They effectively push through

71

the metaphoric walls of the theatre to challenge theatrical conven-
tion and received notions of cultural identity. By experimenting
with different socio-cultural options in performance, these plays
stage heterotopias that spatialize how to perform a diverse cultural
identity and how to frame responses to larger social dilemmas. As
in many other countries, out-dated signifiers of identity have long
defined Scotland, whereas NTS productions like these tend to decon-
struct conservative history and practice, live and in performance. An
additional attraction for me in analysing these productions is that
they are touring pieces, which requires further attention to spatial-
ity and has the potential to yield different results in performance
in subsequent locations. I raise other connections between them as
they occur.

I briefly contextualize this company and its significance in Scotland
before arguing the capacity of NTS to offer heterotopic analysis.
Founded in 2004 and mounting its first productions from 2006, NTS
has taken seriously its brief to intersect with a very broadly defined
community. It performs in town halls and other types of venues as
well as theatres, across Scotland (in addition to touring internation-
ally). It attempts to match plays to the venues for which they are best
suited, while keeping a practical eye on touring possibilities. The NTS
launched an ambitious first year: Vicky Featherstone, Artistic Director
from 2004 to 2012, could write in the *Summer-Autumn Brochure* for
2007 that 'in its first 13 weeks, NTS [...] toured 38 separate produc-
tions to big theatres, small theatres and places where theatre has never
been in 26 different locations across Scotland and beyond' (p. 1). NTS
has continued its prodigious output, but perhaps the most remarkable
production to date was its first: *Home* comprised ten separate, free
productions that opened on the same night, 25 February 2006, across
the country in venues such as a dance hall, the disused Caithness
glass factory, and a private home. The Glasgow production was
a site-specific promenade through tower blocks in the city, while *Home
Shetland* took place on the Northlink ferry. The geography of Scotland
made it impossible for anyone to see the full set of performances but
'people all over the country could connect to the National Theatre
of Scotland on its opening night' (Newall 2008) and experience 'dif-
ferent voices and discourses – "the competing versions" of Scotland'
(Imre 2008, p. 88).[5] Robert Leach called it '[p]erhaps the biggest, most
far-flung "opening night" in theatre history' (2007, p. 176).

Praise has been considerable for NTS; this early and impressive success needs to be read against repeated (unsuccessful) attempts over the previous century to develop a Scottish national theatre.[6] Two comments made in 2007 reinforce the theatrical and socio-political effects that NTS has achieve thus far: first, Mark Fisher maintained that 'it's probably the only national theatre in the world to engage with all the possible things that theatre can be' (qtd. in Rebellato 2007, p. 214). Adrian Turpin extended Fisher's perception, arguing that NTS

> is one of the most exciting things to have happened in British arts this decade. In its first 12 months, the company [...] reached 100,000 people. [...] Scotland's new national theatre would be geographically and socially inclusive in a way that London's building-bound National Theatre can only dream about. (2007)[7]

Not all NTS productions attract such uniformly positive press, but the company remains a major, progressive force in performing Scottish cultural and political identity.

In suggesting ways of interrogating NTS's intervention in Scottish national identity, Trish Reid argues that 'a key driver of Scottish cultural discourse' is the 'dynamic tension' that exists between cultural products that look inward and those that look beyond the borders of the nation (2013, p. 59). She explains that the challenge for NTS is 'striking a productive balance between national and international engagements, and between inclusive and exclusive conceptions of Scottish identity', a balance that connects 'to wider discourses of identity politics in contemporary Scotland' (2013, p. 63). While such investigations of NTS will be fruitful, here I explore NTS not through a nationalist (or 'national theatre') prism, but rather how several of its productions scrutinize 'theatre as a generative process, as opposed to considering it strictly as a representational event' (Zerdy 2011, p. 188).[8] The productions tend to fragment or splinter experience, identity, and the past such that the company has worked against 'consolidat[ing] a sense of "a" national identity', instead, creating theatre to 'accommodate and reflect diverse imaginings of identity and respond to contemporary expressions of belonging' (Robinson 2012, p. 399). NTS productions ask difficult questions about figuring 'Scotland' to speculate about what can be meant by 'performance'.

The exploration of such matters assists in shaping the nature of contemporary performance at large. For Leach, NTS

> demonstrates how performance may generate activism (thought, debate, action), how such activism can inform a fluid response, and thereby itself articulate profoundly a society in flux. In its work, in other words, a new kind of Scotland, simultaneously elusive and tangible, is alive. (2007, p. 183)

The 'activism' that Leach isolates reinforces socio-political debate about identity slightly differently than the tensions that Reid explores (although complementarily) but, as I contend here, the freedom from the spatial restrictions of a fixed venue also contributes substantially to that success.

The company's use of and attention to space is a significant contributing factor to its success in exploring diversity within (and beyond) a national cultural identity (aside from programming decisions). Two of the three productions I discuss were created for theatre buildings, the type of venue that many proponents of site-specificity dismiss as automatically less engaging and even oppressive; the third, *Black Watch*, was eventually performed in theatres but its original choice of a non-theatrical venue was central to its development, as I explain below. Theatre generated in and for traditional venues does not preclude a vibrant heterotopic engagement that can prompt a rethinking of cultural and identity politics and spatial practices. My demonstration of how these texts work in performance incorporates a dynamic exploration of textual and performance dramaturgy, the work of the entire artistic team, and most importantly how these elements were achieved in space: the assessment includes the set, the staging, the literal space that was physically created, the psychic/fantasy space that the characters inhabited, and the awareness created for the audience of the actual world space that they occupied. A heterotopic interpretation draws these disparate spatial elements together. Collectively, the NTS productions' novel ways of staging cultural fragmentation in spatial terms help reconfigure cultural identity. The NTS case studies assist me in articulating the scope for heterotopia by demonstrating its use in theatre venues and in identifying some of the unsettling cultural politics of Scottish identity. In the larger terms of theatrical analysis, this chapter illustrates how a heterotopic

examination brings together into a single methodology an account of the many types of space within theatre venues that Gay McAuley (1999), for one, outlines in her foundational study of space in performance, and which underpins my work. As such, heterotopia can activate an analysis of the effects of theatrical spaces and places to deepen a socio-political interpretation of performance.

Like the previous chapter, my exploration of heterotopia isolates the spatial zone – whether concrete or metaphoric – which presents alternate ways to think about what spatial variations might work better in the actual world. Once we see these orderings operating on stage, it is possible to conceive of them 'taking place' beyond a performance as well. As I explained in Chapter 1, heterotopias exist not on their own but between the two poles that construct utopics: what I term 'constructed' and 'abstracted' spaces. For each play, I identify the two poles that frame the heterotopia and, from there, draw connections to contexts beyond a theatre venue, particularly about the fragmented theatrical form, which reflects the manifold ways of depicting Scotland and 'Scottishness'. Interpreted through a heterotopic lens, these confronting National Theatre of Scotland productions configure a multiply-defined community by illustrating alternate orderings to political, social, and historical issues that matter in the outside world, beyond the walls of their venue. I focus on a spatiality that is explored as effectively as in site-specific performance; while the performances take place in conventional venues, the NTS's decision to avoid a fixed venue results in their use of a vast range of venues.

Black Watch

A heterotopic analysis of the spatiality in *Black Watch* reveals a different interpretation from most accounts. Written by Gregory Burke, directed by John Tiffany, designed by Laura Hopkins, with its movement choreographed by Frantic Assembly's Steven Hoggett, *Black Watch* has been the National Theatre of Scotland's most successful show to date, touring nationally and internationally almost annually since 2006 (Reid 2013, p. 15).[9] About one of the oldest and best-known Scottish highland regiments, *Black Watch* is based on verbatim reports from Black Watch soldiers who were posted to Iraq at the same time as the six Scottish regiments each became a

battalion in a new Scottish Regiment.[10] In writing the play, Burke set out to investigate the question, '[w]here does this martial culture sit alongside the shortbread-tin version of the Highlands, or the socialist glory of the former industrial areas?' (2008, p. 3). *Black Watch* staged that martial culture but it also looked past the glorification of Scottish militarism at the war in which the Black Watch was then involved: Iraq in the early years of the twenty-first century. This section's heterotopic reading enables an examination of the play's staging of some of the complexities of Scotland's relationship with war; it also accounts for its ambivalence towards received perceptions of national identity. Burke recognizes the difficulties in arguing both cases: '[i]t's a challenge to make people feel sympathetic towards a thing they are opposed to: a mechanised killing machine. [...] But at the same time it [the military] gives people jobs and a sense of identity' (qtd. in Logan 2008, p. 18). A spatial interpretation of the play better contextualizes these issues in Scottish history and in the present.

My analysis begins with the identification of the two poles that frame heterotopia in *Black Watch*: they comprise the 'constructed space' of Scottish militarist history in all its glory (with specific reference to the history of the Black Watch regiment), and the 'abstracted space' that is best described as a no man's land of war and death. Between the two emerged a heterotopia of peace and survival, a 'space' where one deals with loss and with the after-effects of war. Despite the remarkable popularity of *Black Watch*, critics drew attention to its reinforcement of a conservative, masculinist Scottish history (see Robinson 2012; Reid 2013, pp. 81–2); because of the partial way in which its history is told, the role of the highland regiments 'in the imperial project and its attendant crimes is never properly acknowledged' (Reid 2013, p. 17). These objections are valid, but a spatial analysis of the play creates a helpful counter-reading that assists in the alternate ordering of both history and the present. My reading of *Black Watch* acknowledges the value in maintaining connections with history but recognizes that there are new stories to explore – and new ways of telling them.

Before identifying *Black Watch*'s constructed space (and following through with the other elements of spatial analysis), I outline the performance itself. There are three narrative strands in this ninety-minute play: a writer character researching the 'real' stories of

soldiers in a notional present, which anchors the play in its verbatim origins; the actual-world events in Iraq in 2004; and the larger history of the Black Watch regiment. All three strands play up a theatricality that both ties in with the military precision that characterizes its movement and identifies the performance of personal and national identities. The stories are interspersed, told in a fragmentary form that contributes to a questioning of traditional representations of identity and storytelling. In performance, *Black Watch* incorporated multimedia, strobe lighting, effects that imitate night-vision goggles, and emotionally charged battle songs, complete with bagpipes and drums. Rousing music fortified this testosterone-driven play, which was punctuated with profanities, sexism, and racism. The set helped define the specific spatial parameters that supported the narrative: it had a large shipping container fixed at one end, used for multiple purposes and surrounded by raised platforms. The three-storey-high scaffolding at the other end was more prominent, serving as the location for news broadcasts, as well as the site of three casualties at the play's end. These set pieces left a large playing space in traverse form between them, framed by the audience on the remaining two sides of an elongated rectangle, ensuring that audience members could gauge each other's reactions. Its tightly crafted movement sequences used the entire expanse of the traverse stage as the ten actors (who were drilled by a sergeant) made flawless formations.[11]

The constructed space for this production was shaped from the beginning in the company's decision to stage it in a drill hall. *Black Watch*'s premiere at the University of Edinburgh's Drill Hall (as part of the 2006 Edinburgh Festival Fringe) immediately evoked Scotland's military history. Robinson observes that this choice of venue

> aimed to mimic, and by so doing subtly satirise, the annual Edinburgh Military Tattoo [which was...] simultaneously taking place at the nearby Edinburgh Castle. The opening of *Black Watch* attempted to recreate the atmosphere of the Tattoo, replete with roving spotlights [...], marching drums and an amplified, disembodied voice, presenting the arrival of the Black Watch in rousing tones. (2012, p. 395)

The effects of this location became even more significant for the original audience, as Chris Wilkinson's review explains: '[a]s we

spilled out into the surrounding streets [at the end of *Black Watch*], the fireworks from the official military tattoo could be heard exploding overhead. [...] On this occasion, though, the sound had an ironic ring' (2008). Even in subsequent productions and tours that did not have the benefit of this additional signifier of a glorified military history, *Black Watch*'s 'alternative' tattoo set up (and played against) a mythic Scottish history that would be clear to many international audiences as well as Scots.[12]

The constructed space, that of a Scottish history of shortbread-tin proportions, or the full pride of a legendary Highland regiment and all it represents in Scotland, began with the tattoo opening structure and was then developed over three scenes, and interspersed through the play to shape the historical 'glory' of the Black Watch. All but the final scene were overtly ironized, in a manner not replicated in the rest of the play. They included a recruitment scene with a ceremonial sword of exaggerated size, the history of the Black Watch told through a recounting of both the dress uniforms and the countries to which the regiment had been deployed, and a battle formation scene that closed the play. Most of these scenes about the glories of the regiment began with a ceremonial fanfare but became 'reduced' through performance, as if to emphasize the ambivalence that even the soldiers recognized in the military legend. Brief descriptions of some of these scenes clarify the role of this constructed space of history.

The first such scene opened the play: almost as soon as the tattoo was announced and the audience understood where they were, expectations of a celebrated historical pageant were thwarted when, rather than the heralded triumphal entrance of the Black Watch, the audience saw Cammy, a nervous-looking former soldier, dressed in civilian clothes, enter alone through a side door to set the scene for the audience and outline the arrival of a writer to interview some former soldiers in a Fife pub. In the recruitment scene, the soldiers themselves poked fun at the regiment's tactics while the Scottish dancing executed by those men who had been recruited amusingly gestured to Burke's 'shortbread-tin Scotland'. The scene that recounted the history of the regiment from the early eighteenth century, before the Battle of Culloden, all the way through to Iraq, again focused on Cammy, the de facto narrator of the play. He was dressed, re-dressed, and manoeuvred by other actors into and through all the regiment's dress uniforms through the years. On a red carpet rolled

out for the occasion, Cammy was manipulated by his fellow soldiers so that *'they resemble a squad assembling and disassembling a military cannon'* (Burke 2007, p. 30)[13] while Terry Allison called it a 'ballet' (2008, p. 275). The final irony was Cammy recording their return to Iraq, the site of a previous campaign: 'Here we are. [*Beat.*] Again' (p. 33).[14] This scene contrasted the proud history of the regiment through the clear manipulation of its soldiers.

The one exception to the ironizing of history was the final 'tradition' scene recounting the last battle of the Black Watch regiment before the 2004 announcement of amalgamation. This scene, called 'Parade', was a feat of physical endurance. Against the sound of bagpipes and drums, the stage directions indicate,

> [*t*]*he parade formation begins to disintegrate but each time one falls* [owing to exhaustion or injury] *they are helped back onto their feet by the others. As the music and movement climax, a thunderous drumbeat stops both, and the exhausted, breathless soldiers are left in silhouette.* (p. 73)

Some reviewers interpret this scene as reinforcing Scottish traditions and nationalist pride, which, for David Archibald, significantly diminishes the play (2008b, p. 12), whereas Sarah Hemming sees it as 'elegiac without being sentimental' (2008). The deliberately ambivalent message about this aspect of Scottish history was, Hemming notes, a 'double vision' that 'respects the soldiers but also depicts their more unpalatable behaviour', whether individual or collective. In each staging of regimental history, the entire performance space became larger than life, like the overarching history, but the military glory was deflated to some extent by, ironically, the experience of war itself. Like our undermined initial expectations of a tattoo, the locations of glory, war, and peace splintered physically in front of us as the staging oscillated between constructed space and the abstracted space (to which I now turn). This oscillation questioned received versions of history. In both the constructed space of a grand history and the abstracted space of war and death, the 'military precision' of the actors' movements significantly enhanced the spatializing process and my understanding of their effects.

Against an unsustainable constructed space – the grandeur of the history of the regiment – *Black Watch* staged an abstracted space

of the physical arena of warfare. The actual geographical location in which *this* war took place was the central desert in Iraq, but the site of war here was not Iraq per se because the geographical setting mattered little. Neither, unfortunately, did the people who lived there. Rather, it could have been any war zone/compound that was removed from local citizens, even those who acted as the translators for the regiment (one of whom was also killed in the incident documented in the climax of the play). This abstracted space of the reality of war was the most overwhelming 'place' in *Black Watch* because the set itself depicted this part of the narrative in most detail. It incorporated the physical set and the more metaphysical aspects of the war and its excitement, horror, claustrophobia, and death. It also covered the racism and sexism that the soldiers expressed. Additionally, it represented the aspect of the military history that most people oppose – killing and destruction – from which *Black Watch* did not shirk. There are two specific spatial locations in which this abstracted space of the site of war was most clearly staged: the literal and metaphoric effects of claustrophobia and the actual deaths of three of the soldiers.

For the first, the pool table in the Fife pub transformed to become a military vehicle in Iraq: a fortified 'wagon' or tank in which the soldiers sometimes remained for days on end, wearing full body armour. Six soldiers (see Figure 3.1) (the sixth is not visible in the figure) sat on the edge of what had been an ordinary pool table a moment before, with the baize dropping to accommodate their feet. The claustrophobic nature of this existence, heightened by the danger, was balanced by the games that the soldiers played to pass the time (deciding on which Indian take-away dishes they would order when they got home). This vehicle preserved the soldiers from enemy fire but the psychological toll of remaining in it for days on end in an intensified state of heat and readiness to respond concentrated the metaphoric fear and proximity to death in one small physical space. The wagon scene focused other aspects of war (such as the waiting) into a confined space.

The second example of abstracted space, the subsequent deaths of three soldiers, took over the entire stage space, even the area above the heads of the audience. A suicide bomber killed the Sergeant, Fraz, and Kenzie immediately following this scene; the force of the blast was reflected in the slow-motion 'reactions' of the surviving soldiers. The

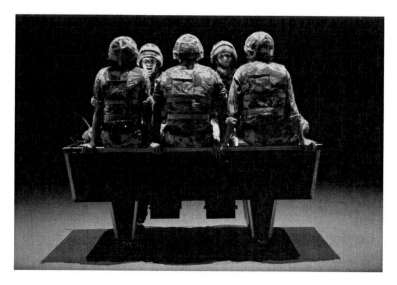

Figure 3.1 Soldiers on deployment in the 'wagon', 2008
Source: © Scott Suchman, London.

deaths were staged in such a way that the audience witnessed the horror experienced by the dying men and the other soldiers: we observed the surviving men watch their friends die (and we watch the other half of the audience watch too). The explosion of the bomb was depicted by having the dead/dying men, covered in blood, appear suspended (by cables) two stories up in the scaffolding; they then dropped slowly to the ground in a scene that powerfully illustrated the dreadfulness of such a death. It seemed that the three (dead) men would never fall to the ground as the slow-motion effect expanded the stage even further, metaphorically and physically. The staging of the deaths – particularly given the scale of the slow-motion display – was an extreme evocation of war, the effects of even its performance shocking.

The exaggerated glory of the regiment's stereotyped history and the horror of the abstracted space yielded something more positive, although it was not always so clearly portrayed: between the two poles in *Black Watch* was a heterotopic space of peace and safety, one that was only occasionally glimpsed but that the soldiers sought out. It became apparent in the way that many soldiers dealt with

the fear of death. For some, such as Stewarty, the emotional world dominated the stage to perform his inability to find the peace and safety he needed: in one scene, Stewarty was alone on the stage and not coping with the sounds of the mortar fire: he '*bursts onto the stage, diving for cover.* [...] *He lies with his hands over his head as mortars explode around him*' (p. 39). Stewarty's mental health was such that Cammy explained that Stewarty 'shouldn't have been there the second time' but the army 'lost the paperwork' of those who tried to leave the service (p. 65). The audience witnessed the psychological effects of war on the soldiers through Stewarty, whose attempts to find security were not always successful: the writer and the audience learned of Stewarty's depression and his attempts to leave the military when Stewarty, in a desperate corporeal move, recounted repeatedly breaking his own arm (and he even attempted to break the writer's arm).

What assisted Stewarty in coping with the sounds of mortar fire was the safety of home, available to soldiers in this abstracted space of the war zone by means of letters from loved ones. More than just pieces of paper, the letters were 'staged' to become a small 'space' of heterotopic sanctuary. In one scene, the Sergeant entered and handed a small packet of letters to Stewarty who

> *opens one and starts reading it, the words giving him comfort. Another soldier enters and takes the remaining letters. Stewarty creates a subconscious sign-language which expresses the content of his letters. One by one the soldiers enter, take the bundle of letters and, finding the one addressed to them, repeat the process for themselves.* (p. 39)

Each letter, once read, was dropped onto the stage, the actual paper of which was not necessary when the sign-language that delineated the world of refuge or sanctuary took over. The words on the page themselves were almost immaterial whereas their very existence helped structure in performance a small patch of peace and physical and psychological safety. By the end of this scene, the stage was filled with eight or nine soldiers: each inhabited a dimly spot-lit private space that the letters constituted for its soldier-reader. The occupation of a different world (one the audience could see physically inhabited in performance but psychically as well) offered a means of psychological survival for the soldiers during their deployment. The stories of

attempting to secure that safety, even Stewarty's lack of success, 'told' the story of this war more honestly than Black Watch regimental marketing and recruitment strategies that were staged as part of the constructed space. Small, unassuming actions in evocative spaces communicated the means for alternate ordering far better than large, grandiose gestures. This heterotopia offered, in its simplicity and quiet, a respite from the competing constructed and abstracted spaces. Beyond the play, it suggested the need to generate peaceful alternatives to war to prevent such trauma and death in the first place; this was particularly true of the actual military engagement in Iraq, which raised so many ethical, political, and strategic matters that were not adequately addressed – let alone answered – before it began. The poignancy of this scene – and this heterotopic zone – presented a stark contrast to the 'war machine', both in the play and in the actual world, which was repeatedly brought into the play via BBC news reports.

The fragmented, incomplete ways of coping with the enormity of war and the prospect of death provided an alternate ordering not just for the individual characters but also for the representation of aspects of cultural identity. The ambivalence that many members of the audience would have felt regarding this war shifts through the mythology of the fighting Scot that clashed with the psychological stresses of war. Read this way, and despite the testosterone-fuelled bravado of the soldiers and the criticisms levelled at it, *Black Watch* promoted peace as much as war. Such potential pacifism may be the effect of plays about war that deal with their topic in an ironic manner.[15] *Black Watch* may not be pacifist per se but understood through this heterotopic reading, it values the historic place of the regiment's history while deploring the war. This is, Sam Thielman argues in his review of an American tour of *Black Watch*, something that the soldiers themselves come to understand: '[t]he sadness that underscores every scene comes from the knowledge that the battles have been picked by venal politicians who couldn't care less about the soldiers fighting them – Scottish Watchman or American Marine' (2007). Clear at the end were the connections to a community that mostly did not support the war (and certainly not the deaths of young men and civilians in its name), if international marches against it are any measure.

In the final scene, the Black Watch soldiers made their last march under that name: they registered a place for warfare in Scottish

history at the same time as the play articulated a rejection of war. For Christopher Hart, it was 'a relief, at last, to have a play about the Iraq war that doesn't lecture us, with the ghastly smugness of hindsight' (2008, p. 19). As Kieran Hurley argues, '[i]t is a piece about Scotland's supposedly proud military history, but does not look favourably on our current operations. It tells the story of the heroic soldier [...]. But it also suggests the wastefulness of death in combat' (2008, p. 275). For Wilkinson, *Black Watch* 'find[s] a symbolic visual idiom which both contrasts with and augments the documentary realism of some of the other sequences. It forges a new and extremely eloquent language with which it speaks to its audience' (2008). He invokes the Scottish playwright, John McGrath, who

> said that for theatre to be able to reach new audiences (in his case this meant working-class audiences) it had to adapt itself to the structures of entertainment that they were used to. In resembling a tattoo and because it is usually performed in non-traditional spaces – drill halls and gyms rather than theatres – the show has done precisely this. It has found an audience not just amongst traditional theatregoers, but also among the squaddies and their families who might never otherwise have taken any notice of what the National Theatre of Scotland does.[16]

The play's years of tours underscore the relevance of the subject matter and its form.

The geographical location in which *Black Watch* is performed does, of course, affect the response. Outside Scotland, where the mythology and the imminent merger of regiments meant less, the war/anti-war message took on more meaning.[17] *Black Watch* spoke not just to Scots with family connections to the regiment but to those who saw some value in heritage and tradition, even if (particularly if) it was questioned. It attempted to move past the glorification of war and the regiment, while taking care not to attack the soldiers. Through its splintered narrative and performance, *Black Watch* shifted positions and situated the stories of this war and these soldiers against a historical backdrop that failed to tell enough of the story on its own. The interleaving of the graphic depiction of war, the grand historical myth of battle, and the humanizing of the soldiers' responses to war pushed cultural identity and theatricality; they broadened interpretations

of Scotland and the value of a generative, activist performance that expanded the meanings invested in literal and figurative spaces. It staged the need to address the war from several perspectives while new aspects emerged, including the realities of Stewarty's post-traumatic stress disorder (PTSD) and limited career prospects post-discharge, to name just two that contributed to an alternate ordering of both history and the future. This heterotopic interpretation of *Black Watch* enabled me to discern more in the play than 'just' the military triumphalism or a verbatim account of a group of soldiers in Iraq. By attending to the forms of spatiality that were developed, staged, and even deflated, my alternative reading recalibrates both Scottish national identity and the role of a national theatre. The next play, *Aalst*, continues this endeavour, from a very different spatial perspective.

Aalst

Black Watch took on stereotyped versions of a glorified Scottish history, but there is nothing exalted about the subject matter of *Aalst*, produced in 2007, about a couple who murdered their children: three-month-old Ellie and seven-year-old Matthew. It premiered at the Tramway, Glasgow, before touring Scotland and London, and then, in 2008, three cities in Australia. The script is based on a 1999 incident in which a couple checked into a hotel in the small Belgian town of Aalst and killed their family. Duncan McLean's adaptation and translation of Pol Heyvaert and Dimitri Verhulst's 2005 play does not directly relocate the play from Belgium to Scotland, although it does give the parents Scottish names: Cathy and Michael Delaney.[18] *Aalst* was developed from transcripts and documentary footage of the parents' trial; approximately two-thirds of it is verbatim, with one third 'invented' (Young 2009, p. 76).[19] The play uses direct-address staging (via a recorded 'Voice' or judge-like figure who addresses questions to the parents) to challenge its audience about their expectations regarding the depiction of such an event. Helena Grehan argues that *Aalst* both 'seduc[es] and estrange[s]' and that 'the concepts of ethical responsibility and judgment are destabilised and radically challenged' in a play that 'refuses to allow any straightforward moral judgements to be passed' (2010, p. 4). *Aalst* left no room for reactions that merely condemned the characters or blamed an unidentified social 'system'.[20]

My spatial analysis clarifies how *Aalst* supports an ethical response: the play created a void on stage – ultimately an anti-space – that must be negotiated but that defied simple explanation. In this instance, heterotopia does not offer an alternative as it does in *Black Watch*; rather, heterotopia enhances Grehan's ethical debate through a focus on performance itself. It affords another way in which theatre can draw attention to its own theatricality in order to question both the form and humanity itself. This heterotopic analysis also articulates a different aspect of NTS's 'theatre without walls' motto: the play is one of several NTS productions to explore stories from beyond Scotland that nevertheless matter *to* Scots, speak to the Scottish psyche, and affect how one might live in Scotland. My reading focuses crucial attention on an absence that encourages audiences to re-evaluate the nature of performance.

Before this absence came into play, *Aalst* demonstrated the subversive powers of space in performance: the same unaltered set communicated several opposing positions, almost simultaneously. The zones that formed the heterotopia seemed to be, then, exactly the same in appearance. Yet each came to signify a location that was at odds with the others. The two poles that shaped the heterotopia were formed first by our expectations that we may come to understand what happened to cause two sane people to kill their children. This anticipation of an explanation was introduced firstly by a court context that is associated with the verbatim theatre form; and second, by the 'performance' that took place late in the play that completely changed the nature and meaning of the stage space, even though the set did not alter at all. Between these poles, the heterotopia, which can be described as an absence of answers, a void, forced the audience to piece together events, rethink our responses to the events, and find a means of processing what transpired. This was not something I was able to discern immediately, but it became clear through the course of the performance (through the minimalist set, the verbatim form, and the staging of the 'performance' in the final scene) that *Aalst*'s production was adding an abstracted spatial element that required further attention (see Figure 3.2). *Aalst* tapped into deep, personal questions about humanity, such as how have we come to live in a world where the actions of the Delaneys are possible? *Aalst* did not deal directly with Scottish heritage like *Black Watch*; rather, it staged the heterotopic potential in engaging with a multiply-defined community by

setting the stage for investigating alternate orderings to inhuman acts. Theatre's generative capacity was ironically depicted through the *subversion* of space. By questioning the function of space through the same, simple set to situate very different literal and metaphoric loca-tions, *Aalst* unsettled theatre: the audience could not rely on any space to be familiar or taken for granted. We were forced to actively seek new ways to engage with theatre, our community, and even humanity.

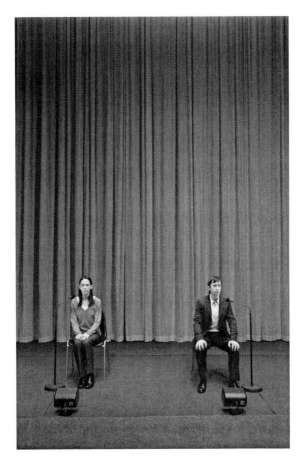

Figure 3.2 Cathy (Kate Dickie) and Michael (David McKay) on *Aalst's* minimalist set, 2008
Source: © Richard Campbell, Glasgow.

As it set up the constructed space of a court-like context, *Aalst* documented Cathy and Michael Delaney's answers in an unidentified official setting about murdering their children. It was not easy to watch: the woman seated next to me left (in tears, not to return) about one-third of the way through the performance. There were no satisfactory explanations for the actions of the Delaneys; they were found to be psychologically competent, although both were abused as children. We learned about their backgrounds and their extensive (unapologetic) use of social service networks. They had many interactions with the police, and Cathy outlined some of their difficulties with a neighbour who complained about them:

CATHY: Said she was bothered by our noisy arguments. So
 I told her: 'Don't be stupid. Do you think we can argue
 silently?' Well, that shut her up.
MICHAEL: She's single. If I was single, I wouldn't have arguments
 either. [...]
CATHY: She should go on the social, that's what it's there for!
 (pp. 16–17; original emphasis)

Their logic produced laughter of surprise or incredulity among some members of the audience when I saw the production. While the Delaneys were right that a single person is unlikely to have noisy arguments with herself, their worldview – that they shouldn't bother to find jobs if 'the social' will pay them – appeared to startle the audience. Bryoni Trezise calls this 'logic [that] makes excruciating sense – somehow. Are we convinced? We don't know what to think' (2008, p. 13). *Aalst* frequently placed the audience member in this position of uncertainty. Its spare set acted to subvert all the expectations that the play created; thus, the audience faced the challenge of finding alternative means of making sense of the events.

For Glass (2007), *Aalst* 'has a minimum of drama, a minimum of trickery. No clever design here – no need – because we are already shocked even before we take our seats; we know what's coming.'[21] Yet the set was extremely cleverly designed *in* its simplicity: it comprised two straight, functional office chairs – separated from each other by several metres – that faced the audience square-on. The chairs were positioned on a large, plain, rusty-red rug. A relatively transparent white curtain covered much (but not all) of the back of the playing space, suggesting

a location that was neither theatrical nor official; a microphone stood in front of each chair. The lighting suggested an indoor, functional location rather than a representational one. There were no other props; very little movement or action punctuated the seventy-minute performance. Cathy and Michael sat in the chairs and looked out to the audience for the entire performance. A single exception was when Michael (played by David McKay) stood to deliver a line in what appeared to be an apology. The Voice immediately asked him to sit again. Cathy (Kate Dickie) looked at Michael once (unacknowledged) early on and they looked at each other briefly in the play's final scene, described below.

Throughout the performance, they answered into the microphones the questions asked by the nameless 'Voice', the offstage authority figure who sounded as though he was positioned behind and above us, thereby enveloping the audience in the action. The uncomplicated set reinforced the statements of fact that the Delaneys expressed and which seemed to hang in the air agonizingly: the audience, with nothing else to look at, had to continue to process the Delaneys and their actions. The deceptively simple staging may have suggested initially that the play had little to offer spatially but its heterotopic potential was in its minimalism, as will become clear shortly. Nicholas Till argues that 'the scenographic element [of minimalist performances] may actually be more fundamental to theatre than language' (2010, p. 160), a point that is well-illustrated in *Aalst*.

Like the other plays in this chapter, the narrative was relayed in fragmentary sections, some repeating or appearing with more context or in different forms, later in the performance. On the expansive stage of the Powerhouse Theatre in Brisbane where I saw *Aalst* (a much deeper stage than in the image that illustrates this section), the two actors initially looked almost as unsure of what to expect as the audience was. They were, nevertheless, compelling, partly as a consequence of their location on the stage in relation to us. As McLean explains, 'we are in a position of unshielded intimacy with these two we'd rather run from. As we sit in our seats, staring at Michael and Cathy, they sit in their seats a few feet away, staring right back at us' (2007a, p. 13). Neither the characters nor the audience could retreat from the interaction (aside from the person next to me who departed altogether). In fact, Dickie (Cathy) even played on this inescapability: she 'would often scrutinize the audience, catching people's eyes, as if defying us to disbelieve her' (Young 2009, p. 80).

The play built its constructed space of expectations fulfilled, whether legal, moral, or theatrical, from almost the first line: we understood ourselves to be located in an official forum. The 'Voice' at first appeared to orient the audience and promised to make sense of the events, an authority figure who commandingly announced to Cathy, 'what we're going to try and do here is solve the crossword puzzle of your life' (p. 3). Audiences experienced with the British common law system might have wondered about the Voice's role, given some of his questions: was he judge, psychiatrist, police inspector, journalist, social worker, or even social conscience? The Voice, whose 'words are based on those of the judge in the original trial' (McLean 2007a, p. 14), reflected the Belgian legal system where judges are more interventionist, although his official function was never explained. Our positioning in this approximation of a court – with the 'witnesses' (in the legal sense) visible in front of us – suggested that the invisible 'presence' of the voice would provide answers and mete out some form of justice. We attempted to make sense of these events, even though it soon became clear that there would be no apology, no conventional justice (and how could there be for the brutally murdered children?), and no insight into the actions that led to this event. The audience, then, became witnesses to this (legal?) 'testimony', required to 'place' this experience in an external socio-cultural context.

The 'promise' of order established by the opening of the play and the set was reinforced by use of the verbatim form. For Stuart Young, *Aalst* capitalized on the fact that 'audiences recognize verbatim testimony as being of a different mimetic order from fictional drama' (2009, p. 75). *Aalst* did not appear to be 'theatre': it was something more, emphasized by its being based on an actual event. The accompanying 'affect-less' performances appeared to reinforce that these words were transcribed from documentary sources. The verbatim form provided a second layer of structure that encouraged the audience to presuppose that answers – or at least some form of understanding of the events – would be forthcoming, since verbatim tends to provide some semblance of what happened and how/why, its retelling of events working towards some comprehension. Philip Fisher claims that the popularity of verbatim theatre 'coincides with a desire to get behind the headlines, to get closer to the truth of real events, to understand the mechanics of the public world' (2007).

The verbatim and court formats reinforced each other, configuring expectations for the audience, even if little resolution appeared to be forthcoming.

This structure that the court and the verbatim form might have provided was ultimately compromised during the final scene of the play when the abstracted space came into play. Without any modification, the set shifted from the legal or institutional setting in which the audience was implicated to become an abstracted space that was characterized by 'performance', which served to completely unsettle audiences. In the final scene of the play, the Voice appeared to be absent; Cathy and Michael, we came to understand, were on their own, even though their positions and body language barely altered from what we had seen to this point. In what followed, they appeared to be working out what to say and how best to say their 'lines' to reduce their prison sentences:

MICHAEL: How was it?
CATHY: It was perfect. Very convincing. That's five years off your sentence, I'm sure.
MICHAEL: Your turn!
CATHY: I can't say the same thing, of course, that wouldn't work.
MICHAEL: Something with a saying in it would be good. To strike a chord. Good to use something that appeals to people.
CATHY: A child without a mother is like a vase without flowers.
MICHAEL: No, that's a bit much. You shouldn't make it too difficult, Coo. Remember, some of those folk aren't educated.
CATHY: Regrets always come too late.
MICHAEL: Can't you think of anything else? You sound as if you're reading from a proverb-a-day calendar.
CATHY: I wish could turn the clock back.
MICHAEL: Cathy Delaney, is there anything you wish to add?
CATHY: I would like to say that I miss my children very much, and that I'm sorry about what happened. And that I wish I could turn the clock back, because what we did was not exactly brilliant. (pp. 47–8)[22]

The fact that the events that the audience had negotiated may have been 'just' a performance only complicated further what

'performance' itself came to mean. Rather than sitting in a court-like environment or learning from the verbatim accounts how to understand and interpret the events, our position was subverted and we were suddenly in a 'play'. The 'authority' that the verbatim form may have provided was now lost, even though the set did not change: the same spare set came to evoke 'performance', albeit one furnished with a very basic set design. It may seem ironic in a book about theatre space that 'performance' could be deemed to be an abstracted space, but the shocking possibility at the end that everything we had witnessed had been designed to manipulate us and others questioned not just the narrative events but the place of theatre itself. Yet 'performance' normally takes place in the building in which we were assembled; 'performance' also accords with our usual assumptions in coming to such a place.[23] *Aalst*'s generation of different expectations (the space, the court context, and the verbatim form) forced the audience to ask what was genuine and what was 'performance'.[24] At least some of the narrative was revealed to be 'fiction', and we were suddenly even more removed from an anticipated understanding of how and why. Grehan uses the word 'hoax' to describe what the final scene suggested (2010, p. 7). I prefer 'subversion', which for me explains how *Aalst* constantly thwarted our expectations of answers and even of form.

The abstracted space, then, was not the absence of justice or the crime itself. Rather, it was the understanding the audience discerned at the end of the play that we might well have been 'played', now that we were once again situated in a theatre. Likewise, we came to understand that the verbatim form had also been played. Young explains that *Aalst* 'draws attention to and taunts us with its refusal to display those quotation marks [that would signal the limits of verbatim text], thereby highlighting the manipulation that documentary drama is capable of exercising' (2009, p. 80). This 'playing' of the audience subverted whatever we may have established in and through this space to make sense of the characters and their actions. *Aalst* demanded an entirely new approach and response, just when it prepared to conclude. The anxiety that this moment produced emerged partly because we did not know where to 'place' ourselves.

Between these two poles was a heterotopia of a void portrayed by the same austere stage, but a stage that now had even fewer of

the structuring agents than we may have needed to understand the matters that demanded explanation. Given that the abstracted space appeared at the end of the performance, and compromised all that had come before, the heterotopia occupied an unusual location, forcing us back to what had come before, and forward to a sense of 'what now?' The play continued to deny us our bearings: the location appeared now to be too simple, the characters physically too close to us, our own positions as spectators compromised by our assumptions – however misplaced – that we would be able to understand the motivations of these characters. We were no longer in court, no longer witnessing verbatim theatre, and even our understanding of 'performance' was challenged. Literally, this heterotopia was characterized by the same space that defined the entire performance but now we became much more conscious of the emptiness of the space in which these characters – and the audience – were positioned. The gap became evident in the wide unoccupied spaces behind and around the two actors. This was particularly so since the 'reveal' occurred at the end of the play: the shocking events remained fixed in our minds when it was time to leave the venue and 'return' to the world outside. *Aalst* played with our perceptions of our own self-awareness, pitted against two characters whose self-awareness appeared and disappeared. It compelled us to re-evaluate what we'd seen and heard. Cathy, for instance, commented in a strangely blasé way that her neck was sore the day they killed Matthew because she'd used her pillowcase to contain Ellie's body and she couldn't sleep on a hotel pillow that didn't have a pillow case on it. Her explanation drew gasps from the audience: '[y]ou never know who's been lying on that pillow, you never know what other folk have been doing in that bed. People do the weirdest things in hotel rooms, and you'd never know about it' (p. 26). When the entire play described people doing unspeakable things in hotel rooms, the audience was once again reminded that the abstracted space, whether in performance or beyond, was unlikely ever to be quite what we anticipated, or quite what it seemed. The gaps and the undefined locations now took on enormous proportions, large enough to accommodate the inexplicable actions of the Delaneys.

Aalst presented a gap that the audience needed to see filled or at least defined; the responses of reviewers suggested that they attempted to supply it themselves to satisfy the demand that these

matters should make sense, as did I. In *Aalst*, we kept trying to dis-
cover where we were and what it meant: since the physical location
did not change, the actions focused us into our minds. The plainness
of the stage made us draw connections to the outside world because
the set was so *normal*. Any 'illusion' of performance was even more
distant than ever. The simplicity of the staging and the proximity
of these inexplicable people brought home the events to our space,
our community, ourselves. Young notes that '[r]eviewers describe
the court as [...] a "psychic space"' (2009, p. 77) that, I would add,
we wanted to render real so that we could deal with it. James Waites
writes in his review,

> I want an answer and we are not offered one. Is it fair to ask this of
> the production? Probably not. [...] I have been cast out at the end
> of the show, [...] as I go over and over the controversial material
> gathered in my mind. It hurts and, in each instance, I make little
> progress on the answer. (2008)[25]

Frequently, both Cathy and Michael responded to the Voice by say-
ing, 'I don't know' or 'I can't remember'. Maybe that was true, but the
audience was not afforded this luxury: we remembered and needed
to make sense of what we witnessed. Perhaps the most disturbing
and unsettling of those discussed so far, this heterotopia made it very
difficult not to engage in a discussion – at least personally – about
the limits of humanity.

There is an element of formal witnessing in watching *Aalst*. For Ann
Kaplan, witnessing 'involves wanting to change the kind of world
where injustice, of whatever kind, is common' (2008, p. 20). She
argues that the frequent portrayal of the images to which we are
exposed in the global media leads to a damaging form of witness-
ing that she characterizes as 'empty empathy', which 'locates the
viewer in a "passive position" of "hopelessness"' (2008, p. 16). She
defines 'empty empathy' as 'empathy that does not result in pro-
social behaviour' (2008, p. 9). The spatial frame for *Aalst* prevented
an empty empathy response, as the production's heterotopia helped
address and open up these matters for discussion (even if it could
not explain them).

What could we do with the gap, whether filled or still empty?
Aalst did not provide answers, but the alternate ordering of the void

questioned assumptions associated with particular locations: their stability, meaning, and affect. The alternate ordering also pointed to a form of witnessing that encouraged a very different personal response and engagement with the community, as Philip Fisher outlines in his review of *Aalst*: '[t]he more we see of their world – a place where domestic violence, uncontrollable rage and sexual abuse are commonplace – the more we are forced to question our own assumptions of normalcy' (2007). Our proximity to people, who at one level appeared so normal, in a setting that seemed almost nondescript, forced audiences to recalibrate what 'normal' means and where 'normal' is situated in geographical and social terms. The effect for Grehan is that '*Aalst* pushes its spectators to reflect on what it means to be human, and to consider what their own personal limits are in terms of judgment, empathy and responsibility' (2010, p. 10). This deceptive play (which appeared to be minimalist in narrative and set) came to contain the entirety of human responsibility. It insisted that we qualify how we interpret our community and the 'proximity' of others and the spaces that we inhabit. *Aalst* staged generative theatre by actively subverting space. Yet rather than providing the ways and means for audiences to achieve this end, it simply articulated such action to be necessary: its success was that it left it to audiences to fathom a response with which we could live.

Ultimately, *Aalst* questioned the nature and effect of art itself. In the process of creating this National Theatre of Scotland performance, Gary Lewis, the actor who played the Voice, noted, 'maybe art can help us understand people in a way a court of law can't. [...] And maybe art has a responsibility to try and understand things we can't get at any other way' (qtd. in McLean 2007a, p. 15). *Aalst*'s subversion of space demonstrates the willingness of NTS to query what can be discussed, performed, and debated in a national theatre, and how those enquiries might take place. Like *Black Watch*, *Aalst* forced audiences to interrogate their assumptions, certainly one measure of effectiveness in art. Specifically, *Aalst* looked to the nature of literal and metaphoric locations, encouraging a spatial analysis of performance in everyday life (for instance, courtrooms). It reconsidered the power of space, even an absence of space, illustrating its potential in performance and, here, its ability to encourage a fundamental rethinking of the boundaries of humanity.

365

My final case study is *365*, about children in care who are, at 16 years of age, relocated to living on their own in 'practice flats' where they learn how to care for themselves, under limited supervision by overworked social workers. Like *Aalst*, *365* staged an absence but here, the absence is not the heterotopic space. It is the abstracted space that spatialized these teens' lack of independent-living skills. Written by David Harrower from, in the first instance, verbatim reports, *365* was directed by Vicky Featherstone, designed by Georgia McGuinness, and choreographed, like *Black Watch*, by Steven Hoggett.[26] The characters were created independently of the verbatim reports and were then significantly fictionalized for ethical reasons. *365* did not receive the critical accolades that *Black Watch* and *Aalst* did, many reviewers responding that the narrative was insufficiently developed, but Robert Gould notes that the play's 'unfinished' feel was 'its strength. It's as incomplete as the lives of its characters' (2008). Reviews aside, the extensive spatializing of its narrative warrants attention. This section illustrates how rendering a social issue in space in performance may yield a greater understanding of the gravity of the issue for its audiences than a naturalistic treatment. I show how a heterotopic reading of the performance can extend our understandings of this production and the social issue that it explores: it depicts space as the young people themselves would have experienced it. The staging of personal and public space in *365* was often extreme, a manifestation of the unformed and/or exaggerated responses of these teens, exacerbated by the neglect and mistreatment that they had experienced.

Like *Black Watch* and *Aalst*, the spatial language in *365* was confronting, bold, and enhanced the narrative to engage with its community, but unlike the earlier two NTS productions, *365* took a more literal approach to breaking down walls to address a burgeoning social issue. As with *Aalst*, no answers were provided, but *365* outlined more directly the full extent of the problem. Given the teens' care histories, their 'constructed space' was a fantasy world. The much more prominent 'abstracted space' was the absence of skills, the repressed trauma, anger, and violence that they brought with them in arriving at this point without the necessary knowledge to live productive lives. Between these two poles, the heterotopia was

the 'practice flat' to which the teens were assigned. As it was built and rebuilt on stage in front of us, some of the characters (but not all) came to acquire the skills to live independently. I had the opportunity to see this production in both Edinburgh and London; in this section, I compare how its heterotopic effects were staged in two very different venues.

In a deliberately fragmented form, *365* followed the lives of about a dozen young people who were introduced to living on their own, even if they did not have the life skills to maintain a flat, retain a job, or remain in a training/education course. A letter of the alphabet identified each young person; the audience pieced together the slivers of information we were given to discern their stories. The story of J (played by Ashley Smith) took more prominence than the others. She suffered from recovered memories of her mother abandoning her at the age of four when J had to fend for herself at home alone for five days while her mother went away with a boyfriend. J's progress was hampered by the presence of her mother (the only 'adult' in the play, aside from the social worker) who demanded a place in her daughter's life. The NTS website described J thus: '[s]he has no idea what her story is [...]. She is a jumbled mixture of melted memories and until she can make some sense of it, J hasn't really got a chance. Tonight, in the silence [of her first night in the flat], she must begin to learn a lifetime' (*365*, 2008).

The use of the Edinburgh Playhouse was distinctive, with *365* beginning with nothing on the stage: the large (deep and wide) expanse of the stage was empty, stripped right back to the brick back wall with the exposed dock door and fire hose. Then fourteen actors, with their belongings in garbage bags, walked from the back of the stage to the front, backlit. Soon thirteen actors left the stage to J while a voice-over read from the guidebook on how to live independently, as an illuminated doorframe fell from the flies. Then more numbered doors appeared, followed by several components of a typical flat that emerged from both above and the wings: a kitchen bench and cupboard, a bed, several walls, a bare window frame. Each appeared to fit roughly into place, but the walls didn't quite meet and the proportions weren't quite right. Once enough aspects of the flat were in place to suggest its shape, it 'exploded', only to be put back together again, not entirely 'squarely', throughout the play.[27] Harrop describes the set as an 'ingenious exploded flat-pack of

a set [that] creates wonderfully unpredictable landscapes' (2008). The frequent reforming of the flat reflected the emotional upheaval that, here, compromised the creation of a stable identity. Through much of the Edinburgh production, the bare brick back wall remained visible, a reminder of the non-illusion, actual-world backdrop to the children's experiences.

Before exploring the flat in detail, I outline the constructed space and the abstracted space that frame the heterotopia of the flat. Given the neglect and/or abuse the teens suffered at home, the constructed space was less concrete than it might otherwise be. It was not their experiences of abuse (which were a given and not articulated at length), nor was it a 'normal' upbringing. Rather, their formulation of a space of fantasy suggested their chief point of reference: here, the teens created a life to which they either aspired or wished to return. *365* threw starkly into focus that there was little else positive in their lives. At its simplest, the fantasy world was evident in the picture that C (Ben Presley) carried around with him: wherever he was, he posted a photograph of his parents and the cat, with the pronouncement, '*that* was a good day'. Throughout the play, others questioned inconsistencies in the story that accompanied the photo but he presented it as his 'truth'. It mattered little if the world in the photo was not his to own: C sought return to a place of happiness that provided, wherever he was, some of the security of this fantasy location, even if he had never been to the 'place' in the photo.

J's fantasy constructed space was much more carefully staged spatially. Following the traumatic memory of a moment from her past, she 'travelled' to a house in the woods, a magical cottage that temporarily pushed the flat off-stage. The forest was evoked by several large, suspended tree trunks, each, like the doors, marked with a number, suggesting that the 'flat' was not so far away, that this fantasy world was a manifestation of J's imagination.[28] J's mother sat atop a very tall chair (like a swimming-pool lifeguard's chair), poised in an unusual silver costume to play either the fairy godmother or the wicked witch. The fantasy worlds that the teens constructed failed to last, unsurprisingly. As the fairy-tale ending to J's fantasy collapsed, the lighting changed subtly and the audience could decipher that the green metal roof was inscribed with 'HELP' in large letters, a few shades of green paint darker than the rest of the roof; we then knew the role J's mother would play. This constructed space served a crucial, if

unsustainable, purpose for the teens: it was their 'norm', regardless how unstable.

Against the beacon of the constructed space was the rather more amorphous abstracted space, characterized by absence. *365* explored the arrival of the teens at the door of a practice flat to which the young people 'brought' a huge gulf in the knowledge required for independent living. This staging of 'absence' was one of the most profound spatial elements of the production: Harrower explains that he worked on building 'a story [that] can arc round an absence instead of a presence' (qtd. in Phelan 2008, p. xxiii). C, for instance, attempted to make tea in his new flat for his social worker, but he didn't know that tea requires hot water (although he was adept at making the toast on which he seemed to subsist). Harrower notes that children in care 'don't have control of their own narrative. They don't have family photos, they don't have family members to tell them what happened early in their childhoods' (qtd. in M. Brown 2008).[29] The gaps in the young people's background and under-standing were displayed through their being dwarfed on the large Playhouse stage, or, in the case of R (John Paul McCue), a different order of physical, spatial confusion. R met with his social worker who brought him his police file, documentation of what he suffered at the hands of those supposedly caring for him, a file to which he had been seeking access for some time. He appeared to be coping well with this new phase of his life, but the staging of this scene suggested otherwise. His inability to understand the social worker was made physical: as the meeting with the social worker continued and each sat at one end of a rectangular meeting table, other actors brought in more and more tables, and inserted them between the two speakers (see Figure 3.3). The distance between them grew until at the culmination of the scene, the social worker sat at one extreme of the table, at the opposite of the vast stage from R, who remained at the other.

Then R carried his file around, a macabre account of his whole short life. Eventually he was lifted well above the stage (in a harness) as the thick file fell away from him, page after page flying across the stage. It would be pleasing to assume that he was relinquishing the past and looking towards a better future, but the staging implied that the file represented that he was losing his delicate control over his life. The extreme responses reinforced the teens' absence of control and their inability to demonstrate a grounded sense of self.[30]

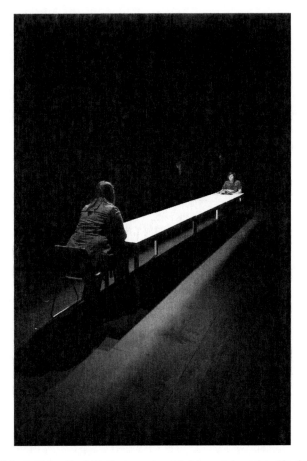

Figure 3.3 R (John Paul McCue) meets with his social worker (Gayle Telfer Stevens) across the growing expanse of the meeting table, 2008
Source: © Peter Dibdin, Dundee.

Joyce McMillan's review calls *365* a 'scenic meditation on the inner journey of these youngsters', 'a brave, beautiful, complex attempt to imagine the inner landscape of a generation who have been failed by language and our old ways of structuring drama' (2008, p. 35). With the failure of language, space became much more expressive, even, in the case of the abstracted space, as a locus of absence.[31]

365's heterotopia was the building of the flat as an alternate order-
ing for these young people, an action that paralleled the building of
the self. As if echoing the function of heterotopias, Stephen Phelan
asks in the programme, '[w]hat is a practice flat, if not a rehearsal
space for life in this world?' (2008, p. xxii). Much more literal at
one level than some of the other heterotopias in this study, the
flat's deployment on stage also brought a figurative dimension. Its
significance was in what this flat came to mean, given the limited
experience of the teens. The flat was as fragmentary as the teens'
nascent personalities, representing home, a shelter from the ele-
ments, a new start, and the virtual impossibility of accumulating –
very quickly – the requisite knowledge to live independently. The
play deliberately exploited these gaps as it 'built' both the flats and
the teens themselves.[32] It was hardly surprising that under these cir-
cumstances, not everyone fared well while countless others remained
unaccommodated.[33]

Further, once the flat became a solid, structurally stable home (as
opposed to the edges not quite meeting in its earlier iterations), it did
not necessarily remain that way, as J discovered: what she thought
was finally her safe house was threatened by both the physical pres-
ence of her mother (outside its door) and the emotional damage that
her mother wrought. This instability was staged by the shifting of
her flat off its foundations, an action that deposited her under the
kitchen table. For this scene, the box-like flat was 'built' so that the
component parts met. This small flat was a 'put-together' version of
the flat that we had seen explode throughout the play: the kitchen
unit, a single bed, a door, and a window. The cube of the studio flat
interior was suspended from above, sitting about a half metre off
the stage. J was in her flat, alone and distressed. Her suffering was
manifested physically as the flat suddenly shifted on its wires, sliding
her across its floor under the table, back to the hiding place where
the police found her when she was four. The exaggerated emotional
effects took control of J in a physical expression of her memory.

J's experience of recurring trauma was not isolated and the flat
came to represent the capacity to both box in its tenants psychologi-
cally as well as physically. Yet as the final scene reinforced, it also
had the power to expand to attempt to encompass all teens in care.
Once J's flat settled back to be suspended horizontally, just slightly
above the stage, another actor came in and made himself at home,

followed by another, and another, each taking up a comfortable position in the flat. Since no one acknowledged anyone else, the audience understood that each was 'alone' in his or her own flat. When A (Marlene Madenge) entered, she added the personal touch of curtains for some privacy. C put up his photo. Another knocked holes in the wall in rage. All the actors entered, making themselves at home, each oblivious to the others. More and more young people came in, now spilling out over the front edge of the flat's 'cube' onto the stage's apron: approximately three times the number of cast members now appeared on the stage – fifty or more – each coming through the flat's front door, the large stage filled with young people living on their own and trying to become adults. Finally, in the play's last action, the outside wall of the flat (the fourth wall, as it were) came down with a thud, its bay window covered with grime and graffiti. It confirmed the flat as a type of prison, even if a prison of the past. The number of kids at risk or in care remains staggering, and the number of actors on stage illustrated graphically the magnitude of the problem. The unadorned back wall of the theatre was no longer visible in this scene: only the flat was lit, focusing the audience's attention on all it must now contain, as more and more and more people crossed its doorway and spread onto the stage, threatening to spill over the edge into the auditorium. This heterotopia spatialized the gravity of the predicament while also suggesting the limited effects of current care strategies, given the vast numbers of children who need assistance.

Designed to appeal to a young audience, *365* was not, however, *for* that demographic, as Featherstone outlines: '[w]e cannot tell them anything about their world that they do not know already, because they live in it every day. This is for the rest of us, who need to understand how they survive and how resilient they are' (qtd. in Phelan 2008, p. xxiv). Older audience members were challenged to consider the heterotopia of this flat and alternate ways in which children in crisis could be adequately cared for. The play provided no answers, of course, nor could it, but it generated an impact that many audiences felt compelled to discuss. The night I saw the Edinburgh production, the audience hung around in the foyer and on the street, clustered outside the theatre; they seemed to need to take the events from the stage and make sense of them in the light of the summer evening, in the actual world.[34] To assist with such discussions, the Edinburgh

production offered audience members a page of information about the almost 80,000 children who were in care in the UK in 2007.[35]

I saw *365* in two differently scaled theatres. At the Lyric Hammersmith in London, *365* required some restaging because this Victorian theatre is much smaller in both width and depth than the expansive 1929 Edinburgh Playhouse.[36] The production 'fit' differently in each; nevertheless, it worked in much the same way heterotopically. Certain elements were emphasized in the Lyric production where the smaller theatre intensified some of the issues of containment. Other aspects that may have been conceived for the expanse of the Playhouse stage in Edinburgh were lost. Following the Edinburgh run, Mark Gorman speculated that the play's London run would suffer: 'it will be rather less spectacular than in The Playhouse which, as a stage, offers wide open spaces (and which contributed to the theme of isolation by its very brooding presence)' (2008). The flat seemed much smaller and more institutionalized at the Lyric, suggesting a heterotopia that was even less idealized. When the fire curtain went up in the London production, the illuminated white door was already in place on an otherwise empty (black) stage. The back wall of this theatre was not exposed and lighting effects seemed to have replaced this image with the shock of harsh white light against black curtains. The smaller stage emphasized the cramped nature of the practice flat and how restrictive the life skills of these teens were at this point. Likewise, the scene between the social worker and R (described above) seemed even more confining. The forest in the fantasy scene was slightly reduced in size, but unlike some of the other elements, it fit this stage better than in the Playhouse, where it seemed slightly out of place, even more than simply being J's fantasy location. Finally, the London production's finale with dozens of children arriving 'home' to their flat generated an even more claustrophobic feel: the smaller stage meant that the point about the crisis of thousands of children in care was made much more quickly and forcefully. Seeing the production in different venues inevitably deepened my understanding of its achievements, and while I appreciated the reinforcing of the point in the intimate space of the Lyric, I preferred it on the expansive Playhouse stage, which emphasized the function and effects of the heterotopia.

Like *Aalst*, *365* did not target a specific form of outmoded Scottish cultural identity. Rather, it aimed to establish alternative orderings of

spatial meaning of a broader spectrum of matters relevant in Scotland. The heterotopic space illustrated the scale of learning for teens in practice flats as well as the enormity of the social problem of children in care generally, in Scotland and elsewhere. *365*'s fragmentary narrative and its 'exploding' set staged the experience from the perspective of impressionable teens in care. This delivered an urgency that was difficult to ignore. NTS's *365* marked the first step, with the company's circulation of information about children who need assistance being a second step: the potential for further action then rested with (older) audience members who might be able to engage in grassroots action, or have the means to contribute financially to the cause, or lobby councillors and politicians for the issue to be made a much higher priority, or simply keep the reality of the situation in discussion.

I found it difficult to observe *Black Watch*, *Aalst*, and *365* and not be moved. It may have been the nature of the narratives, the skilful performances and use of choreography. It may have been their treatment of verbatim and/or documentary forms, even if not all NTS productions begin this way. These productions had their origins in the actual world, before moving beyond that structure. Their stories were anchored in the world in which they were performed (I include *Aalst* in this grouping, even though the events took place in Belgium). They also encouraged their audiences to 'witness' affecting events and to take their responses to such events *back* into the world. Further, each toured beyond Scotland, suggesting the relevance of the stories beyond their points of origin. The transfer of *365* from Edinburgh to London necessitated some restaging, but not in a way that compromised the heterotopia at all.

 Yet for me, the most compelling reason for their affective response was, as my heterotopic interpretation suggests, a strategic use of spatiality that communicated on several levels. One particular element that all three productions shared was a staging of the space of absence. It took the form of the heterotopia in *Aalst* and in *Black Watch*, while it was the abstracted space in *365*. Absence is unlikely to be a constructed space, because that zone tends to set up spatial awareness, usually in a more concrete manner (although the constructed space in *365* is immaterial in its fantasy space, even if its materiality is firm to the teens). Two of the productions even featured spatial explosions of sorts, generated by or generating different

types of voids. Not all NTS productions are necessarily heterotopic: for instance, I saw Bryony Lavery's *Beautiful Burnout* in which I could not detect a heterotopia. But the attention that the company makes to venues increases the likelihood that they might be.

In addition to the various forms of space that heterotopia can encompass, this chapter encompasses a wide socio-political understanding of national identity. National theatres emerge from ideological beginnings and the National Theatre of Scotland is no exception, but its initial ideology – theatre without walls – has been significantly modified as NTS continues to present theatre that challenges Scottish cultural identity. The company maintains its push at the boundaries of theatrical form, revives narratives from the past, and adds new dimensions to what 'Scotland' might be. As Hemming notes, NTS 'invites scrutiny of its name and remit. Its elastic programme, accommodating both conventionally staged classics and experimental pieces, embraces the fact that our notion of "theatre" has shifted enormously in the past few decades' (2006). This approach typifies NTS but it could equally be applied to other touring and festival productions that foreground the potential for space to influence cultural development.

I have investigated how three plays from the earlier part of the NTS repertoire used space to tell their stories: these stories have been staged in fragmentary, generically daring, and spatially impressive ways. They complement a narrative that is equally splintered and that deliberately challenges received notions of 'Scottishness'. A company that is not bound to a single venue (or a venue complex) naturally addresses issues of spatiality more automatically than those that maintain a fixed venue: the former must inherently *think* spatially from the first instance. The absence of a permanent theatre venue for NTS productions generates an interest in spatiality that facilitates the exploration of other complicated spaces, even their absence. The plays also deploy physical movement to fill the gaps where language breaks down; this alternate form of conveying meaning encourages a different relationship with space than a traditional narrative often does. A major factor in the NTS's success is, then, its commitment *not* to have a fixed venue. This decision enables a more profound exploration of space: with such a choice, there is no opportunity to take for granted a venue. The attention to space in *Black Watch*, *Aalst*, and *365* significantly enhanced the overall effect and impact of these

productions and the possibilities of theatre generally. The National Theatre of Scotland presents a model of how, as a production tool, heterotopia might promote a more spatio-centric approach to performance, a tool that might then also raise socio-political implications. This chapter diversifies the ways in which heterotopia might be used and the ways in which it helps locate and articulate spaces on stage.

From a company that chooses not to be supported by a permanent venue, I move to a venue that appears to be extremely fixed in both its architecture and its history: Shakespeare's Globe Theatre might appear to be very limited in its spatial reach but, through careful staging, it can also generate productive heterotopic spaces.

4

Re-establishing Heterotopic Relationships at Shakespeare's Globe Theatre

Shakespeare's Globe Theatre, situated on the south side of London's River Thames, has, since its first productions in 1997, achieved its aim of becoming a popular tourist site in London and a location for experimentation with historical performance. But can a venue that is identified with tourism and with a fraught historicity lend itself to heterotopic analysis and to alternate orderings that are relevant for a contemporary London? I believe it can. The previous chapter's exploration of the National Theatre of Scotland surveyed productions that capitalized on performing in multiple locations, the absence of a fixed venue, and even absence itself. In this chapter, I address in the Globe a single venue laden with historical significance. The tremendous weight of 'history' associated with this venue can overpower performances: early modern 'time' combines with recreated Renaissance 'space', threatening to preclude other spatial or temporal possibilities. Yet not all Globe productions perform an unrefracted historical focus: I illuminate the potential for heterotopia at Shakespeare's Globe by analysing productions that shift historical exclusivity and facilitate a connection with communities beyond the venue. I argue that if it is possible to convey contemporary spatial and temporal significance through and around the historicity of the Globe, then it should also be possible for theatres that are not so heavily identified with a particular figure or moment in history to support heterotopic revisions of spatiality that actively intersect with their communities. This chapter broadens perceptions of the Globe while also suggesting a greater awareness of spatiality as a tool in production and in investigating performance.

The three productions I analyse succeed in engaging heterotopi-cally with contexts beyond the theatre and its historicity. They stage sites that provide the testing ground to propose alternative ways of understanding the possible relationship between what happens on stage and what takes place in the world beyond the venue. As Chapter 1 details, heterotopia does not exist on its own: it operates between the two poles that form what Louis Marin identifies as utop-ics. These poles, which I term 'constructed space' and 'abstracted space', frame the heterotopia that provides an alternate ordering for the actual world. Heterotopia is more detailed than simply the imaginative space of a play, evoked on stage: it is a location in which alternate possibilities can be tried out in the 'safe' space of the thea-tre. Once we see how these alternate orderings might work on stage, it is possible to conceive of them 'taking place' beyond the theatrical context as well. It aims not necessarily to make specific changes in the actual world but to introduce audiences to the possibility that an alternate ordering can influence their decisions and perspectives off-stage. Heterotopia helps rethink what might take place in a thea-tre like the Globe, even though it appears to look back exclusively to the past.[1] This spatial dynamism can in turn assist the Globe in sidestepping the potential for it to be seen as a passive receptacle for performance from the past. W.B. Worthen notes that '[l]ike all space – built or unbuilt, constructed or natural – the Globe space is saturated with meanings. For many audiences the Globe appears to cite not merely the conditions of Shakespeare's theatre, but an entire vision of the past' (2003, pp. 98–9). I explore performance that shifts from this 'pastness' to identify the venue's relation to a 'present' and even 'future' social world.

I investigate Kathryn Hunter's *Pericles* (2005) and Lucy Bailey's *Timon of Athens* (2008), both of which intervened overtly in the structure of the Globe's space. To take account of non-Shakespearean theatre, the third production I analyse is a contemporary play that examined an era much later than Shakespeare's: Mark Rosenblatt's 2007 production of Jack Shepherd's *Holding Fire!*, a play about the Victorian Chartist movement. I have not included 'original prac-tices' productions: those that attempt to reproduce early modern performance techniques and methods as exactly as possible. While such productions can be very revealing in recovering historical performance, they are, now, structurally prevented from exploring

one essential element of their 'origins': a relationship with the city beyond the venue's walls. The city that helped to define early modern theatres – and indeed performance itself – no longer operates as it did then. London's transformation (geographically, architecturally, structurally, and politically) necessarily alters the meaning and effects of performances at this venue today. Yet it should not be impossible for performance at the Globe today to engage at some level with the contemporary world beyond its walls, particularly if the genre of theatre is to retain a connection with its socio-political surroundings. Thus, I am interested in productions that accept that they are performing in a venue that is steeped in history, but recognize that there is a world beyond the venue, one with which the play *in* the venue might engage, just as, to quote Russell West, early modern theatre demonstrated a 'permeability of worldly theatre and theatre in the world' (2002, p. 42).[2] If performance interprets and shapes a culture, we need to comprehend whether (and how) this permeability operates today.

Even though the Globe is likely the best-known venue of those discussed in this volume, it nevertheless requires some contextualization. Rebuilt near to the original site of its Renaissance namesake, Shakespeare's Globe commemorates early modern theatrical culture in contemporary London. Performance there has proven quite popular: the ticket prices for standing room in the pit have remained at an accessible £5 since its 1997 opening. Contemporary actors and audiences appear to enjoy the banter they can share with actors, something that is rare in proscenium arch theatres. A wealth of scholarship has been published on the decisions made in designing and building the Globe and in the material effects of performance there (see Carson and Karim-Cooper 2008; Mulryne and Shewring 1997, among others), but not all commentators discuss the endeavour positively: as Paul Prescott summarizes, 'the Globe not only has provoked controversy [about authenticity] but constitutes one of the key sites for the cultural contestation of Shakespeare' (2005, p. 359). Some critics argue that the Globe shares more with tourist theme parks than historical theatres, while others continue to pursue historical authenticity by exploring performance in 'original practices' form.[3] The multi-layered historicity of this venue can be difficult to set aside, though, a perception that Worthen explains thus: '[t]he Globe epitomizes a host of attitudes toward history, not least the

commodification of "pastness" within the economy of international tourism' (2003, p. 29). He suggests that by selling 'Globeness' (2003, p. 116), productions there engender what he calls '"Shakespearean performativity": the sense that a Shakespearean play can, or sometimes should, evoke the pastness of the text and what the text represents – early modern values, behaviours, subjects – in the present action of performance' (2003, p. 29).[4] Worthen argues that 'Globeness' inadvertently sells a perception of historical authenticity that neither the venue nor its performances can claim. No one who attends the Globe can 'unknow' it – it cannot be neutral. While my own argument takes a different direction, I acknowledge the weight of 'Globeness'. These debates converge in and are concentrated by the powerful signifier of the venue itself.

The actuality of the venue remains influential. When Howard Brenton wrote *In Extremis* for the Globe, he discovered in formulating his script just how much 'the presence of the building dominates' (2007). For instance, the two faux-marble columns on the large thrust stage can presuppose a performance style, not to mention a relatively immovable design aesthetic. The overarching sign of 'history' (both in terms of time and place) complicates the possibility of a contemporary experience of heterotopia taking hold in the Globe.[5] The power of history combines with the particular spatial features of this venue's shape. Kristen Poole argues the significance of space in the Globe: '[t]o see the world through the proscenium arch is to see the world through a stable frame. [...] Within the unframed space of the Globe, however, packed with an audience exposed to competing theo-cosmologies, space is neither assumed nor invisible' (2011, pp. 166–7). The visibility of theo-cosmological space may have been more apparent in venues in the early modern era than in today's reconstruction of the Globe, but, as the examples I analyse demonstrate, it is not entirely obscured.

The social and political relationship that I seek between spatial representations *on*-stage and an audience member's understanding of their impact *off*-stage was, in early modern theatre, something of a given.[6] This is the nature of theatre itself, but, as I have argued in previous chapters, the analysis of heterotopia requires a more detailed investigation of spatial worlds than simply 'on-stage' and 'off-stage' locations. The difficulty in achieving this in the Globe is, however, that what transpires 'on-stage' is so embedded in history

while what might matter 'off-stage' appears to be radically altered from its equivalent in the early 1600s. How might socially interactive space(s) be created at the Globe Theatre today so that the performance that takes place there engages more directly with its social and cultural contexts?

To provide the foundations for understanding heterotopic potential at the Globe today, I first briefly isolate some of the ways in which space and spatiality communicated in early modern theatre more generally.[7] D.J. Hopkins explains that in early modern London, theatres such as the Globe functioned geographically and politically to fabricate the space that came to be known as London itself:[8]

> Shakespeare's theatre had the capacity to generate material change: to produce space. The physical space of the city, the innovations in visual culture, and the representation of space in Shakespeare's plays all mutually informed each other. At a time of particularly acute social dynamism in London, the public theatre played a part in deciding what the city was, and what it could become. (2008, p. 18)[9]

In other words, Shakespeare's plays – and those by other writers at the time – contributed to the development of a specific shaping and understanding 'of' (a secular) London. It is not surprising, then, that Darryll Grantley argues that theatre of the day 'offered the audiences imaginative ownership of the terrain on which the theatrical narratives were being played out, but in the process would also have affected and helped shape their perceptions of their actual habitat' (2008, p. 7). He reinforces that theatre cannot be read in isolation from the socio-political context that it is helping to produce. To some extent, this is true of all theatre, but in the early modern era this is pronounced in a particularly structural manner. I investigate to what degree this is still possible in a very different London.

This formative function of the theatre was enacted even though – or perhaps because – the theatres themselves were located outside the boundaries of the city beyond the purview of the city's laws. The relegation of the theatres to these peripheral parts of London, known as the Liberties, gave them the critical distance with which to comment on – and shape – events central to the city, without fear of prosecution by the Lord Mayor.[10] Theatres thus constituted 'a threat

to the political well-being and stability of the city' (Mullaney 1988, p. 53) through their power to reconfigure space on stage, because performance on the stage provides a 'constant interlinking of theatrical and non-theatrical worlds' (West 2002, p. 42). At times this was a mimetic relationship, and at other times not, such that, for West, 'theatre signifies that which it *is* not, but *in* which it is implanted: its own exterior, the world which surrounds it' (2002, p. 42; original emphasis). This enactment of comparability with the real world is also marked by a distinction from that world. This distinction gives theatre its spatial power by providing the critical distance so that what happens on-stage can be *in dialogue with* what happens off-stage. Heterotopia takes this relationship further to explore at least one more spatial realm that is associated with the off-stage world, thus enhancing the potential for theatrical engagement with its community.

With the reinforcement that some contextual history of the era provides, I turn to productions at the Globe that engage differently with the historicity of the venue. I investigate the ways in which some Globe performances have succeeded in generating a heterotopic relationship wherein the audience is invited to look beyond the Renaissance-look painted walls, and to read some engagement with contemporary life off-stage in what is realized on-stage. The venue that memorializes a long-gone Renaissance environment should also be able to connect to the contemporary city in which it is (now) located. Of course, I do not suggest that this should be a requirement of all productions. The investigation of performance in a context of the contemporary community would create a synergy that would, however, attract audiences who wish their performance to engage with their socio-political context(s) while not necessarily alienating those intent on a historical experience. The productions that I examine generate in the Globe a site something closer to what Cynthia Marshall describes as 'a radical theater space' rather than 'a tool for historical recovery' (2000, p. 354). I recognize that I may be interpreting Globe productions somewhat against the grain, but this is, I believe, an effective test of both my version of heterotopia and of the evolution of performance at the Globe. In the case of all three of my examples, the constructed space that forms one part of the utopics in which the heterotopia is found is shaped by the venue itself and specifically how these productions use or re-use or even

reimagine the venue physically and conceptually. There is potential for productions at the Globe to play with space and imagination beyond 'mere' spectacle to (re-)invest in the venue a modicum of what Marshall calls its 'radical' roots. I address the potential cultural and political effects of the heterotopic spatiality that the venue can have as it exists in – and helps construct – London today.

Two of the three productions took place under Dominic Dromgoole's artistic directorship; Dromgoole has moved away from the predominant historicity that characterized much of his predecessor's work. Given that the focus of performance at the reconstructed Globe was originally historical accuracy, not surprisingly most of the productions under Mark Rylance, the first Artistic Director, tended to reinforce the venue's early modern function. Dromgoole's approach speaks in several different voices to a contemporary audience somewhat more than previously. This is not a criticism of Rylance's legacy, but an observation of the ways in which Shakespeare's Globe is evolving. Either way, the venue must balance the uneven weights of its audience, comprising tourists, locals, and fans of the early modern, each of whom likely arrives with differing expectations and experience.

After attending several Globe productions and realizing what spatial transformation was possible, I watched many other productions on DVD; this chapter is informed by analysis of both live productions and DVD recordings.[11] My analyses illustrate the effects that can be created from careful spatial deployment. My response to them will inevitably vary from others' accounts of these performances, as is typical in performance analysis (and I indicate such divergences from the productions' reviews where relevant), but these accounts illustrate some of the ways in which performance at a venue commonly thought to be historically bound and spatially static can nevertheless communicate to a contemporary audience about *their* world. Ultimately, these productions' manipulation of spatiality on the stage of Shakespeare's Globe created in stage space a location for audiences to think about alternate orderings with the world outside the theatre venue.

Pericles

The numerous narrative and staging questions posed by *Pericles, Prince of Tyre* mean that it is performed less often than other

Shakespeare plays, but Kathryn Hunter's 2005 *Pericles* surmounted these difficulties to reconsider the historicity of the venue, exemplifying how a production might engage with what Shakespeare's Globe has come to represent. This cut, augmented, and reordered *Pericles* achieved a spatial rethinking of the Globe for a contemporary audience.[12] Shakespeare's *Pericles* relates the journeys of the eponymous prince as he encounters corruption, narrow escapes, love, and loss in his travels around the eastern Mediterranean. In the script, the power of the play's concluding family reunion is somewhat reduced by the toll that the narrative's demanding events take. In Hunter's *Pericles*, the 'space' in the Globe came to depict a complex combination of the events and locations at the same time, not just the locations stipulated in Shakespeare's narrative and not even just geographical places. The space of the stage also encompassed, among other features: a rethinking of how to interpret the performance space of the Globe itself; the aerialist-dominated spaces of the evocative and haunting shipwrecks that accompanied Shakespeare's narrative; the geography of colonization and its implications; a spatial manifestation of the grief Pericles suffered later in life; and potential sites for healing the personal and social ills that these events wrought. Some of these spaces were literal locations that were depicted by particular positions on stage whereas others were metaphoric and/or evoked through the action on the stage, rather than identifiable by a fixed spot. The production not only used the stage fully, it augmented the ways in which locations on stage came to signify place and space by, among other features, extending the performance space up into the area above the stage and pit for the shipwreck scenes. The integration of these locations contributed to a heterotopic space of healing that connected to the world immediately outside the theatre and beyond. Specifically, *Pericles* used the Globe to rethink the effects of imperialism and to celebrate London's multicultural composition.

The many spatial layers to this production confound simple description, but two staging decisions helped frame the use of physical and metaphoric space. Challenging the history that is embedded in the Globe, Hunter first cast an actor of Sierra Leonean heritage to play Gower as a griot (a West African singer, story-teller and healer; played by Patrice Naiambana). An anonymous reviewer describes Gower as 'joyously vibrant' ('The Globe Gets Tossed Out to Sea' 2005) while Hemming interprets him as having 'gravitas and flamboyant

mischief' (2005). The second decision was to cast two actors to play Pericles: the younger Pericles carried out the trials that structure the action of the play, while the older man reluctantly reflected back on his life. Traumatized and grief-stricken, Pericles the Elder traversed the production's literal and metaphoric stage spaces, coerced along the path of his younger self by Gower who controlled almost all of these zones.[13] Not simply expanding the imaginative space of the stage/setting for its own sake, Gower restored Pericles through a rethinking of the stage space as a heterotopic site of cultural healing, an alternate ordering to the actual world outside the Globe. The two spaces that framed the heterotopia in this production were complicated by a multifaceted narrative action and a multi-layered staging that pulled in different directions. A reminder of the pun in the theatre's name helps distinguish the 'constructed space' and the 'abstracted space'. The theatre that we know to be called the Globe Theatre forms the constructed space, although as I explain in subsequent paragraphs, this Globe is significantly rethought. The globe that represents the entire world (and here, the specifics of colonial travel) forms the abstracted space. Between them is a heterotopia of healing, as I develop below.

The constructed space depicted the Globe as a literal venue for theatrical entertainment. Yet not resting with what the Globe had come to mean as a location of performance for 'original practices' of Shakespeare and other traditional signifiers of English heritage, *Pericles* enhanced what diversified performance at the Globe might become through a more nuanced dynamism between venue and form. It staged on the thrust stage numerous forms of 'theatre' that may, at first, have been perceived to be at odds with the Globe's repertoire. Gower brought music, stand-up comedy, and acrobatics to this theatre, in addition to his usual function as the chorus. This stage was not just the location for Shakespeare's poetic language but for all manner of expressions of the enjoyment of life. Paul Taylor's review describes Gower as 'an outrageously charming and wily African storyteller who delights in departing from his brief to josh the punters about everything from the anti-snob nature of the Globe [...] to their memory of the highly episodic plot' (2005).[14] Amid magic tricks and song, Gower discussed the role of Shakespeare in contemporary theatre: 'I'm sure some of you are saying, "this is not Shakespeare." [...] Don't you people know that Shakespeare was

black?!'[15] The effects of ridiculing assumptions about Shakespeare on the very stage where his legacy is perpetuated encouraged a rethinking of the potential for this stage space while also beginning to make a link to the outside world, particularly when Gower explained to the audience, '[w]e don't do art here. If you want art, go to the museum. [...] Here at the Globe, we do life!' By reclaiming theatre as 'reality theatre' (unlike the more recent novelty called 'reality TV', which he dismissed as, effectively, a misunderstanding), Gower resituated the traditional 'place' occupied by the name and industry of 'Shakespeare' in the very theatre that bears his name. He dominated the whole stage, ranging over all parts of it, walking through other action when it suited him, and even freezing scenes to make an extra-textual point to the audience. Gower determined when Shakespeare's narrative would be interrupted and when it needed support, such that Gower's own delineation of the potential for performance provided the fundamental and overarching reason for the audience being there. He effectively reconfigured what (and how) 'theatre' could mean at the Globe.

The expansion of what the Globe's stage might connote in performance terms was mirrored by an extension of what it might convey in geo-political terms. The second pole, the larger 'global' geography – the abstracted space – began with Pericles visiting country after country.[16] Shakespeare's *Pericles* takes place in the eastern Mediterranean, but Hunter broadened the geography staged on Shakespeare's Globe theatre to the actual globe. Pericles became a type of Everyman explorer/colonizer, emblematic of a British leader, not necessarily the Lebanese prince that his title, 'Tyre', identifies. He was forced by Gower to look back on his life and travels to make sense of his world and his part in its changes. This combination of geography was effectively no one place – its staging was well more and well less than a faithful rendering of the globe – but it evoked 'geography' generally and the cultural and political effects of what such explorations wrought. While the venue didn't change, its multi-layered incorporation of the geography of the world ensured that *this* Globe felt unlike the venue at which audiences may have seen other Shakespearean plays. The stage continued to transform from one geographical location to another. Pericles' voyages stood in for the centuries of European exploration and slave exchange that contributed to the multiculturalism that characterizes contemporary

London. Rather than a specific place, this abstracted space was the accruing of geography itself. It thus altered the Globe as a symbolic venue by extending even further the potential for its 'global' reach.

Such travels have effects: the aftermath of slavery and other forms of international people trafficking is apparent, in just one example, through the multicultural mix that has shaped London today. Shakespeare's Globe is situated in Southwark, which at the time of the production, was the London suburb with the highest proportion of African population in the UK;[17] this production encouraged a broadening of what might be construed as 'culture' at the Globe where the high culture that Shakespeare represents can co-exist with numerous multicultural performance traditions. The historical context of 'Africa' was introduced through the casting of Gower, an actor of African heritage. This was not an example of 'colour-blind' casting: rather, this Gower actively reinforced his background and what Europe's historical engagement with Africa has wrought. Gower made direct references to, among other things, Bob Geldof's then-timely aid work: when Pericles arrived in Tharsus, he relieved the famine, and Gower froze the action to make a joke about Bob Geldof, philanthropy, and empire. Suddenly, we were no longer 'just' in Tharsus but also in Geldof's Africa in 2005 as the audience was faced with the specific effects, today, of the establishment of European empires elsewhere.[18] Gower also referenced asylum seekers, thus addressing more recent effects of mass migrations. The production accumulated locations of British engagement in international geography throughout history, demonstrating how the international sphere is enacted in London today: the 'space' of Shakespeare's Globe became much bigger than what could be contained by any theatre's walls.[19] Casting an African Gower reinforced in this *Pericles* a specific multicultural London while also drawing attention to the history that produced London's contemporary geography and demography.[20] For all the constructed space's celebration of 'theatre', the abstracted space was tinged with Pericles' guilt, repentance, and shame, such that the heterotopic zone of a healing space became all the more urgent.

Before moving to this production's heterotopia, I discuss the device that links these two poles: the two storm scenes connected the two central 'Globe/globe' zones spatially in a stunning fashion (see Figure 4.1). Twice, Pericles' ships were wracked by horrific storms,

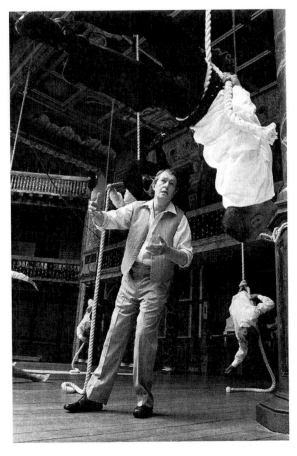

Figure 4.1 Corin Redgrave, as Pericles the Elder, ponders the shipwreck that has left sailors drowned in the ship's rigging, 2005
Source: © Tristram Kenton, London.

even breaking apart as desperate sailors climbed ropes high over the stage to save the ship, only to become entangled in them, action that was punctuated by thunder, alarms, and haunting yells. A mesmerizing combination of props and actors mimicked the ship's movement on an unpredictable ocean while actors acrobatically climbed (and dangled from) the ropes. Taylor notes that the production 'thrillingly takes the storms right out into the audience, with mariners swinging

on ropes in dizzying desperation and clutching for dear life onto then packed balconies' (2005). For Jerome Monahan,

> [t]he Globe has never been more fully used. In the first tempest the action occurs high above the main stage – the aerialists evoking in quick succession the desperate efforts of the sailors in the rigging, then the giant waves crashing on Pericles' vessel. Topping it all is their slow unravelling descent at the storm's end, suggesting the inexorable downward progress of drowned men headed for the seabed. (2005, p. 7)

Through Gower's control of the globe/Globe in maritime explorations and disasters, the venue presented a strong link with both the spectacular capacity of performance and the production's social history and political geography. The designer, Liz Cooke, used the Globe's height as well as its stage to fashion the effects of the shipwrecks, reinforcing that spatial meaning can be created and explored well beyond 'simply' the space of the Globe's stage.

The two forms of 'globe' assisted in enhancing the implications of the production's setting while also testing the opportunities for establishing different ways of articulating space, geography, history, and performance in the Globe. Between these two poles, Gower produced a heterotopic space for an aging Pericles to relive the terrible events of his life in a form of psychological therapy that would assist him to 'reintegrate' with his younger self.[21] The trauma of colonization and slavery were not performed on the stage: rather, Pericles performed his responsibility *for* these events. Gower explicitly outlined his own function in making Pericles take responsibility for the events of his life, telling the audience, 'you see this thing that we are trying to do here? Trying to get a ruler, someone in high authority to reflect back on his past? Well we all have to do it together, eh?' Rather than 'merely' replaying colonial era abuses, this *Pericles* addressed the effects of empire today with Shakespeare's Globe standing in for the world at large, re-placing in the Globe Theatre the capacity for performance to speak to the shaping of the world beyond its walls. While Gower maintained control over the events and the stage space, Pericles was forced to witness on stage what his voyages wrought. The audience was also implicated in this act of witnessing. Gower compelled Pericles to return to the moments from the past that he

would have liked to forget. Even watching Pericles relive his life was confronting: witnessing his pain in revisiting certain events amplified their emotional effects more than might have been possible in a 'straight' dramatization of the narrative. Pericles the Elder resisted returning to sea, but Gower retorted, 'Papa how do you expect to make competent history when you refuse to check out your own history. You can't just skip the pages you don't like, you know. It's not healthy.' This 'competent history' emerged from the narration of Pericles' own life but the heterotopic zone of healing came to be read well beyond 'just' Pericles himself.[22] His eventual reintegration with his younger self in the conclusion implied some success in Gower's disturbing, heterotopic 'therapy', while the audience's obvious enjoyment of the performance offered another measure of success.

Performing this *Pericles* at the Globe affords the opportunity to contrast the audience's assumptions about Shakespearean performance, about the Globe, and about the relationship between the two. Not only does the performance generate a new understanding of *Pericles*, it also provides a deeper awareness of the power of performance itself, rethinking the venue's symbolic purchase and cultural potential. Finally, as I explore next, it situates these conclusions in a broader socio-political context than do many productions.

To emphasize the production's merging of, among other things, personal narrative with the reprise of a broader history, Gower and Pericles the Elder often stood to one side of the action, occupying the margins of the stage, but remaining very much engaged in the action: they actively witnessed the events of the past, as the audience watched their witnessing. Frequently, Gower intervened in that action in various ways: when Simonides slapped young Pericles, Gower slapped Pericles the Elder to connect the two actors physically and directly in the moment. The geographical and theatrical worlds merged, as did the two versions of Pericles, forming a reinterpretation of what the Globe might mean, as *Pericles'* far-away worlds were connected to the multicultural and intercultural context of London today. The simple family reunion narrative was extended well beyond Pericles' own family to an exploration of how the culture beyond the theatre was formed – and how the construction of space *on*-stage might contribute to altering the potential shaping of space *off*-stage. This production's deployment of the past created a space in which a reconfigured history and performance examined the

present, with a view to rethinking the future. While Pericles the Elder continued to seek escape from what Gower forced him to relive, the audience was afforded the opportunity to isolate alternate orderings of interpreting Shakespeare, the Globe/globe, and the 'global' context of the venue itself. It presented a playful approach to history, an approach that did not shy away from the horrors of the past, but suggested ways of healing that demonstrated learning from history and a willingness to cultivate a shared cultural community that may not be underpinned by a traditional approach to Shakespeare. It 'repaired' the rift between Globe and globe.

Beyond just this remedial work, the performance suggested a means of carrying the play's 'healing space' outside the theatre into the diversity of the city of London. In Shakespeare's original play, the historical character of Gower drew references to a broader historical reach through Gower's mortal remains, which are interred in the nearby Southwark Cathedral; in Hunter's version, Gower continued to maintain a close geographical proximity to the Globe as well. Rethinking performance in this venue prompted reflections on the demographics of Southwark, London, and the wider UK, and how theatre can engage in demonstrating alternate orderings of history, geography, and the traumatic consequences of colonization. The innovative use of the literal Globe venue in *Pericles* rethought the power and function of the Shakespearean tradition and Shakespeare's plays; it actively referenced the world beyond the Globe's walls and left open the potential for other productions to extend the theatre's boundaries, literally and figuratively. Shakespeare's Globe came to connote much more than 'simply' an early modern venue: it made connections between a seldom-performed play and the lives of its audiences, expressing the ways in which theatre – and specifically this theatre – can continue to suggest how ways of alternate orderings of performance can be achieved.[23] Hunter's *Pericles* suggested connections between global history/geography and its effects on much more local geography, whether in the form of African populations engaging more directly with the Globe; Anglo audiences acknowledging the contributions, place, and histories of African compatriots; or any number of other modes of reconciliation. I found myself investigating the demographics of Southwark and the Globe's location (and role) there and researching Shakespeare's Globe's associations with that local community.[24] This self-reflexive relationship

between past and present sought a (re-)unification of sorts in which the audience better understood the possibilities inherent in the multicultural citizenry of London, the UK more generally, and beyond. *Pericles* updated and broadened both the historical and geographical reach, demonstrating the Globe's potential elasticity, moving away from simply a view to the past – or at least connecting the past to the present and future. This is a feature that the next play explored quite differently.

Timon of Athens

The gaiety underpinning Hunter's *Pericles* balanced the trauma that Pericles the Elder faced, but the next production offered few light-hearted moments of any sort. If Hunter's *Pericles* repositioned Shakespeare's Globe in geo-historical terms, Lucy Bailey's 2008 *Timon of Athens* generated a heterotopic space of ambiguous escape through an intensifying of the venue's circularity; it challenged the audience to evaluate their positions in relation to the Global Financial Crisis (GFC) that was playing out beyond the theatre. Spatially, *Timon* enhanced the thrust stage through a farther-reaching use of the area above the stage and pit than even *Pericles'* ship scenes did: a net was erected over the skyward opening of the theatre, from which acrobatic actors abseiled into the audience. *Timon* is already a bleak play but this production accentuated its nightmarish qualities. The actors evoked, among other things, the attacking creatures from Alfred Hitchcock's movie, *The Birds* (Dudley 2008, p. 7).[25] This bold use of the venue transcended Worthen's delineation of 'Globeness': it reconceptualized the space and function of the Globe, by, among other things, borrowing from cinema, medieval fable, and circus. The resulting heterotopia was even more disturbing than usual: the abject horror of the actors' performance of 'birds' and the rapacious greed that they represented encouraged the audience to flee the venue. The timing of this production significantly enhanced its narrative about materialism: most design decisions in Bailey's *Timon* would have been made before the onset of the Global Financial Crisis (GFC), heralded by the collapse of the Lehman Brothers' bank in September 2008, but this backdrop to a play about generosity versus greed gave it a topicality that augmented the visceral revulsion generated by the Hitchcockean birds.[26]

In Bailey's production, the heterotopia was shaped by a constructed space that was, like *Pericles*, determined by the circle of the venue itself: this circularity suggested a perfection that the abstracted space disrupted. The abstracted space was also circular, but in this case the circle formed an aviary, a net-covered (but somewhat permeable) home to abseiling actors playing scavenging birds and hovering above the audience's heads. Between the two spaces, the heterotopia of a disturbing, dubious space of escape developed to provide the alternative ordering to the play's world (and to the world beyond the Globe). *Timon* generated a heterotopia of escape, but, as the GFC loomed outside, escape became an increasingly doubtful proposition.[27]

Timon of Athens is one of Shakespeare's least-known plays, perhaps because it refrains from offering a redemptive message for its miserable main character or the audience.[27] In this 'secularized, anti-traditional morality play' (Lancashire 1970, p. 35), the wealthy Timon who showers his friends with money and gifts suddenly finds himself in financial difficulties. No friend is willing to help him, despite the lavish ways in which he assisted each in the past. Philanthropy turns to misanthropy. Broken by his experience and completely destitute, Timon must leave Athens to forage for food among the roots in the woods outside the city; Bailey's production signalled the turn of Fortune's wheel by Timon's costume change from a pristine tunic to only a loincloth that was soon covered in mud and filth.[28] His (mis)fortune to discover gold in the woods seals his fate as the Athenians flock to him again to mine the remnants of both riches and generosity. The play ends unhappily, leaving the audience not just contemplating humanity's worst aspects, but also lacking a role model among the dramatis personae to assist in how one should confront greed (see Cartelli 1991, p. 192). This section illustrates how Bailey's *Timon* reconfigured the Globe in especially bleak terms from which audiences were forced to discern their own alternate orderings.

In this production, the relationship between the 'wooden O' and Timon's seeking a place amid human greed was developed to an extraordinary degree: the designer, William Dudley, introduced a *mise-en-scène* that stretched well beyond the theatre's architectural shape.[29] The prolonged, three-dimensional demonstration of the perfect form – the circle – created the constructed space. *Timon's*

comprehensive circularity that formed the constructed space was fashioned through graphically realizing – even amplifying – the 'wooden O' metaphor that the venue itself contains and depicts. The rectangular edge of the Globe stage was rounded with the help of a small extension to the front of the stage, while a half-height, rounded (marble-look) backdrop positioned in front of the rear doors was joined to the stage edge to complete a circular effect around the entire stage. This backdrop served as the banqueting table for half the guests (among other functions). Just inside the rounded edge of the stage was a deep trough in which the remaining guests stood so that their heads were somewhat elevated above the heads of the groundlings but did not obscure anything else on stage.[30] The floor cloth and backdrop were integrated so that the floor looked as if it curved upwards. The steps into the pit curved around the stage-edge extension, emphasizing circularity. During the two feasts (one demonstrating generosity, the second a macabre parody of the first at which Timon curses his false friends), the set reinforced Timon's centrality: his friends' locations at different vertical levels surrounding him promoted this reading even further. Even when he lost his wealth, he occupied centre stage, a Vitruvian Man defining the circle. The stage's three-dimensional circle enhanced the world-as-stage metaphor and echoed the 'Totus Mundus' (All the World) theme selected for Shakespeare's Globe 2008 season. This augmented circular performance space also led the audience's eyes upwards to the heavens, a location that came to represent menace.

The abstracted space occupied a different interpretation and dimension of circularity. The roundness of the venue was stressed further by the net rigged over the Globe, forming a roof (albeit penetrable) over the open O: anchored behind the musicians' box, the net circled the top of the stage's two columns and extended to the top of the upper galleries, effectively covering the venue. Actors reclined and cavorted acrobatically atop this net as the audience gathered in the theatre before the play's start. The constructed space could not be sustained: the effects of the abstracted space (the Hitchcockean birds in their aviary) thwarted the circular perfection.[31] The remarkably convincing 'bird' actors seized the space such that audience members risked being surprised by their sudden, nightmarish appearance (and even pecking) from overhead.[32] The birds (supported by ropes and cables attached to the netting) depicting Timon's false friends,

swooped from all directions to take advantage of his largesse and, when there was no gold left, to torment him (see Figure 4.2). Clare Smout's review reinforces the all-encompassing use of the Globe's stage, beyond the birds' darting and plunging:

> [a]ll levels and areas of the building are exploited, and entrances and exits come from all angles: from above, through holes in the netting, either on bungee cords or more sedately via standard rope descents or down ladders attached to the pillars; from below, via the gulley at the front of the stage or up steps from the central trap [...]; from backstage, as normal, through the doors or discovery space, though with the added dramatic possibility of the wall to surmount; and through the audience. (2009, p. 86)

The birds' ability to exploit these locations sustained the spatial metaphor even after Timon abandoned Athens. Following the interval, a black floorcloth indicated the burnt-out wasteland that the filthy,

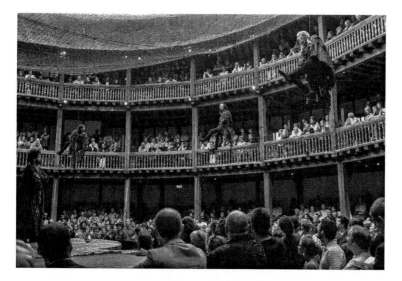

Figure 4.2 Three of Timon's erstwhile friends suspended from the nets that covered the opening in the Globe Theatre, 2008
Source: © PA Images, London.

weak Timon now occupied, crawling through this landscape search-
ing for food. Apemantus asked him, 'Where liest a-nights, Timon?'
His answer – 'Under that's above me' (4.3.294–295) – suggested
a crueller interpretation than usual, given the netting 'above': Timon
slept not just under the stars but also under the surveillance of the
birds waiting for his body to become their next food source.

The most confronting aspect of this staging was the heterotopic
space that was generated between the two poles of circular perfection
and avian nightmare: that of escape, but an escape that was only
partly executable. At the end of the first half of the production, the
birds attacked Timon and then swooped on the faithful Flavius, cov-
ering huge swathes of the stage in their flight. Then the birds shifted
direction to all but push the groundlings out of the theatre (for
interval), the same direction that they had pursued Timon moments
before. Ironically, the heterotopic 'escape' pointed to a location out-
side the three-dimensional circle and outside the theatre altogether.
Athenian greed implied that there was no room in either circle for
us. At the end of the play, the birds' assaults culminated in the image
of the black-clad Athenians feasting on Timon's body, leaving only
a bloodied loincloth. Ultimately, the audience left the theatre seek-
ing escape from these Athenians who, despite their macabre attempts
at harmony in the final scene, showed faces still covered in Timon's
blood. The space of the heterotopia was, then, situated outside the
theatre because the circularity of the venue took over so thoroughly
in creating both the constructed and abstracted spaces, leaving little
room within them for alternatives, alternatives that needed to be
sought beyond the venue. This disturbing heterotopia also provoked
panic since the birds were able to permeate the circle by 'flying' out
the top of the nets. That is, the audience's escape was frustrated by
the possibility of the birds' own travels into the audience's world:
images of carnivorous vultures were likely to persist with audiences
as they left the theatre to re-engage with the world beyond. Forced by
the birds to leave the theatre (physically manoeuvred by them, and
simultaneously seeking escape from them), the audience was faced
with being positioned *outside* the theatre to make sense of what tran-
spired *inside* its walls. When what took place inside failed to provide
answers, we had to look to assistance from the external geography.

What did this 'escape' look like, how was it rendered spatially, and
where did it lead us? The circularity that the production fostered to

this point was fractured, so escape needed to be sought elsewhere. It seemed that escape was an uncertain, individual space rather than a communal one. Most significantly, I saw *Timon* during the Global Financial Crisis on yet another day of financial insecurity as banks around the world failed, shares in stock exchanges plunged, and all manner of firms laid off staff or closed their doors altogether. The Globe is a very short distance directly across the Thames from London's traditional financial district in the city's square mile, while the towers of the second financial centre, Canary Wharf, the home of Lehman Brothers' bank and the focus of the GFC, are almost visible from the river outside the theatre and certainly close, as the crow flies, as it were. The echoes to the collapse of Timon's 'bank' suggested that the audience could witness similar extreme behaviour outside the theatre as they had within the walls: examples of corporate greed and the expectation of bailouts supplied headlines in all media. Given the Globe's proximity to the hub of the GFC and the play's theme of greed and bankruptcy, the relationship between the two could not be overlooked. While this heterotopic context was coincidental (staging *Timon* in this way obviously necessarily predating the crisis), it contributed to the ways in which the audience was able to interpret the events and to read the production through their own world(s).[33] By challenging all forms of the Globe's physical spatiality, this production questioned where the base level of earth and/or human decency lay.[34] The audience was forced to find a metaphoric (and sometimes literal) location in and around the metaphoric birds.

The alternate ordering that this heterotopia of escape provided (however awkward and unsatisfactory) was perhaps the best way to interpret *Timon*'s challenge: how one might address and accept the difficult questions of some of the foundational human failings regarding greed and inhumanity to others. The bloodied Athenians offered a model few would choose, but emulating Timon would be extremely demanding (and, as the production demonstrated, foolhardy). Timon deemed Apemantus' seeking the 'middle of humanity' to be inadequate (4.3.301) while Alcibiades' alternative of compromise was also labelled as flawed.[35] Yet it was difficult to avoid engagement with at least one of these parties because the production cleverly ensnared the audience into the pictorial and metaphorical world so that we could not help but be enmeshed in Athens: Timon first appeared walking through the pit, tossing gold (chocolate) coins to the groundlings and to audience

members in the lower galleries, so, in receiving Timon's generosity, the audience was implicated in Athenian behaviour. Ironically, the birds' darting and weaving ultimately represented the best course of action for the audience: their irregular paths suggested the prospect of accepting parts of one person's perspective and rejecting others rather than a complete identification with one or the other. This formed another version of Apemantus' suggestion to seek the 'middle of humanity' and not 'the extremity of both ends' (4.3.301–302). But associated with that philosophy must be the realization that such a response might leave blood on our faces as well. The transience of the sphere of perfection proposed a need to find a balance against greed and what it wrought, a balance that eluded Timon.[36]

Heterotopia does not need to be designed specifically with actual world referents in mind for it to work, as Bailey's *Timon* demonstrated: the accidental context of the GFC provided a useful way to read the play and the world in which it was performed. If I had seen this *Timon* before the GFC crisis, perhaps the medieval nature of the birds would have signalled other extra-theatrical contexts for generating meaning. It is, however, all-but-impossible to speculate (after the fact) on what precisely such meanings might have been, given the weight that the GFC interpretation came to create for me with its intensified connection to the world beyond the theatre. This bleak production transformed the Globe theatre into a vastly different space that opened the potential for further spatial play in future productions. Smout's review notes the 'unsettling' effect of the conclusion (2009, p. 89) as Dudley's design created a striking performing space that used the features of the early modern stage to successfully experiment with expanding the spatiality of the venue.

Both *Timon* and *Pericles* suggested circular forms of heterotopia in the Globe (not a surprise, given the theatre's shape) but diverged quite significantly in their spatial explorations as they attempted to reorder spatiality in the Globe. The circle – much less acrobatics – is not the only way to achieve heterotopia: the final production in this chapter shaped its aspirational heterotopia in what could be termed intangible spaces.

Holding Fire!

How easily can Shakespeare's Globe stage plays that are not early modern in topic or focus? The Globe presents not just the work

of Shakespeare and his contemporaries but also plays about topics related to the early modern era; sometimes these are commissioned (such as Brenton's *In Extremis*) and designed to fit a particular season's theme. More recently, it has programmed performance that branches out beyond a strict definition of the early modern era. The venue presents particular challenges to contemporary writers and their plays: the early modern architecture is difficult to ignore and the venue's historicity may appear to be insurmountable. Clearly an attempt to broaden the ways in which 'history' defines and shapes the Globe, these programming choices are very useful in testing what the venue can become and, for my purposes, whether such plays can generate heterotopic relationships with their communities. The final example, Jack Shepherd's 2007 *Holding Fire!*, largely worked in bringing to the Globe the very different historical moment of the Victorian Chartist movement.[37] *Holding Fire!* recounts the 1837–1839 struggles of the real-life Chartist leader, William Lovett, to gain equal opportunities and voting rights for all men regardless of class (although not women at this point), while it maps the story of the fictional Lizzie Bains onto Chartist history. Lizzie is given an opportunity to exchange the extreme poverty of London's slums for a position in service in the West Yorkshire mansion of Arthur Harrington, a fictional industrialist. In attempting to extricate herself from the lecherous clutches of the household's cook, Lizzie is implicated in his murder when her boyfriend, Will, also in service, kills him. The two flee but Will is eventually shot in an assault on protesting workers and later hanged for murder. *Holding Fire!* is a sprawling play, with eighteen actors playing over eighty named roles and additional parts, including several historical characters (such as Lovett, Friedrich Engels, and Ira Aldridge). A ballad underscored the production, the ballad singer acting as a narrator who set the location for the audience, a move that was helpful in a play that visited many locations in England and Wales. The numerous scenes, most very brief, included Chartist organization meetings, workers' marches with Chartists' banners, stage-coach crashes, the arrival of trains as regular transport, and a charming reprise of Queen Victoria and Prince Albert's courtship.

This section demonstrates the success of *Holding Fire!* in overcoming the early modern architecture and focus of Shakespeare's Globe and in producing a heterotopic relationship with both the Victorian and the contemporary worlds outside the theatre. The two

spaces between which the heterotopia was located in *Holding Fire!* were defined by first, the theatre itself, and second, director Mark Rosenblatt's 're-use' of it to suit the Victorian context. The 'constructed space', the assumed knowledge of how the Globe theatre space operated for Shakespeare productions, opposed the 'abstracted space', which was shaped by an uncertainty of where each new scene took place, what the audience's (new) role was, and how to position oneself there. Between these poles lay the heterotopia of the Chartists' dream: a place of equal rights for all. This heterotopia generated an alternate ordering against Victorian London *and* the wider contemporary community outside the venue, where deprivation and inequity remain, even if child labour laws around the world have at least improved the plight of many children.

In the establishment of the constructed space, the production's quick pace reflected the early modern tradition of easily changed scenes while the Globe's thrust stage was transformed somewhat by large, squared-off timber double doors that covered the back of the stage, a large staircase extending from just inside the stage right column up to the stage right musicians' gallery, rough wooden benches fixed around the columns, and a wide stairway from the front edge of the stage that connected the stage with the pit. It was astonishing how quickly *Holding Fire!* could distance itself physically from the venue's Renaissance associations. The straw in the yard, the barrows, the children selling violets, and the nineteenth-century costumes established (and sustained) a much later era. There were very few other obvious changes to the stage. By and large, reviews of *Holding Fire!* acknowledged favourably the work of Rosenblatt and the designer, Janet Bird: while some critics found that the play dragged, the weight of history inevitably working against it, most commended its remaking of Shakespeare's Globe such that the incongruity of a Victorian play on the Globe stage quickly became immaterial.[38] The first scene evoked the feel of a tavern in a poorer part of London in the very early years of Victoria's reign, with a refectory-style table next to barrels set between the columns which assisted in, at least at the beginning, making the stage feel somewhat smaller for interior scenes.

If some interior scenes appeared intimate, the production also deployed the pit especially thoroughly in its 'updating' of the Globe from early modern to Victorian. Robert Shore's review explains the

play's main feat in situating the 'involving spectacle' of this action in the Globe:

> the action flows dynamically across the stage and out into the auditorium. Wherever you position yourself, at some point in the evening, you're likely to end up seated among delegates to the People's Parliament or standing at the foot of a gallows, a body swinging in the wind above your head. (2007, p. 23)

Frequent performance in the Globe's pit in itself is hardly original, but its far more extensive use in *Holding Fire!* was remarkable, from the beginning of the play with the staging of a lengthy Punch and Judy show (not in the script) to a bare-knuckle fight (fought to the death by desperately poor men). Additional fights and altercations took place in the pit, regularly moving the action beyond the stage into the realm of the audience. Staging so much action in the pit brought the play's subject matter closer – physically – to the audience. In fact, Colin Thaxter's review comments that the pit was so well used that the stage at many times appeared to be empty (2007, p. 18).

When the stage was occupied, its focus was overwhelmingly on the world of servants, workers, and the poor, especially the difficult working conditions of labourers, including children. In one scene, the stage's trap door led to the industrial hell that children endured working in Harrington's mill to clean his looms. Harrington refused to assist one ill child worker, commenting that the boy would be dead before long anyway; the boy and his friends should 'count themselves lucky' for 'sweat[ing] off their perdition before Judgement Day' (Shepherd 2008, p. 40).[39] Harrington's confronting and cavalier approach to human life aside, *Holding Fire!* presented an effective modernizing of this landmark venue in its remarkable depiction of a constructed space.

One exception to this use of the trap was Harrington's West Yorkshire house, which expressed an expanse of space that contrasted the slums. The central doors leading to the backstage became the inside of the grand entrance; the upper gallery became a grand hall, while the trap led 'downstairs' to the kitchen (although it marked a place that would became a hell for Lizzie). When Mrs Harrington returned from London with Lizzie, the servants all stood in a line at the bottom of the stairs (on the main part of the stage) to greet her. The

expansive space available to Mrs Harrington contrasted the tiny single room allotted to Lizzie's family in the slum or the debtors' prison cell. The 'space' of Mrs Harrington's house continued to expand: the discovery space behind the central doors suggested, through clever lighting rather than props, yet more depth in large entertaining and receiving rooms. Finally, the audience glimpsed a neo-classical wood finish in parts of Harrington Hall that contrasted with the industrial look of the servants' halls, factories, taverns, and almost all other locations in this play. Otherwise, the production's skillful use of space focused on the constraints (spatial and otherwise) of the poor.

In contrast to the audience's assumed understanding of the use of the Globe, the abstracted space marked the degree to which the production played with the audience interaction, a feature that was essential to its success. The frequency with which the audience's geographical, political, and emotional positions were changed generated some (initial) confusion for the audience. Through constantly relocating the action, the production shifted the audience's understanding of our positions and functions as we were linked with unfortunate workers across the country. Most reviews draw attention to how the audience was implicated in the stage's redesign (see Hassell; Logan; Millard; 'A Global Success', all 2007). Taylor reports that '[w]ith delegates positioned in every part of the auditorium, theatre is thrillingly transformed into a "People's Parliament" in the scene where Shepherd dramatizes the acrimonious [workers'] convention in Birmingham', such that the play was always 'vibrantly alive' (2007a). The audience was mobilized to 'perform' with/as fellow working people, sometimes sympathetic to the Chartist cause and sometimes not. Peter Brown explains that '[r]anging over almost every corner of the Globe's cavernous space, the actors pop up in the yard, in the seating bays and above and on the stage itself. It's almost an assault on all fronts, with the audience being engaged in debate and even harangued by the actors' (2007). Unlike most audience interaction for early modern productions (which usually limit interplay to audience members in the pit), *Holding Fire!* also implicated audiences in the upper galleries in direct contact with actors and the narrative. Rosie Millard reports that the galleries were 'constantly invaded by gentlemen politicians' (2007). The play contrasted classes and challenged the Chartists' positions by means of this substantial use of the audience. One of the many devices the production used

included actors planted in the audience during speeches to interject in such a way that all audience members were subtly encouraged to support the movement's aims and to reject the upper classes' abrogation of responsibility for the welfare of their workers.

The 'location' of most stability amid this combination of abstract and concrete spaces tied directly into the production's heterotopia: this technique encouraged audiences to explore and embrace the heterotopic location of the Chartists' dream of equality. In *Holding Fire!* it was notable by its absence. The audience saw where it *should* be yet the operation of the society beyond the theatre prevented it from occurring. This was more than the constraints of historicity or what Worthen's 'Globeness' might present; this was the failure to ensure that all citizens are treated equally. Instead, too many scenes of extreme inequality and exploitation obscured a concrete loca-tion of fairness, reinforcing the disturbing nature of this heterotopic relationship. Lizzie escaped to Australia but her sister sought survival in prostitution, while Aldridge, the nineteenth-century African American Shakespearean actor visiting England at the time, noted that the British poor – 'citizens of hell' (p. 28) – were worse off than slaves in the US. Further, the scenes of the government's resistance to the Chartists' demands were particularly chilling, almost guarantee-ing that the audience would seek the heterotopic space of equality. On two occasions, armed soldiers brought a very large cannon onto stage, aimed at the audience/protesters. It was easy to imagine the damage it would do, and the soldiers appeared to be quite willing to fire it. Towards the end of the play, they did fire, leaving many dead and maimed bodies littering the stage: the victims in this event died fighting for rights that the audience would have taken for granted. The Chartists' attempts to legislate change in the late 1830s were disastrous, although in the play's epilogue, William Lovett explained that thirty years later, Prime Minister Disraeli's Bill of Reforms enforced many Chartist demands. Nevertheless, audiences would have recognized that they could observe many examples of inequal-ity in the city outside Shakespeare's Globe Theatre. The production was designed to appeal to workers whose conditions are what they are today because of the Chartists' efforts then. This relatively recent history of workers' rights connected this space of absence (even in, for this play, an incongruous venue) much more closely with an audience than the more traditional spatial uses of the Globe. This

interpretation may have also occurred if the play had been per-
formed at another theatre in London (although it would no doubt
have been staged differently in another venue), but its location at
the Globe accentuated the potential of the communalizing venue.
Further, the placement of an unexpected historical moment on the
Globe stage provided the opportunity to rethink the role of history
itself in theatre and in our interpretations of it. Inevitably, this play
came to 'mean' differently at the Globe than it would have if viewed
elsewhere.

Holding Fire! connected to the community outside the theatre in
several ways through the final scene that made direct references
to the Victorian world beyond itself, by means of remnants of the
Victorian era in contemporary London, and its indictment of work-
ers' rights in the twenty-first century. In this last scene, four separate
locations took up space on the stage simultaneously, including:
Marshalsea Debtors' prison where Lizzie's parents came to reside; the
prison where Will was on death row and where he was hanged; the
establishment characters in much finer surroundings, entertaining
Ira Aldridge; and the sentencing to prison of Zephaniah Williams,
one of the Chartist leaders. This scene merged the major ways in
which heterotopia communicated with the world outside.[40] The
heterotopic zone of the Chartists' dream of equality produced an
alternate ordering against the 'reality' of the Victorian world, but it
also provided a parallel with the twenty-first-century world where
the dream has yet to become reality in many quarters.

For the first of three connections with the world beyond the stage,
the episodic structure and the detailed picture of England and its
workers directly recalled the world that Charles Dickens described
in his novels (and which also contributed to the displacement of
the Shakespearean overtones of the venue). The incarceration of
the Bainses in Marshalsea Debtors' prison, where Dickens himself
resided from the age of 12, is key here. The Marshalsea, a prison
since the fourteenth century, was best known as a debtors' prison
in the nineteenth century, until its closure in 1842. It was located
only a few hundred metres from Shakespeare's Globe, and several
portions of its walls remain visible today as a monument of sorts.
The prison formed the basis of Dickens's novel, *Little Dorrit*, and it
makes appearances in other novels. Like the use of Gower to make
contemporary observations in *Pericles*, the Marshalsea speaks to the

historical moment as well as a contemporary one. The actual prox-
imity of the prison to the theatre made the Victorian era appear to
be even closer than it is. Dickens's world is reinforced architecturally
just outside the theatre, since Georgian and Victorian architecture
continues to anchor the landscape of Southwark, even though con-
temporary buildings also push in.[41] The deprivations that Dickens
documented would have coincided with the aims of the Chartists
and it is likely that the audience would have been aware of that, at
least in vague terms.

Secondly, almost in an attempt not to completely sever the play from
its Shakespearean venue, this concluding scene referenced Aldridge,
the great nineteenth-century African actor of Shakespeare, recalling
a time when such an occupation for someone of African heritage
defied the odds. It is not a novelty now for African actors to perform
at Shakespeare's Globe (as my analysis of *Pericles* reinforces), but even
opportunities for African actors require comparable improvement
both on- and off-stage, as it were, like the Chartists' dream.

Third and finally, this concluding scene from *Holding Fire!* reprised
the need for equality for all. Chartist claims for equal rights were
underpinned by the unjust hanging of Will, the most prominent
depiction of the absence of heterotopia. Will's death was the most
realistic hanging I have seen staged. That it was staged in the pit,
not on stage (where the script suggested that it be), was even more
chilling because it brought the horror of Will's death that much
closer to the audience standing around the scaffold, about half way
between the stage and the entrance to the theatre. This stand-alone,
removable platform was raised a bit higher than the stage. Rather
than disappearing into a trap, Will's body hung in full view, making
a few jerky movements, before simply swinging for what seemed like
a very long time. It was a silent and lengthy scene. Lizzie Loveridge's
review singles out this scene and its effect on the audience: 'I heard
cries from the crowd of "Horrible!" as a man swung on the gibbet.
Have we at last found a scene that can shock the Globe audience
rather than making them laugh?' (2007). The hangman cut down
Will's body and carried him off over his shoulder as the actors who
watched the spectacle with the audience dispersed. This play about
revolution did not incite the audience to revolt: its description of past
revolutions did, however, remind audiences that despite the efforts
of the Chartists, there is a long way yet to travel to achieve equal

rights, even if we may wish to think the actual world is much more equitable than the industrial and labour record of the Victorian era. Sam Marlowe makes the point that *Holding Fire!* speaks to 'contemporary concerns about the emergence of a 21st-century underclass,' thus becoming 'fiercely relevant' (2007). The alternate ordering in this production is the potential for this relevance to take stronger hold outside the theatre. Through *Holding Fire!* our assumption that labour laws and human rights are universally fair were questioned and significantly challenged.[42] Mark Rosenblatt downplayed the early modern feel of Shakespeare's Globe theatre to create a very different atmosphere that assisted audiences in engaging with reading heterotopic references between the Chartist movement, Victorian London, and the London to which they would return once the play concluded. Lovett's speech in the play's epilogue suggested that the change that he imagined has yet to completely take effect:

> I can see a day coming when the working population of this country will no longer be held down in the shadow of ignorance, but released into the sunshine of a universal enlightenment. And on that day, our Parliament will be made up of men of all classes – *good* men – who will begin to mitigate against the evils of property and oppression. And devise the means by which prosperity and happiness shall at last gladden the face of our fertile land! (p. 114; original emphasis)

Holding Fire! overcame the potential limitations of the early modern atmosphere and recreated in the Globe a heterotopic moment that connected audiences to both the production and to their worlds outside the theatre. It did so by locating the Chartists' dream of a better and safer world in and around each audience member. There is, perhaps, an increased potential for heterotopic communication between the Victorian spaces enacted through *Holding Fire!* and the London outside the theatre, by virtue of the nineteenth century being just that much more recent than the sixteenth or seventeenth centuries. Staging *Holding Fire!* at Shakespeare's Globe illustrated the ways in which seeing versions of our cultures performed in front of us actually matters.

One might speculate about whether these plays would produce heterotopias if they were performed in other venues. A venue and

its context(s) contribute considerably to the generation of heteroto-
pia so this is a difficult matter to determine for certain. *Pericles* and
Holding Fire! worked in the way I have discussed here *because* they
were performed at Shakespeare's Globe. *Timon* presents another
option, partly because the narrative of the play lends itself to the
development of a heterotopia (as the production at the National
Theatre in 2012 also demonstrated). The production of *Timon* at the
Globe nevertheless also developed a venue-specific interpretation of
the ideas therein. More important is the manner in which each of
these productions identified ways in which the well-known venue
could be re-thought and re-used to good effect. Their examinations
of the venue alternately emphasized, de-emphasized, and even
skirted around its historicity and iconicity. These plays did not seek
to transcend the Globe, nor am I proposing that productions aim for
that. Rather, they provided ways of diversifying how we think of the
Globe and the performance that takes place there in the next phase
of its life.

That Shakespeare's Globe can stage productions that surpass an
assumed early modern hold suggests that other theatre companies
and/or complexes that are designed to serve a national and/or monu-
mental function can also seek a heterotopic relationship beyond the
utopian or representational one that such examples of dominant
architecture and/or ideology sometimes generate. Heterotopia can,
then, turn what might otherwise be seen as a conventional, predict-
able venue into the 'radical theater space' that Marshall describes
(2000, p. 353). For the Globe stage to be a proving ground for con-
temporary interpretations, some (temporary) alterations or modifica-
tions to the venue and to the staging therein may be required, as the
productions discussed here illustrate, but they also outline the aes-
thetic, historical, and intellectual value in pursuing different ways of
inhabiting this emblematic theatre. These heterotopic productions at
the Globe recognized the significant power of history and its poten-
tial for social change but also that history needs to be understood
in the context of the present and the future. This exploration of the
heterotopic potential of the Globe affords a lens through which to
rethink the potential impact of the venue and both historical and
contemporary performances there. These productions prompted
audiences to think spatially about interpreting cultures while con-
testing the boundaries that shape those cultures. Each began with

the physical and metaphysical constraints of the venue (refusing to accept them as constraints); each produced what might at first appear to be a somewhat intangible heterotopia that nevertheless could be 'placed' both on stage and, through the alternate ordering that heterotopia produces, beyond the bounds of the venue.

The next chapter moves from historicity to much more recent theatrical innovations. It pursues performance that incorporates a high degree of technical modification, in the form of multimediality, a factor that extends and reconfigures spatiality in yet other directions.

5
Heterotopia and Multimedia

Since about the 1990s, performance has increasingly deployed a range of different technologies to generate new theatrical (and non-theatrical) effects: live video, digitized presences, cyborg actors, motion capture, among many other possibilities.[1] While some of these technologies are costly to mix effectively with the more conventional experience of live performance, the ready availability of many multimedia practices has made it achievable for even low-budget performances to incorporate aspects of new media into 'old' theatre. The ubiquity of screen technology has already altered the way we think about space such that in Simon Phillips's 2013 production of Verdi's opera, *Otello*, at the Lyric Theatre in Brisbane, Otello looked into a regular computer screen to 'see' what Iago wanted him to see on what the audience assumed was a live surveillance camera (his unfaithful wife in conversation with Cassio). This scene is usually staged in the opera version with Iago and Otello looking off-stage into the distance or with the manufacturing of a glimpse of the two watched characters that the audience can also see, depending on the complexity of the set. With Phillips's production on Dale Ferguson's set of a military ship, we could see nothing except the act of looking since we were not even privy to what was *on* the screen, only seeing the back of the monitor. But our understanding of Otello gazing into another space was rendered 'real' for us (even if what he was 'seeing' was faked by Iago).

The presence of new media alters how we understand space in theatre and performance, and this is the focus of Chapter 5. Before exploring what space might mean in new media, I return to the fundamental

function of space in traditional theatre. Arnold Aronson argues for the significance of the stage itself in representing space and place far beyond the particular physical dimensions that define or frame it:

> [e]ven the tiniest stages – the mountebank's trestle of the Middle Ages, for instance, or the minuscule platform of Caffe Cino, the first off-off Broadway theatre – are boundless; like Hamlet's nut-shell, they contain 'infinite space'. To look into such an expanse is potentially frightening, especially if, as Nietzsche suggests, it looks back into you. And the stage most definitely returns the gaze. We are spatial creatures; we respond instinctively to space. (2005, p. 1)

Aronson's summation provides a useful starting point for a broader interpretation of space in the forms of performance that exist today. How might the gaze be returned in contemporary performance where its spatial reach is multiplied and/or fragmented with the introduction of multimedia technologies, specifically video and vir-tual reality? How have recent technological developments changed and enhanced the potential for the 'infinite space' of performance? This chapter investigates technology's extension of spatiality in performance through a heterotopic analysis, which provides a con-ceptual and literal way of isolating spaces of hope and possibility; heterotopia is just as identifiable in multimedia performance as in conventional theatre. In fact Steve Dixon maintains that while the vision of postmodernism looks backwards, performance driven by technology is world-building; this forward-looking quality also describes heterotopia. That is, 'digital performance [is] characterized by the very forward impulsion postmodernism lacks: digital perfor-mance is an avant-garde that propels itself toward the future; it seeks the "new worlds" that postmodernism eschews' (2007, p. 654).[2] I demonstrate how heterotopia might operate in performance where space cannot be accommodated 'just' within conventional under-standings of theatre and/or standard interpretations of traditional venues; in the process, I extend the understanding of heterotopia that I have developed and illustrate how it accounts for the added spatiality of multimedia in performance.

I have isolated three examples of performance or means to theatrical production that present heterotopic interpretations and challenge our perceptions of space: Complicite's *A Disappearing Number*, a theatre

venue-based production that is highly mediated in form and content; Caryl Churchill's *Seven Jewish Children: A Play for Gaza*, which has been produced for the internet in a combined performance/video format to increase its circulation; and Ortelia's immersive virtual theatre environments. Each breaks the frame of the proscenium arch – and of theatre more generally – not to compromise the genre but to enhance the performance experience by extending its spatiality. Each thus connects more directly with its cultural context, and thereby broadens its potential for communicating to its audience. I chose these three because they take the potential for heterotopic analysis – and, of course, the investigation of space – in very different directions to articulate the myriad ways in which heterotopia can operate in theatre and performance. By studying different versions of 'multimedia performance', I can demonstrate not only the diversity of the field, but also how a spatial lens contributes to our understanding of what multimedia can achieve theatrically, and, with Churchill's piece, politically.

As I noted in Chapter 4, the development of a sophisticated understanding of multiple spaces operating on stage at the same time began in the early modern era. In a postdramatic world, technology has enabled a significantly expanded spatial arena. This magnified realm also affects the conceptual power of heterotopia because it rethinks the nature and number of 'spaces' to which theatre has access. I isolate the spatial zones of a performance – however it may be defined, through live action, recorded video, virtual space, or digital activity – that may relate to the world outside the performance.

As with earlier chapters, I explore heterotopia's alternate ordering of the actual world: it engages with other ways of thinking and other ways of structuring spatiality on stage and, by implication, in the world outside a theatre venue. I first identify the two contrasting components of the utopics that are formed, for Marin, by two locations that I term 'constructed space' and 'abstracted space'. Between these two spaces may be the space and scope for a heterotopia. Once we see how these alternate orderings might work on stage, it is possible to conceive of their effects 'taking place' off stage as well. Analysing performance in this chapter is slightly more complex than in previous chapters because the spaces can be multiplied, differently configured, and harder to isolate. They may be of quite a different 'dimension'. The process is, nevertheless, much the same.

The field of multimedia performance is growing exponentially with each new technological advance and the appeal and availability of previous ones. It is impossible to cover all aspects or even to summarize them, and much has been written about the topic by others. In the remainder of this chapter's introduction, I outline the parameters for my analyses. I do not have the space to delve into the larger debates in any detail, but I refer readers to those who explore them more fully.[3] I raise the issue of terminology and the constant change that characterizes this field, as each subsequent technological development arrives. I provide examples that help situate the expanded types of space that emerge through performance, as well as signalling the ways in which performance itself transforms in the process. Finally, I introduce some of the particularities of space in multimedia performance, including the fundamental relationship between 'absence' and 'presence', which operate somewhat differently here than they have in earlier chapters.

Terminology in this field, like the technology itself, continues to be fluid. Freda Chapple and Chiel Kattenbelt popularized the term, intermediality (2006, p. 22), to cover postdramatic performance that incorporates multiple forms of media, so as to avoid privileging one medium over another. This term has attracted some criticism (even in Kattenbelt's own subsequent work; see Bay-Cheng, Kattenbelt, Lavender, and Nelson 2010), as have other terms such as multimedia performance, new media performance, digital performance, and virtual performance. Peter Eckersall, Helena Grehan, and Ed Scheer prefer 'new media dramaturgy', which accounts for performance's interactive turn as well as its deployment of a combination of possible media as part of its expression. New media dramaturgy, they argue, 'maps in art the movement of social space into mediated environments, but it also engages in a complex dramaturgy of response' (2014, p. 379). In this chapter, I use multimedia performance as an umbrella term, even if it is not entirely satisfactory, but I take account of the context of new media dramaturgy. Whatever terms one chooses, Randall Packer and Ken Jordan note that '[p]erhaps multimedia's most consistent quality will be its relentlessly changing nature' (2002, p. xxxviii).

While readers will be familiar with performance that incorporates multimedia, I provide several examples of the different ways in which such work broadens the spatial reach of creative expression.

These brief illustrations also suggest how the use of multimedia extends what 'performance' might be. The first is Katie Mitchell's *The Waves*, an adaptation of Virginia Woolf's novel of the same name, performed at London's National Theatre in 2006–2007. *The Waves* extensively incorporated pre-recorded video combined with real-time video and live action (not to mention other techniques such as the depiction on stage of the sound effects used to produce radio drama). In addition to staging the interiority of the characters' minds that is more typical of the modernist novel than most theatre, it demonstrated the means of production (for instance, the process of making recorded sound and the presence on stage of hand-held cameras and/or camera operators who appeared in the frame of performance as part of the production). *The Waves* extended the time and space of the theatre stage to accommodate the broad temporal, geographical, and psychological scope of the world of the novel (its layers, locations, and dimensions), Woolf's characters, the 'space' of its adaptation to the stage, and the combination of all these spaces, often operating simultaneously. The numerous spaces that contribute to Hamlet's nutshell of theatre's 'infinite space' were particularly divergent in this production and, for me, resonated with the possibilities of a wider spatial view. While many spaces were not typically 'theatrical' in form, they built on the potentiality of a theatrical space that took on multiple dimensions.

A second adaptation that takes spatiality in a different direction is Rupert Goold and Ben Power's 2008 production of *Six Characters in Search of an Author* at London's Gielgud Theatre. Luigi Pirandello's characters intruded into a producer's studio as she was completing a documentary about a gravely ill fourteen-year-old who elected to end his life through assisted suicide. As Pirandello's narrative played out, a child injected himself with a lethally-dosed syringe. Only the producer seemed to see this and rushed to find assistance for the dying child. She ran through the (off-stage) backstage areas (recorded on what appeared to be a live feed that the audience watched) and then through what audiences would have recognized as the Gielgud Theatre foyer. She then sought assistance further afield, going next door to the neighbouring Queen's Theatre on Shaftesbury Avenue where *Les Misérables* was playing. At the point that the producer entered the backstage space of another production, the audience understood for certain that the video feed was not live.[4] These

expansions of space encourage both a reconsideration of space and an examination of the ways in which multimedia can communicate spatially in performance, as this chapter's first two case studies illustrate.

A briefer example that encompasses an even wider spatiality of performance is virtual performance: that which takes place in a computer-generated 'world' rather than a physical location in the 'real' world that conjures an imaginary location. More than simply 'imaginary', the spaces of virtual performance are 'other-worldly' (since they do not take place in actual world perceptions of time and space), but their structures intersect with what is known outside the virtual realm as the 'real world'. The continued popularity of the performance of the virtual, whether delivered via mobile phone or conducted in a studio, rethinks existing locations of the 'here' and 'now' (see, for instance, Blast Theory's *Rider Spoke* and Jeffrey Shaw and David Pledger's *Eavesdrop*).[5] The identification and exploration of the various spatial dimensions that multimedia performance constructs should be an essential part of contemporary performance analysis. Further, the investigation of spatiality in virtual performance intersects with gaming technologies and culture, as my final case study illuminates.

While some may wish to resist this trend of multiplying spaces and spatiality, Shannon Jackson reminds 'antitechnologists' of 'theatre's long history of technological incorporation and cross-medium redefinition. Theatre and technology have always been in a constant state of mutual transformation' (2011, p. 154). The presence of myriad technological innovations inevitably means that such 'new' technologies will be incorporated into theatre and performance, since theatre has always absorbed cultural changes – both technological and ideological. The potential for witnessing the generation of multiple locations that converge in a performance venue (or on one's computer screen) encourages us to conceive of space, time, and our participation differently; this alternative interpretation of spatiality can even affect our understanding of our own existence.

Explorations of multimedia performance frequently favour the evaluation of time and the use of bodies over space.[6] While Alice Rayner argues that cyberspace privileges the temporal over the spatial (2002, pp. 350–1), the latter should not be overlooked. Jackson suggests that in the relationship between the spatiality of

multimedia performance and 'traditional' performance lies a particular quality that can shift our interpretation of space and performance fundamentally: '[i]f the feeling of volitional mobility characterizes the digital world, then theatre's anachronistic territoriality might be the most interesting thing about the medium right now' (2011, p. 180). I find the opportunity for investigating spatiality in more detail to be located in that tension between the comparative 'stability' of space in, for instance, text-based, scripted performance, versus the mobility of space in multimedia. The aim of this chapter, then, is to resituate space in multimedia explorations and analyses, extending our understanding of multimedia performance *and* of space in the theatre.

Now that this introduction has gestured towards terminology and signalled how multimedia performance extends the spatiality of performance, I turn to the fundamental contribution that the chapter makes to the analysis of multimedia performance and to the development of an understanding of heterotopia: an articulation of multimedia's capacity to stage 'absence'. To argue this, I must first trace some of the limited explanations of multimedia spatiality that have been advanced. Rosemary Klich notes that 'interactive multimedia performance' engenders 'a spatial extension of the temporary present, in which causal logic and temporal progression are dismissed' (2013, p. 428).[7] Like Klich, Birgit Wiens explores the varied real, metaphoric, and even 'indistinct' spaces that exist in intermedial performance, whether the 'virtual representations of space that show up on the surfaces of screens and other interface screens' or 'the spaces of electronic communication and the Internet' (2010, p. 95). She argues that in such spaces, the task is 'to understand the interpenetration of differently constructed spaces and the concepts engaged within them: connectivity; presence, telepresence and absence; perception and teleperception; and new performance modalities' (2010, p. 96). Frequently, the spaces that multimedia performance stages deliberately blur the boundaries between 'here' and 'there', as well as between live and recorded. These performances might activate space by understanding 'here' and 'there' to be identical locations, or perfectly overlapping, sometimes simultaneously, or even existing in different dimensions that Wiens describes as 'transgress[ing] local contexts and environments and playfully connect[ing] to telematic and other remote spaces' (2010, p. 94). However they are figured,

they tend to help reposition traditional binaries about space and spectacularity beyond simple 'presence' versus 'absence', the definitions of which have exercised many (see Hayles 2010, p. 285). Kurt Vanhoutte's comprehensive interpretation is useful here:

> [t]o understand our digital era as a dialectic between the virtual and the real would slightly miss the point. We no longer find ourselves dealing with the real/virtual, embodied/disembodied dichotomy. [...] The individual at the beginning of the 21st century is instead perpetually undulatory – in orbit – through a continuous network of embodied states of presence that are increasingly defined according to participation and agency, rather than physically co-present. (2010, pp. 45–6)

The previous chapters have demonstrated that heterotopia is capable of underscoring the 'presence' of matters or concepts or places that have, for many reasons, been rendered absent. The capacity to stage 'absence' in a material way is even more relevant in multimedia performance, which can change the nature of what might be present and what might be absent, even simultaneously. Multimedia performance affords numerous methods for staging 'absence' in material, binary-challenging ways, even oscillating between presence and absence.

Given that the still-nascent sub-genre of multimedia performance is so broad, I have selected case studies that emerge from different performative aspects, to demonstrate heterotopia's potential through a spectrum of performances. The first, *A Disappearing Number*, takes place in a conventional theatre venue, although it deploys a range of media and attempts to breach the boundaries of the form. Its heterotopia emerges through its multimedic effects, which take audiences 'beyond' the frame of the proscenium arch, as I discuss below. *Seven Jewish Children* had its genesis in conventional theatre, then moved to video and has since migrated to YouTube; the blend of theatre and multimedia in this production helps generate a constructed space that challenges both genre and politics. In the third, Ortelia's virtual worlds, the entire project is a multimedia experience. I invite readers to consider how these ideas – and the tensions that they uncover – might play out in other forms of multimedia performance in the creation of different (new, multiplied, fragmented) spatial dimensions

for performance. This chapter pursues multimedia performance to enhance our understanding of its spatial aspects, when most critical accounts favour corporeality. Further, these performances broaden the reach of heterotopia, demonstrating its value in a wide range of performance models.

A Disappearing Number

Complicite's *A Disappearing Number* employed numerous multimedia devices to break through the literal and figurative limitations of the proscenium arch frame that appeared to bind it. This metatheatrical production about mathematics and theatre demonstrated how both numbers and performance illustrate ways of understanding the world. *A Disappearing Number* expressed this not only through its narrative exploration of mathematics but also its staging of numbers, patterns, and space. From its complexity emerged beautiful and provocative patterns, and this is partly the production's point. To summarize my argument, the 'constructed space' is formed by an image of a Hindu temple – a *goporam* – that contains what might be termed a completeness of everything; a multifaceted 'abstracted space' is generated by mathematics. The heterotopia is the creation on stage of the patterns that mathematics and performance shape, patterns of an alternate ordering of the world, particularly an alternate means to understand it. It might be convenient to interpret *A Disappearing Number* as an example of a traditional understanding of theatre's capacity to present 'illusion versus reality' but that would miss the richness of the narrative, the multimedia, and the effect of Complicite's collective work. This production provides a link between the examples in the previous chapters and the even more innovative multimedia projects in the second and third case studies. It reinforces and extends theatre's already long-established experiment with space through the carefully patterned use of multimedia.

The narrative merged two locations – London in the 'present' with Cambridge and India of almost one hundred years ago – through two pairs of characters. The first pair charts the true story of how a mathematics genius, Srinivasa Ramanujan, travelled from Madras to Cambridge just before World War I to work with the mathematician, G.H. Hardy. The second records the fictional romance between Ruth Minnen, a Brunel University mathematics lecturer with a research

interest in Ramanujan, and Al Cooper, an American futures trader. Ramanujan suffered in England from the cold, the inability to find sufficient vegetarian food, and overwork. He returned to India to die of tuberculosis at age thirty-two. The two worlds are linked by Ruth's enthusiasm for her profession: she visited India to study Ramanujan's work in further detail.[8] While there, she suffered a brain aneurysm and died. Al subsequently visited India to trace her steps; he met Aninda Rao who also knew Ramanujan's work, who was returning to India with his aunt's ashes, and who narrated the beginning of the performance. None of the action was relayed chronologically; rather, *A Disappearing Number* capitalized on the complex mathematical patterns it discussed to communicate the narrative, its affect, and its point. It used mathematics and multimedia to discern patterns and relationships between the characters and their stories, as I explain below. The two-hour performance received resoundingly positive reviews, no doubt as a result of the engaging theatricality and the expression – in an easily understood manner – of complex concepts that matter to our lives.

In the early stages of the performance, we were introduced to what I interpret to be the constructed space, an image of the goporam, the large, ornate tower at the entrance to the temple in Madras near Ramanujan's house. It was projected onto the back wall, looming over Aninda and Al. Aninda explained that '[i]n one structure [the temple], we can see all reality, the inter-dependence of everything' (Complicite 2008, p. 25),[9] just as the play presented for us a heavily interdependent network of patterns and connections. From what might have at first appeared to be a chaotic jumble of images and ideas, the most beautiful patterns of numerical sequences (and their implications) were demonstrated, projected, and performed in multiple ways.[10] *A Disappearing Number* enacted our search for the understanding of meaning itself, whether past, present, future, or even beyond conventional dimensions.[11] This meaning was, at least metaphorically, encapsulated by the image of the space and place of the goporam. It mattered little that the goporam could not physically contain the infinite: it still encompassed the world and the connections of its elements. The image of the goporam also provided an enticing definition of theatre's ability to metaphorically take on the potential of all that the world contains, a variant of Aronson's interpretation of Hamlet's nutshell of 'infinite space' with

which I introduced this chapter. Yet as Aninda pointed out, theatre is a place of illusion. The production itself came to resemble the goporam, but only once the contribution of the abstracted space and the heterotopia were added. In most productions that I have described in this study, the constructed space is compromised somehow by the abstracted space, but in *A Disappearing Number*, the abstracted space enhanced the constructed space; it was another world set aside from it, but nevertheless paradoxically contained in it. This example clarifies that the constructed and abstracted spaces need to be read in relation to each other and that the heterotopia cannot emerge from outside that relationship.

The abstracted space is that of mathematics, a world that is both functional and aesthetic.[12] While non-mathematicians might see this as an unorthodox definition of 'space' or 'place', mathematicians understand their discipline as taking physical 'shape'. Amir Alexander explains that about the 1830s, the discipline of mathematics came to be seen as an 'ideal [...] other world [...] that is more beautiful than our world' (2011). He notes Hardy's role in shaping 'an alternative universe' that is 'completely logical, completely rational, completely perfect' (2011). Mathematics is a competing 'world' that is in dialogue with the actual world. Like the multimedia in this production, it came to exceed the illusion that the proscenium arch frame attempted to impose on it (see Figure 5.1). This world in itself is not unsettling per se (after all, both Hardy and Alexander speak of it as beautiful) but it is one that many people resist, something that *A Disappearing Number* attempts to change.

Mathematics (as a concept and as a different 'world') was introduced to audiences cleverly. First, Aninda Rao (in his role as a narrator) interrupted Ruth's lecture (while she continued, oblivious) to remind the audience of the illusion of theatre: he poked his fingers through Ruth's glasses to show that they contained no glass. While the lecture was, then, demonstrated to be a form of 'theatre' or illusion, not 'reality', Aninda intoned to the audience that 'the mathematics is real. It's terrifying, but it's real. [...] In fact we could say that this is the only real thing here. [...] Everything is fake BUT the mathematics' (pp. 23–4; original emphasis). Further, while Ruth tried to get her class (the audience) to understand the complex Reimann zeta function where $1+2+3+4+5... = -1/12$, he performed a devastatingly simple mathematical game in which the audience came to all

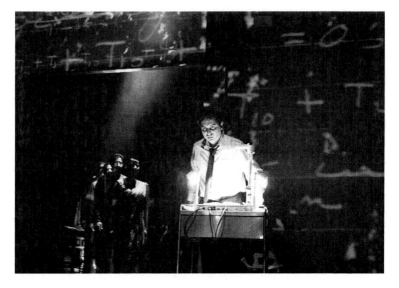

Figure 5.1 Firdous Bamji as Al Cooper learning how to understand the patterns of mathematics forming around him, 2007
Source: © Tristram Kenton, London.

think of the number seven at exactly the same moment, without being prompted or having the number suggested in advance.[13] At the conclusion to this exercise when we were all thinking of the same number without realizing it, Aninda noted, '[a]nd what I like about the theatre is that we are all able to imagine the same thing at the same time, just as now, we are all imagining the number seven' (p. 25). This moment provided a practical introduction to how the image of the goporam could intersect with theatre: a mathematical puzzle generated in the audience an interdependence that was, at this moment, much more communal than the fact that we all purchased a ticket for the same performance. At this early point, Aninda firmly grasped the audience's attention and the links between mathematics and theatre began to unfold: the audience quickly became transported beyond their seats to a world of numbers and patterns that we came to see as meaningful and entirely relevant to our own lives. Mathematics was practised before our eyes in numerous ways.

It presented a parallel goporam, a world of its own that has a relationship with the actual world, but that is separate from it. It may lack the geographical context to be charted on a map but it nevertheless took up space both on this stage and in the actual world, as *A Disappearing Number* came to demonstrate.

How might heterotopia take place in this context? Mathematics is a form of representation of space, separate from the theatre and the image of the goporam, but how might its patterns produce meaning and even beauty in our 'parallel' actual world? From the constructed space and the abstracted space emerged the heterotopia of interconnections that assisted us in understanding how the goporam (or, standing in for it here, theatre) might contain everything of the world. The production's heterotopic possibility encouraged audiences to explore the relationships of these patterns through our own lives, which are themselves heavily patterned by comparable forces. Exploring heterotopia requires a leap of faith of sorts, one that is coincident with the world of mathematics. In the introduction to the script, Simon McBurney, Complicite's Artistic Director, argues that mathematics frequently involves 'a leap of the imagination' (2009, p. 8) in creating concepts such as the imaginary number. *A Disappearing Number* produced a heterotopic space in which the concept of the mathematical imaginary number intersected with theatricality. The heterotopia was, then, an imaginary leap or the connection from a world of what many perceive to be meaningless chaos and/or randomness to one where patterns and sequences came to make sense.[14] Yet as with mathematics, what seemed at first to be a leap of faith came to make sense through multimedia.

This heterotopia operated outside of any chronology of the plot, but then the performance itself did not proceed chronologically. Rather, we understood setting and character by letting go of chronology and allowing the patterns of mathematics to guide us. An unidentified Indian speaker relates to the audience, '[t]hough one sits in meditation in a particular place, the self within can exercise his influence far away. Though still, he moves everything everywhere' (p. 55). Before addressing the multimedia aspects directly, I explain the patterns themselves. Scenes overlapped so that the stage directions indicated at times that the characters *are all speaking simultaneously* while a '*chaotic jumble of numbers*' (p. 37) was visible. This jumble was only incomprehensible until the pattern became

clear, when they were repeated in different contexts, whether about death, loss, or mathematics itself. One of the ways in which this was achieved was the overlapping of images: Ruth placed on the visualizer in her lecture theatre Hardy's book, a picture of Ramanujan, and other items, as she lectured. Al, later accidentally locked overnight in the same lecture theatre, added Ruth's passport to these items, following her death. Other objects were projected onto the scrim: for example, a map indicating Ramanujan's immensely difficult voyage from India to Cambridge in pursuit of mathematical knowledge. The connections at the narrative level were incredibly complex: including Al's business deal which favours cheaper labour in the Philippines but puts his British Telecom telephone sales representative (the Bangalore-based Barbara) out of a job.[15] The audience pieces this together, but Al does not. These numerous connections were associated not just with the here and now of international geography but also the past: Aninda tells Al of the *Upanishads*, which suggest that 'from death to death walks a man who does not see everything as being connected', a comment that Aninda 'translates' as '[i]f we cut ourselves off from our past, we will have no future' (p. 84). Each location took up literal space on stage, extending the parameters of 'here' and the relationships between each place. They were spatialized through the layers and repetitions of multimedia so that the role of mathematics in the world off-stage came to be more legible. This formulation of space across time (and numbers) suggested a reconfiguration of the parameters of space, something that was only apparent through the multiple ways in which numbers and images were projected.

A closer look at this projection is necessary. The use of multimedia is hardly new to Complicite: McBurney has noted that video in his productions provides a 'sense of another world coming into focus and going away' (qtd. in Rocamora 2008, p. 88). The multimedia in *A Disappearing Number* included old-fashioned education technology (slate, blackboard, whiteboard, overhead projector, visualizer) and old-fashioned theatre technology (voiceovers and a scrim). Voiceovers from people who were no longer present – or even alive – continued to influence events and helped generate the patterns of the play. The voiceovers contributed to the sense of time moving forward and backward, reaffirming the connections from incident to incident or person to person, and even beyond: Ruth asserts,

'[a]nd if space is continuous we are linked to the absent' (p. 30), suggesting the need to reformulate how we think of space and how it relates to the past and the future. At least one scene was replayed in video, almost simultaneous with live action; the script's stage directions reveal that the 'doubled' scene *gives the impression of shadows, spectres of repeating time'* (p. 30). Traditional forms of communication and meaning-making were matched with much more complex forms, including mobile phones, podcasts, Skype, images of India and other locations, projections of mathematical formulae, and, most importantly, the frequent appearance of what at first looked like snowflakes but came to be clear as numbers, spilling over the multiple surfaces onto which objects could be projected. The numbers bounced off the floor, scrim, walls, and were 'projected' into our own lives. They became three-dimensional, filling the space of the proscenium arch theatre. This was more than a flat structure or a metaphor when it occupied the space of the theatre and beyond.

The quick pace and the frequent parallels, relationships, and symmetries meant that there was frequently a blurring of what was live video and what was pre-recorded. More importantly, the projections appeared to be bigger than any screen on stage: they often deliberately exceeded the frame of the proscenium arch to absorb all action and all space, contributing a plentiful and beautiful patterning of connection and infinite possibility to the action on stage. The numbers in particular almost reached out to touch audience members, clarifying the function of the image of the goporam (and of the possibilities of theatre itself).

Through these techniques, we came to see beauty in the ordinary and to connect that to the actual world.[16] We were provided a glimpse of infinity, where the imaginary can become the real. The performance urged us to explore such patterns in our own intertwined lives, particularly to understand the implications of the many interconnections, for example, between our lives and those around the world. The aim of the production was not necessarily to encourage us to learn more mathematics but rather to demonstrate the power and ubiquity of mathematical patterns. Further, while the implications of these connections were staged, they also illustrated how, in the words of Liliane Campos, 'mathematics can become a source of patterns with which we can relate to time and to the absent' (2007, p. 331). For all the connections, there were also separation, exile, and

absence, which Ramanujan describes thus: '[i]deas, like all human needs – food, sleep, warmth – require a search, a going elsewhere. In our imaginations we leave the immediately present, the centre of the circle, and when we do so we begin to count' (p. 70). An understanding of mathematical patterns provides a form of comfort even amid apparent chaos. *A Disappearing Number* thus resists the norm, its alternate ordering suggesting how mathematics and the heterotopic leap can contribute to make sense of a complicated world.

This production intervened in the infinite, the imagination, and the sheer magic of theatrical performance, but here heterotopia was also integral to and inherent within the theatrical form: it assisted the performance to achieve its theatrical potential of creating community, even if only temporarily. For McBurney, 'the image of the theatre is the image of the human community' (qtd. in Knapper 2010, p. 242), which returns us to the image of the goporam and its potential in theatre. He takes this point further in exploring theatre's function, something that the patterns of this production elucidated beautifully:

> [w]hat happens when the audience watches a piece of theatre is that they imagine and they imagine almost the same thing at the same instant. They recognise this when they laugh together and they also recognise it when they weep. They recognise it when there is that moment of holy silence and when they recognise – perhaps unconsciously – the lie: the modern lie that we are all individuals who are not connected with other people, whose internal lives are entirely their own. Because at the moment when you all imagine together your imagination, your consciousness is joined as a whole and you know at that moment that you are not alone. [...] That is where theatre is important. It tells us who we are, which is not one person but many. (McBurney qtd. in Knapper 2010, p. 244)

The production created an 'alternate ordering' on stage whereby numbers and their patterns came to make sense. *A Disappearing Number* explored the infinite utility of maths to understanding our world. It also examined an enhanced theatre by which we see this combination of items that reinforce our humanity. *A Disappearing Number* staged the breadth of space in multimedia performance in such a way that audiences more comfortable with traditional theatre could

accept its potential. While mathematics requires a leap of faith, this production's multimedia did not: it extended what 'theatre' could mean and where theatrical space might be with relative ease, much the same as the audience followed Aninda's mathematical puzzle.

This production's various spaces (narrative, theatrical, mathematical, and more) were initially as mystifying as the Reimann zeta function, but once I grouped them into categories I could articulate the heterotopia and its effects, well beyond the narrative, and generate a much fuller interpretation. Linking these spaces to the notion of patterns assisted me in reading the sometimes quite diverse spaces of multimedia performance stages. The next example, which operates on a very different pattern, takes form, the function of multimedia, and its heterotopia in a different political and theatrical direction.

Seven Jewish Children: A Play for Gaza

Adaptations between film, novel, or theatre (and other genres) facilitate the exploration of the spatial potential in each contributing genre when elements from several genres are 'recombined'. For instance, *Brief Encounter* by Emma Rice and Kneehigh Company delivered a stage 'adaptation' of David Lean's 1945 film, *Brief Encounter*, itself a version of Noel Coward's play, *Still Life* (1936). The play version included moments from the film projected onto a screen in front of which sat a theatre set. The presence of the filmic world within a theatre frame extended the time and space of the theatre into the realm of the cinema (assisted by its being performed in a cinema). The reverse also operated, as audiences also engaged with the flesh-and-blood actors in front of them, performing live. As this chapter explores, performance that is predicated on multiple media does so in myriad ways, such that variability is paramount. Lev Manovich reads new media as building on such variability: '[i]nstead of identical copies, a new media object typically gives rise to many different versions' (Manovich qtd. in Punday 2011, p. 26). This combination of genres and new media versions is central to this case study, which explores multimedia characterized by viral iterability to generate new forms of (spatial) responses to an intractable political problem.

This section evaluates several orders of space in productions of *Seven Jewish Children: A Play for Gaza*, by Caryl Churchill. The controversial play premiered at London's Royal Court Theatre on

6 February 2009, having been written in January 2009 in response to the Israeli action, Operation Cast Lead, which, in December 2008, led to the heavy bombing and ground invasion of Gaza.[17] This military action resulted in the deaths of over 1400 Palestinians; more than three times that number were wounded, and over 20,000 buildings were ruined (Clements 2013, p. 357).[18] The Royal Court's *Seven Jewish Children*, directed by Dominic Cooke, was performed by nine actors, for free, in the same doorless box set that Johannes Schutz designed for Marius von Mayenburg's *The Stone* and the subsequent production, Mark Ravenhill's *Over There*.[19] For *Seven Jewish Children*, Schutz's set took on the feel of a domestic space that was 'made uncomfortable and claustrophobic by the lack of exits and the low ceiling. When actors were not taking part in a scene, they leant against the walls [...], the only exit being the one into the auditorium' (Clements 2013, pp. 362–3). This exit literally connected the events that took place on stage with the audience, as did the post-performance collection that was taken for Medical Aid for Palestinians (MAP). Anyone can download the script and perform it however they wish, provided there is a collection taken for MAP.[20] Groups around the world have taken up the opportunity to perform the play and others have 'written back' to it, as I outline later in this section.[21]

Churchill's desire that the piece have a wider audience than the Royal Court's thirteen performances offered resulted in a production created for the internet: the version of *Seven Jewish Children* on the *Guardian* website is the basis of this analysis (*Seven Jewish Children* 2009).[22] The video monologue, performed by Jennie Stoller (who also featured in the Royal Court production), makes particular use of the nexus of performance and video. Called a 'play in performance' in its credits (*Seven Jewish Children* 2009), it is not as static (theatrically or videographically) as one might imagine. The format of *Seven Jewish Children* contributes to a heterotopic reading that encourages a much broader interpretation than many of Churchill's critics allow. I see this performance as generating a heterotopia that opens up a space for dialogue about the conflict between Israelis and Palestinians, beyond usual partisan responses. I explore the 'staging' of the *Guardian* internet multimedia performance of *Seven Jewish Children* and consider what its extension of spatiality might mean.

I describe and contextualize this stark performance before beginning the analysis. In the *Guardian* version, Jennie Stoller wears a

nondescript blue top while the camera's position focuses on her roughly in a headshot. Only in Scene 2 does she obviously change her accent but in each scene she clearly performs a new character. She achieves these shifts by sitting slightly differently, or directing her comments more to herself (into the distance of her thoughts), or possibly to an out-of-shot, silent respondent, or occasionally, directly to the camera. At times it feels as if she is justifying decisions to herself, whereas at other times, it seems that she is in conversation (and disagreement) with unseen family members. No names of characters – absent or present – are supplied.[23] Scene 2 suggests much more reminiscence than the urgency of Scene 1, whereas in Scene 5 the character proudly looks into the distance to savour military victory, which diverges from Scene 2's recollection of family members lost to the Holocaust. The soft front and side lighting does not change. This face-to-face format provides a theatrical effect that situates me in theatre audience mode as I watch it, but the video context remains prominent too, because the piece is much more immersive and proximate than one might anticipate. It feels that the actor is speaking *to* me, even if she doesn't directly make eye contact with me (she all-but does). It is performative but it retains aspects that are not theatrical. The combination of performance and video provides an excellent means of spatialization, even though it appears at first not to generate different or discrete locations.

Seven Jewish Children, which Tony Kushner and Alisa Solomon call 'intentionally indeterminate' (2009), is confronting and at times shocking, no matter what one's politics or religion. They maintain, however, that '[a]ny play about the crisis in the Middle East that doesn't arouse anger and distress has missed the point' (2009). Almost a century of Jewish history is condensed to six pages of elliptical text (roughly ten minutes in performance) that addresses what to tell an inquisitive child about events around her. Its seven scenes cover historical points: before World War II, shortly after World War II, the formation of the state of Israel (including both migration to Israel in Scene 3 and the expulsion of Arabs from that same land in Scene 4), and shortly after the Six-Day War.[24] Scene 6 takes up several matters that span a broader temporal moment including: disputes over water, the construction of the Israel–Gaza barrier wall, and two intifadas.[25] The final scene takes place following Operation Cast Lead, the Gaza crisis of 2008–2009 that led to the writing of the

play. The performance appears to foreground language in the 'tell her/dont tell her' exhortation that begins just about every line but it is also about space; after all, securing land for Jews and Palestinians underscores most of the events that structure the play's discussion about what to tell the girl.[26]

I interpret *Seven Jewish Children* to intervene spatially into our responses to the Gaza issue. To situate my argument, the script is itself an excellent example of a heterotopia: the adults in the play continue to try out possibilities of what to tell the child, rejecting many of their options, sometimes as soon as they test them. What remains is the establishment of potential new ways of viewing the world, thus far only partly shaped and in some cases, unsustainable. World-making is common in Churchill's plays, as Rachel Clements notes (2013, p. 366), but here, the *Guardian* production also experiments spatially with form to recalibrate political responses to the Gaza crisis. For Clements, '[t]he play stages and exposes an irreconcilable complexity [...] [to] think about the ways in which normative frames of discourse might unsettle one another' (2013, p. 367). Thus, the 'constructed space' is not merely 'territory' or 'Israel'. Rather, it is the means of performance being 'extended' generically by its intersection with video, an extension that moves beyond these unsettling narrative parameters. This production uses a mediated face-to-face 'alternative' to the liveness of performance to disseminate its message of fluidity (versus maintaining fixed positions) while retaining the impact of live action. The 'abstracted space' is evident in the various orders of displacement, including its political and linguistic and generic expressions, as I detail further below. Between these two locations is a heterotopia of the many absences and uncertainties that we are invited (even forced) to fill, primarily the 'place' of the absent child. From this location, *Seven Jewish Children* suggests an alternate ordering of our perception of the historical events, the generic forms it uses, and the scope for marking out room for new 'spaces' for peace in the future. By extending and then displacing spaces in front of the audience, this production articulates that there are more spaces – and more ways to appreciate these spaces – than traditional arguments about Gaza allow.

It is difficult initially to isolate the constructed space – the creation of a heightened, cross-generic location that combines the genres of performance and video – partly because the production's many

components are tightly interlocked. Any attempt to situate con-
structed space as geo-political proved impossible. That is, it is not
appropriate to identify the performance's geo-political locations of
Israel and Gaza as the constructed and abstracted spaces, for two rea-
sons: these two geo-political locations are not the only ones at play
(although they are the main ones), nor does *Seven Jewish Children*
support them in a binary structure. The nature of a heterotopia auto-
matically provides a tripartite structure that avoids a simple reading
of partisan politics and this is the strength of the performance. In
addition to the multiple locations that are introduced, Scene 2's
Holocaust survivor cautions, '[d]ont tell her to think jews or not
jews' (Churchill 2009; original use of lower case). This proposal to
avoid a Jewish/non-Jewish binary is integral to the performance, and
this comment, unlike many others, is not disputed in the text by
a character responding with 'Dont tell her that'.

The constructed space in this production is, rather, derived through
a generic blend of performance and video that merges times and
spaces (historical, geographic, and more metaphoric) to encourage
a different type of interaction with the issues of Gaza. While this
multimedia constructed space incorporates geo-political territory,
it is not necessarily defined through or by it. Its structure emerges
from the nexus of performance and video and from the ways this
combination helps create a space characterized by movement: space
through which to view the production, and space that increases the
possible interpretations and effects of issues about the Gaza crisis.

The multimedia presence helps establish a complex 'here': the
assumptions that we make about where 'here' is located are quickly
unsettled because Stoller's performance alters our perceptions of
(and through) both the potentially claustrophobic effect of the
video medium and, paradoxically, the opening out spatially and
temporally that the play permits, particularly in this video context.
In more detail, this blend of genres deploys some aspects familiar to
each genre on its own, but it also uses others that are only apparent
in a combination with the composite generic form. At their simplest,
whereas traditional theatre usually uses a single space (the stage) to
metonymically tell a layered story about people in a different time(s),
video has the capacity to use multiple locations to set a scene. In
Seven Jewish Children, neither performance nor video is deployed as
one might anticipate. The production exceeds various 'frames' of

genre (particularly the video frame that the *Guardian* production presents). The spatial extension beyond this narrow frame challenges the belief that there is nothing to be done regarding the matter of death and destruction in Gaza. Video promises an opening out that is even greater, spatially, than theatre because of its capacity to film on location (or somewhere that resembles the actual location) but here, it doesn't operate in quite that way. Instead, video is stretched another way, through the promise of wider reach and broad access via YouTube: this alters the format somewhat, but that alteration enhances both performance and video, rather than compromising either. This powerful piece, brought into our personal context (via our computer screens), is not performance, and simultaneously not video. The space is not played out in the usual performative (or video) form but its presence forces audiences to re-evaluate their traditional parameters and here, what their effects are.

Seven Jewish Children requires more careful analysis of what *is* present theatrically. The *Guardian* version appears at first to have no 'built' theatrical set at all. Neither do the scenes contain evidence of a video 'location'. Further, the playing space is framed (anti-theatrically) by the computer screen and narrowed even more by the camera lens that focuses our view on Stoller's embodiment of Churchill's characters. The expectations of both performance and video are subverted, forcing attention back onto (empty) space through which, paradoxically, we are encouraged to *add* layers of spatial complexity. The darkness that is behind Stoller in each scene comes to suggest a physical depth, a sense of space that we attempt, inevitably, to fill out, but the fluidity between scenes, actions, times and places makes it impossible to retain rigid geo-political or partisan interpretations. Even though there is no apparent literal stage set, each scene appears to generate a geo-political space by means of the historical photographs that frame it. None is captioned but each contextualizes the subsequent scene in what appears initially to be a static form that is customary to neither performance nor video. In the first, a group of men stand in front of a row of dead bodies (presumably of Jews in the lead-up to World War II) while the last, in colour, depicts an apartment block with its front wall blown off (exposing small family groups of Palestinians looking out from what we imagine to be their apartments while they may be salvaging what they can). The photographs and the compressed words of the script complement Stoller's expressive performance to

create a location for each scene, even if the detail is supplied by the audience's imagination as they attempt to understand this historical and political (and artistic) situation. It shifts with each new scene just as the 'we' and the 'they' vary from scene to scene, refusing any construction of a place in our minds for a uniform self and other. Rather, the 'us' and the 'them' continue to shift in power and position and we must re-establish places for these events to play out: the fluidity of the geo-political context modifies our understanding of the performed spatiality of the socio-political contexts. The production urges an abandonment of a fixed understanding of the 'spaces' of Gaza and Israel so that new options might be shaped, discussed, and implemented.

The spatial movement in *Seven Jewish Children* extends to people in that the character construction enhances a spatial analysis. The performance/video combination that shapes the constructed space is augmented by a personal/family one: the seven characters whom Stoller enacts stage divided selves who wrestle with ideas. They self-correct and even self-censor. The presence of the speaker, against the larger political and historical events, renders the location more domestic, more personal, and more likely to relate to the audience member who may well be watching the play at home, a rough equivalent to the domestic setting of these scenes. At other times, the character confidently establishes what to say; sometimes she is anxious or uncertain, and sometimes more resigned to facts, even if she is not happy about them.[27] Again, the audience must create a 'space' for these family discussions, against the geo-political ones the photos fashion. The combination of these two provides a significant spatial 'set' in theatrical terms, despite the spare use of both performance and video. The constructed space shifts our spatial expectations, something the abstracted space, to which I turn next, also pursues. *Seven Jewish Children* was written to change perceptions about the Gaza issue; my analysis reinforces how this goal is established and activated spatially.

While these multiple, fluid spaces and locations have been created through the blend of performance and video, *Seven Jewish Children* also stages a displacement that generates an abstracted space defined by removal from one's place – whether by choice or by exile. There are three dimensions to the abstracted space: literal, personal, and generic. With literal displacement, the characters in the play continue

to discuss attempts to protect land, while they or others are being displaced. In fact this could be called a displacement of displacement, in much the same way as Michael Rothberg refers to Edward Said's statement that Palestinians are 'the victims of the victims' (qtd. in Rothberg 2011, p. 540). In other words, those who were displaced subsequently displace others. Yet it is equally true that those who were displaced may be displaced again, particularly when geopolitical boundaries shift. Military incursions cause further displacements, all of which materially point to a more fluid or mobile sense of place that underpins this region, more than one might initially comprehend. Rothberg explores this slightly differently through his account of the asymmetry of this place of literal displacement which has taken on much larger figurative connotations:

> Israelis and Palestinians have been brought together by the contingencies of history, by logics only partly in their control. They occupy a shared, yet divided place – both a geographic territory and a geography of memory. This place is not, today, a site of symmetry and peace – it is a site of asymmetry and violence. [...] [B]ut without changing the way we think about the past it will be difficult to imagine an alternative future. (2011, pp. 540–1)

Churchill's intention in *Seven Jewish Children* is to provide the means to imagine an alternative future, something to which the abstracted space also points.

The displacement is not just geo-political: it is also personal, the second type that I itemize here. Perhaps the most effective means of understanding displacement in *Seven Jewish Children* is through the instability and uncertainty that emerge from many of the family members in several of the scenes. In Scene 6, the speaker refers to the use of stones as weapons, saying '[t]ell her they're not much good against tanks/Dont tell her that' (Churchill 2009). Stoller performs the first line with a wry laugh, but then in the subsequent line, she seems horrified that she could have even voiced the first line. The same is true with the final three lines of the play in which the character delivers a diatribe against Palestinians but then, in shock and surprise at her own outburst, pauses and says in an impassioned recovery, '[d]ont tell her that./Tell her we love her./Dont frighten her' (*Seven Jewish Children* 2009a). This disaverring of the lines as soon

as they are spoken identifies the abstracted uncertainty. This call and response of '[t]ell her/Dont tell her' shifts our expectations of a narrative, as well as any simple fixing of the positions of the Jewish characters (whether subject positions, political positions, or parental positions).

The third type of displacement is played out generically: one assumes that the video will open matters out spatially to create a larger context than can be located and contained within the context of the screen, but that option is itself displaced by the way in which the video is used in *Seven Jewish Children*. The space of the actor expands and 'invades' the audience's own space through the personal computer screen. Stoller's representation of the characters is still 'there' on my screen when I look into it, even after the video has ended and I have closed the browser. Spatialization is displaced through video in the curious way in which the audience is situated. The audience member's viewing position (most likely an audience of one person at a time, but multiplied by the number of downloads) is particularly carefully constructed: we face 'back' to the characters Stoller performs, almost identically situated, as we look at the actor directly.[28] As Grehan notes, the significance of this close proximity between actor and audience means that the spectator comes to be 'complicit in or responsible for the decision-making process that is unfolding on screen. It is as if the intensity of her [Stoller's] gaze and her direct address act to ensnare or entrance those who sit on the opposite side of the screen' (2014, p. 103).[29] It appears that there may be more taking place than 'just' returning the gaze. In noting how technology is increasingly part of our lives, for instance, Hayles argues that 'the keyboard comes to seem an extension of one's thoughts rather than an external device on which one types' (2012, p. 3). This sense of Stoller's characters inhabiting my computer (an emplacement of sorts) is unsettling in that the ideas that she performs remain with me. Yet in *Seven Jewish Children*, the proximity and curious disjunction of the characters on my computer screen also present a generic displacement that shifts the combined function of performance and video while also pursuing Churchill's point: displacement is performed spatially in front of us through the abstracted space from which we come to understand there to be more perspectives than initially thought.

The displacement of the abstracted space combines with the fluidity of the constructed space to shape a location for a curious

heterotopia. In *Seven Jewish Children*, heterotopia can be identified in and through the location of the unstaged inquisitive child who is asking difficult-to-answer or awkward questions. Ultimately, the performance is about how to create a safe space for this child, and by extension, all children caught up in the conflict. No piece can provide the answers to such a difficult, entrenched, political and historical problem such as the Gaza crisis, but *Seven Jewish Children* forces spectators to consider the nature of possible solutions, or, like the parents, to at least discount some. The adults' imagining of the impossible situation forces the audience to imagine the same thing: '[d]ont tell her that'. Kushner and Solomon point out that '[t]he last line of the monologue is clearly a warning: you can't protect your children by being indifferent to the children of others' (2009). An effect of this warning is that the performance encourages spectators to fill the absences, to work out what we would tell the child and, beyond that, to think seriously about the conflict and to investigate other forms of response. Kushner and Solomon argue, 'it is perhaps only on stage that the central characters of the play come into their own: the eponymous seven Jewish children who are its heroines. We never see them. Our empathic imaginations are enlisted by the playwright. We have to conjure them' (2009).[30] As we do, we inevitably conjure the Palestinian children who are as 'present' in their absence as are the Jewish children in this performance about the 'place' of peace (rather than territory), and the place of the calmed, loved child, against the knowledge of many other, equally loved, frightened children.

Comparable to the effect produced in the National Theatre of Scotland's *Aalst* (discussed in Chapter 3), the deliberate absence of an adequate response forces us to provide our own and generates the 'room' for that to happen (for those who wish to take up the difficult challenge).[31] This production yields a heterotopia that disturbs (or has the potential to disturb) the usual responses to the Gaza crisis, whether through indifference or the assumption that there is no possibility of meaningful resolution. My own actions may seem paltry – investigating the history of the crisis, the work of MAP, and the responses of various governments and the UN, in addition to writing this analysis – but they contribute to the shift in thinking that Churchill's piece seeks. The performance's expansion of space combines with its immersion and the proximity of its location on

one's own computer screen to powerfully extend the responsibility for and agency in the Gaza crisis to audience members.

The final measure that Churchill has taken to encourage response is the releasing of the version under analysis onto the internet. The form of the performance, easily circulated to others, broadens discussion on a topic where potential solutions are frequently deemed to be impossible. Through this dissemination process, the spatial scale of this production develops in a different way, as I discuss in the conclusion to this section: theatre's infinite space gives way to an infinite reproducibility of the video format via YouTube.

The potential for 'viral' dissemination of *Seven Jewish Children* facilitates, for Miriam Felton-Dansky, a 'mutation of private viewers into public participants. [...] [I]ts productions dismantle distinctions between performers and spectators, enclosed theatres and open public spaces' (2011, p. 162). She argues that this multiple means of repeated dissemination (and even writing back) 'chronicles the viral spread of historical ideology; its public presence embodies the viral, audience-driven dissemination of performance itself: dramaturgy that mutates in the internet's endless echo chamber' (2011, p. 158). This combination of performance and video enables iterations of *Seven Jewish Children* to exceed the conventions of theatre that takes place at a set place and time. Further the heterotopia of the absent child shifts position to accommodate the multiplication of the performance. The availability of the script for *Seven Jewish Children* has sparked many productions, including a production in New Zealand with four actors, an outdoor production in Jaffa with three actors and what appears to be an infant in a pram, a school production in Taiwan, a university production in Warwick, UK, and a community reading in Catford, UK, to name a few.[32]

The most impressive production available on YouTube is The Rooms Production from Chicago (2009c1; 2009c2), which uses 11 actors, each performing to someone, whether in person or via different forms of communication appropriate to the setting of the scene, including two different vintages of telephone, a hand-written letter, a manual typewriter, a tape recorder, a laptop, and Skype. It 'places' the means of communication squarely front and centre to foreground that these are the instruments that will yield better dialogue. Directed by Andrew Manley, this production creates a different affect from the *Guardian* production. Appropriate for a performance that

takes place in a gallery space, the scenes are broken up and 'performed' in different parts of an oblong room, more or less around a long table. The actors are discrete to each scene; at the beginning and then at the end, the actors repeat their lines, simultaneously. The website explains that the live version was 'a three hour looped performance installation' (2009). The separation of the lines into parts gives a different dynamic so that for every person's statement, there is an opposing (or at least variant) reaction. The looping of the Rooms production mirrors the looping of the script at large: it is performance that is designed for wide and repeated dissemination.

Seven Jewish Children compromises the non-reproducibility of theatre for a political action, yet it still deploys theatricality. Read through a heterotopic lens, it extends the potential of genre (the combination with video and the implications of uploading performance to YouTube in this way). *Seven Jewish Children* exemplifies the full range of spaces that heterotopia can accommodate and the kinds of political action and reaction that its focus on 'gaps' can reinforce. It succeeds in prompting conversation and debate, and, through such debate, making room for the protection of all children and the changing of assumed positions.

The final case study moves away from contemporary politics to consider multimedia that addresses both theatre's history and its future.

Ortelia

The immersion that operates to a limited degree in *Seven Jewish Children* increases substantially with virtual reality work (VR), the subject of my final example: specifically, Ortelia's virtual reconstructions of heritage theatres. Ortelia is a software company that designs VR versions of contemporary cultural spaces such as theatres, art galleries, and museums, contexts that preserve and curate culture.[33] The historical and research-based aspects of Ortelia's work concentrate on late-sixteenth-century London theatres such as the Rose Theatre and the Boar's Head Theatre, and by exploring the virtual Rose Theatre here, I investigate heterotopic spatiality in the virtual realm. I address the virtual performance of a brief section of a monologue from Christopher Marlowe's *Dr Faustus* in the VR Rose Theatre and the potential use of stage properties from Robert Greene's *Friar Bacon*

and Friar Bungay and Thomas Lodge and Robert Greene's *A Looking Glass for London and England*, all of which were staged at the original Rose Theatre.[34] The frame for the heterotopia operates slightly differently in this case study, as a result of the context of virtual 'sampling' and the effects of a longer-term project than most performances, but it nevertheless follows the principles of earlier examples. To summarize my argument, the constructed space is the virtual version of an actual location, whereas the abstracted space is the capacity for a less conventional narrative experience that emerges from the virtual project overall. Between them the heterotopia is the modifiable and recombinative potential for theatre and performance – and, here, for theatre and performance research – in both the virtual and actual (or real) worlds. Heterotopia in the example of Ortelia suggests the opportunity to extend our knowledge about historical theatres and theatre practice, even revealing more than archival or other documentary evidence has yielded in recent times. This section also points to factors significant to the analysis of virtual performance.

Ortelia is not the first group to recreate theatres that no longer exist, in order to establish how performance might have taken place there. For instance, work on the Roman Theatre of Pompey conducted at King's Visualisation Laboratory at King's College London has led Hugh Denard to speculate that

> in the future, classicists and archaeologists might get their first exposure to the theater through the visualization [of the Theatre of Pompey], in effect shifting the sensorium of knowledge construction from text-based artifacts to an interactive 3-D rendering that allows them to change perspective; zoom in and out of details, floor plans, and architectural features; and imaginatively explore the space to visualize how classical plays might have been performed. (qtd. in Hayles 2012, p. 49)[35]

The spatial potential in virtual work requires further critical attention, but the analysis that exists has focused on performance in VR contexts. The absence of a critical framework is complicated by continued software and hardware developments. As Manovich outlines, we inhabit a 'world of permanent change – the world that is now defined not by heavy industrial machines that change infrequently, but by software that is always in flux' (2013, pp. 1–2).

Ortelia matches Manovich's vision: its developments take account of the technological advances and the potential for conventional research enhancement that can be supported by such innovations, rather than arriving at a point of 'completion'. A central aspect of the analysis of such work is, as Hayles explains, that the digital and the virtual, broadly configured, are not simply contrasting elements for the 'real' of the actual world (2010, p. 285; see also Vanhoutte 2010, pp. 45–6; Giannachi 2004, p. 126). Virtual work is not removed from reality. Neither does it necessarily 'oppose' the 'real' of the actual world, as the heterotopia in this example articulates.

Before I address Ortelia's version of performance in the Rose Theatre, some context of the original theatre is required. It does not have the profile of the Globe Theatre, its size being smaller and its life span shorter (1587–1603; it was demolished in 1606), but Marlowe's plays and Shakespeare's early work were staged there. Its lozenge-shaped stage (following its final renovation) differs from that of the Globe. While the theatre no longer exists, its foundations (excavated in 1989) can still be visited in London, a few metres from the current site of Shakespeare's Globe Theatre. Ortelia set out to recreate this long-demolished venue to determine how performance might have worked there and to test the possibilities for recreating theatrical spectacle in this small, open air theatre. The VR model of the Rose is based on easy-to-use Quest 3D software (a gaming engine). Various textured surfaces are placed over the geometric frame to provide the aesthetic finish and detail appropriate to this venue and time. The model includes several of the renovations that were documented to have taken place to the Rose (See Bowsher 1998). By incorporating these renovations, we enable users to compare the venue at different times, including what it would have looked like with no stage, with a temporary stage, and with the significantly expanded stage and alterations made in 1592 and 1594. To make the virtual model, we calculated the average size of citizens of the day, typical ceiling heights, and the construction methods appropriate to the day. Ortelia's models raise discussion about how performance might have operated then and how virtual performance functions more generally today, information that, for this theatre, is not found in remaining documentary records.

Unlike other examples in this book, this section is less an account of a particular performance than small segments of performance 'samples' which demonstrate possible spatial solutions that have

implications in and for the actual world.[36] These samples include a Dr Faustus avatar, the engulfing of a character in flames, and the deployment of a dragon in this venue. The latter two may appear to be difficult to execute in a small outdoor venue like the Rose. The first performance sample is the closest to conventional performance: the avatar, a motion-captured actor performing the final monologue from *Dr Faustus*.[37] The avatar of Dr Faustus was created by capturing the movement of two actors, the files of which were merged onto a figure generated for the purpose, based on a man's appropriate height and shape for the day (see Figure 5.2). One actor speaks the text of the final monologue when Faustus is about to be taken to hell.

The second example focuses on establishing how to stage two particular 'spectacles' when detailed information about these staging effects has not endured. In the first, the King's advisor, Radagon, dies in *A Looking Glass for London* by being engulfed in a flame that, the script suggests, emerges from the trap door. In establishing how to recreate this effect, we positioned the trap in a comparable location to where it is at the Globe, although the smaller stage requires a proportionately smaller trap. The actor achieves this effect by descending a few steep steps into the trap: while it is steep, it would

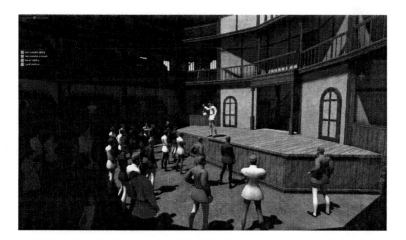

Figure 5.2 A screenshot of the avatar of Dr Faustus performing in the VR version of the Rose Theatre, 2014
Source: © Lazaros Kastanis, Brisbane.

be manageable for a fit actor. Two cresset torches – metal flame holders – provide illumination and are positioned to keep the flame away from the wooden stage floor. This effect is relatively easily realized, with only the need for one assistant under the stage.[38]

The second sample, the deployment of a three-dimensional dragon, is more complicated and while Philip Henslowe's diary lists such a creature as a part of his inventory of stage properties for the Rose, no records remain about its size, shape, or the materials used in its construction (see Figure 5.3). The repeated use of such creatures has been recorded (Butterworth 1998, p. 82), and *Friar Bacon and Friar Bungay* specifically calls for such a creature in Scene 9. It is one thing to read about these creatures and their effects, another to experience them in a venue where they are known to have been used. Based on evidence of what was possible at the time, we decided to make the dragon fly from one fixed location (the tiring house) to another (the gallery above the main entrance to the theatre), over the heads of the standing audience. Having it fixed on a line would still ensure the spectacular effect, while keeping it manageable for assistants who may have been backstage. We have experimented with the

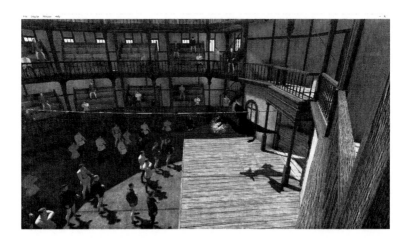

Figure 5.3 A model of how the stage property of a dragon might be realized in a VR version of the Rose Theatre, 2014
Source: © Lazaros Kastanis, Brisbane.

angle of its travel; in fact a steeper angle that takes it to the top of
the theatre is also mechanically achievable. The body of the dragon
could be made from papier mâché or from canvas on a light frame.[39]
Operating the dragon would require one person backstage to secure
the rope, set the dragon in place, and light the firecrackers that were
likely placed in its mouth, while a second person at the other end
would pull it up into place.[40]

The constructed space for this example is the creation of the vir-
tual version of the Rose Theatre: it is 'constructed' in perhaps the
most literal sense in this study. Rather than the 'real' thing, it is
a close approximation (taking account of as much detail as possible)
that is designed to shape a world for performance. The Ortelia Rose
cannot be an exact copy because there remains uncertainty about
several architectural aspects of the venue: only two-thirds of the
foundations have been excavated and the creation of this model in
virtual form has isolated a number of construction problems, issues
that have changed our original assumptions about what the venue
looked like.[41] Such structural questions do not compromise the work,
because the VR Rose still delivers a sense of what this venue could
have sustained in and for performance at the time, and in much
more visual, immersive and haptic detail than otherwise possible.
Until VR recreations were possible, research into performance from
the past needed to rely on actual architecture (when such build-
ings continued to exist), archaeological foundations (if available at
all), documentary material (in the case of the Rose, the incomplete
diaries of Henslowe, the owner of the venue), and information
gathered from other venues, sketches, and so on. The information
gleaned from the De Witt drawing of the Swan Theatre and the vari-
ous versions of indoor theatres of the early modern era suggest that
while valuable, these resources can also be flawed or incomplete.
VR reconstructions assist in establishing which resources can be
accepted in their entirety and which cannot. It is easy to assume
how performance took place when one is speculating about a venue
to which we no longer have access, and when one needn't worry
about scale, practicalities, orientation, and so on. A VR version of
a theatre enables more specific, immersive investigation within the
parameters of specific dimensions of a venue, matters that can sim-
ply be (accidentally) overlooked when one works only on paper. The
option for users to fully navigate the model of the venue reinforces

the performance possibilities presented by a particular venue but also its limits: the small scale of the venue necessarily restricts or compromises some performative action. Given VR functionality, it is possible to navigate more aspects of a virtual venue than is generally possible in a bricks-and-mortar version (since one can position oneself anywhere and view the venue from any perspective).

Even though the constructed space mirrors the original, it is nevertheless a curious *other* location because of the effects of the virtual sphere. As Giannachi explains, in a virtual venue, the user or viewer is positioned in two places at once: 'in virtual reality, simulations are both present and not present, while viewers, too, are both inside and not inside the world of virtual reality' (2004, p. 123). Constructed space, then, is multiply-located in the actual world and in a distinct (if related) virtual zone. The action in this constructed space of VR takes its cue from the actual world but it generates its own different reality at the same time. It could be argued that theatre automatically achieves this (since we exist in the actual world while a different world is enacted in front of us) but the potential for a visceral effect of this different emplacement of space is intensified in VR work. Giannachi explains the spatial effect: 'the viewer is able to exist in fragmentation, in both the real and the virtual, as both a subject (in the real) and an object (in the virtual), performing their own presence (and therefore absence) in between the two worlds' (2004, p. 123). While the virtual operates more or less along the same spatial rules that the material world does (and therefore, heterotopia would operate much the same as it does in the material world), it represents another dimension that is connected but less anchored to the rules that govern the actuality that we share, outside the performance context. The immersion that one experiences in virtual reality – the sense that one is absorbed into another realm – reflects our expectations of space in the actual world, even though there is capacity for the virtual space to resist or to operate counter to actual world space(s).[42] Nevertheless, the constructed space is relatively straightforward, whereas the abstracted space introduces more of the interactive potential of multimedia.

The abstracted space is characterized by the overlap between virtual performance and gaming technology. Specifically, the 'ergodic' function that gaming introduces intersects productively with Ortelia. Espen Aarseth's concept of the 'ergodic' refers to a combination of

'path' (hodos) and 'work' (ergon). The ergodic occurs when '"non-trivial effort is required to allow the reader to traverse the text" (1997, p. 1), an effort greater than that involved in reading a novel, watching a film [or performance], or cognitively processing the material contained in such forms' (Aarseth qtd in King and Kryzwinska 2002, p. 22). Capitalizing on game technology provides a more palpable sense of the conditions of performance than traditional methods, even though the basis for this immersive VR environment is firmly grounded in conventional theatre research.[43] Ortelia is not a game, but it deploys gaming technology and an immersive, ergodic environment that is conducive to understanding the experience of time and space (which are also key features of theatre and performance). Ergodic participation, more than 'just' interaction, may be useful in assisting in the development – and take-up – of aspects of theatre research.

Ortelia's aim is to make the historical theatre models available through open access; once this occurs, users will be able to interrogate the decisions made at each stage of construction and performance and to experiment with their own speculations. There is the potential for a much more ergodic relationship with this environment than there is in most traditional performance. While many games tend to offer an infinite number of routes to a conceptually 'given' end (such as winning or losing, but not just these options), Ortelia provides a more stabilized approach to an infinite range of possible outcomes. Games tend to operate not through narrative but through actions or events. The exploration of actions and events is akin to performance, although of course a play's narrative holds significance too. But a focus on action and events assists in understanding the perceptual layers of performance. Ortelia could, then, be construed as a mirror image of a game: the user 'interrogates' the environment rather than 'contesting' it. Games suggest near infinite approaches to an anticipated goal (whether or not achieved). The combination of time and virtual space suggests a countless range of possible decisions, any of which will trigger responses which, although to some extent pre-programmed, are as infinite as the player actions to which they react. The Ortelia user will not demolish the building or do battle with its occupants, but may seek to know the range of possibilities that would have been available to those who made theatre in the given space, the documentary evidence used to decide certain

details, other solutions for the illusion of Radagon's fiery demise, or alternatives for the dragon's flight. Users may wish to try out the alternatives to decide whether or not the Ortelia team made the best decisions. Ortelia allows an ergodic understanding of the space under enquiry, using the technology and dynamics of the computer game to its own ends. The connections between a 3D model of a theatre and the 3D physicality permit the exploration of items and devices in a more perceptually appropriate context. The haptic demonstration of the ergodic enables us to draw conclusions from comparing multiple options. This abstracted space holds the potential of a greater degree of ergodic engagement.

The heterotopia that emerges between these spaces in this example is the potential for new discoveries about historical theatre practice. In the first instance, the combination of the constructed and abstracted spaces may well produce new knowledge. Secondly, the models are easily modifiable. Once new interpretations become available (whether derived from experiments into the logic of construction or revealed through newly uncovered documentary evidence), the virtual venue can also be altered, with the various iterations saved for comparisons. Dixon notes that in such models, '[s]pirit, rather than absence, is one of *the* defining features of multimedia' (2007, p. 656; original emphasis). We found this to be the case with Ortelia's models once the venues were activated by the avatar and then subsequently by staging devices and even the presence of static human figures as audience members. The framing of theatre history in terms of immersion renders the research more immediate: it becomes possible to identify the implications of research decisions more effectively in the context of an entire environment, not just an immediate problem at hand. This cannot be captured even in a bricks-and-mortar venue, even aside from the impossibility of modifying the structure of an actual theatre building for experimentation.

The relationships between the virtual version, the virtual performance, and the modifiable, ergodic heterotopia do not exist on their own. They need to have an actual context against which to suggest meaning, even if they do not oppose the actual world. Giannachi outlines the nature of this connection:

> the main characteristic of a virtual reality immersion is not so much its skill in simulating the real, but rather its ability to

estrange the viewer from the real, thereby interfering with their capacity to see and consequently read the real. This is why, after a virtual-reality experience, coming back to the real seems both strange and estranging. (2004, p. 126)

Not only is the estranging effect of VR potentially disorienting in visceral terms, the proposition that VR does not counter the real also contradicts traditional ways of thinking. As a result, VR work has to actively eliminate suppositions that it is simply a speculative or hypothetical game that is not based in documentary research. Rather, as Kaye articulates, 'investigations of "media space" imply the performance of a kind of palimpsest in which real, virtual, and simulated spaces and events negotiate a writing over, reconfiguration, and translation of each other' that form a *'disjunction'* (2009, p. 129; original emphasis) that devalues none of the elements, but that causes a rethinking of each in its own right.

Even if there is overlap between this virtual heterotopia and that of the shadowed actual world, there also remains a gap between the two. The Ortelia project achieves a heterotopia of possibility by facilitating a specific, VR-based theatre environment in which to assess theatre practice and history. The potential for understanding theatre from the past lies in the theatre tools of the future. Visualization tools help us recreate movement in historical spaces, so we can move beyond the even less 'real', static reproductions of performance of the past. The possibility of bringing to life performance captured in engravings, sketches, and photography is exciting. The gaps will not all be filled, but research into performance and the virtual facilitates a means for their exploration. This is not a matter of continuing to oppose VR and 'real', but rather to use VR to enhance the 'real'. As Matthew Causey argues, with multimedia, '[t]he theatre is once again the test site, the replica, or laboratory, in which we can reconfigure our world and consciousness, witness its operations and play with its possibilities' (2002, p. 182). Heterotopic theatre provides an even more intensive testing ground for, in this case, theatre history.

The examples in this chapter augment our understanding of space to exceed theatre's 'frame', whether it be the frame of the proscenium arch in *A Disappearing Number*, or the performance/video frame in *Seven Jewish Children*, or the shadowing frames of virtuality

and reality in Ortelia. The chapter also points to other directions for research: in addition to pursuing virtual theatre spatially, it raises the scope for further exploration of Churchill's political use of displaced space and world-making. A heterotopic reading of all of Churchill's work would be revealing theatrically and politically. The Ortelia case study points to heterotopia's usefulness to and intersection with the study of gaming and theatre history.

My analysis offers an emergent approach to spatiality, the niche area of multimedia performance, which is frequently explored as a separate entity, not a logical continuation of more mainstream theatre and performance. Further, whereas multimedia performance analysis has focused on time and the body, my spatial concentration emphasizes the importance of investigating a range of new possible forms of space, not to mention their implications. These spaces bring with them issues of intensity, immersion, and interactivity that have not yet been adequately examined in theatre and performance research. Multimedia performance is a natural extension of theatre's sustained playfulness with spatial ordering; we encounter this layering/juxtaposition of space in the 'real/actual' world everyday through, among other things, mediatization. By drawing attention to the clash of spaces, theatre equips us to negotiate our mediatized real world more knowingly, as my analysis pursues. It is essential that we engage deeply with multimedia performance as its influence continues to grow. Causey argues that investigating the nature of multimedia of performance is urgent, for 'it is the human itself that is in crisis as it attempts to understand its position in the space of technology' (2002, p. 182). 'Crisis' may be an exaggeration, but the spatiality that technology explores is destined to continue to expand in ways that audiences may occasionally find 'disjunctive', to use Kaye's word (2009, p. 129). Such disjunctions confront our lines of thinking at a time when technology also challenges how performance takes place. These disjunctions also assist us in adjusting our parameters away from the binaristic relationships of real/virtual and/or live/not-live. A heterotopic interpretation of space is an excellent means of overcoming the default to these binaries. Even more specific spatial analyses of such technology and its effects are required.

Conclusion: Gaps, Absences, and Alternate Orderings

The Canadian playwright, Judith Thompson, articulates a specific effect that she derives from the best theatre. She believes that theatre ought to intersect deeply with our understanding of the personal, a process that might entail the following:

> [w]hen theatre works, it truly does hold up a funhouse mirror, but we know it is not actually a distortion, but a deeper, much more difficult truth. [...] The play not only controls what we see, but when we see it – incrementally, suddenly, in flashes, or a slow reveal; and we will not look away from a great play, for a great play entices us and excites us enough that we cannot look away or leave the theatre, and before we know it, we have done what we have spent our lives avoiding – we have confronted ourselves. (2010, p. 510)

This potential for performance encapsulates the engrossing and appealing qualities of theatre and performance as a form, even when other types of entertainment and aesthetic and artistic expression compete for limited time and funds. The attraction may be the personal confrontation that Thompson raises, but it may be much broader. Rustom Bharucha figures the power of theatre in a slightly different fundamental relationship with being: '[t]heatre is neither a text nor a commodity. It is an activity that needs to be in ceaseless contact with the realities of the world and the inner necessities of our lives' (1993, p. 10). For me, the realities of the world and the confrontation of the self emerge when we locate ourselves within a spatial

(and hence, socio-political) realm. Space remains one of theatre's fundamental elements but it attracts less critical prominence than it should. In addition to reviewing the main arguments in the book, this Conclusion points to how one particular spatial method of analysis, heterotopia, might be more widely deployed in theatre and elsewhere.

The absence of sufficient critical attention to space has been a strong impetus for this work, but the process has uncovered a range of other gaps and absences; there are several others to discuss briefly here. My study reveals two orders of gaps: first, what remains to be examined, and second, it returns to 'absences' within theatre. With regard to the first, inevitably, there are gaps in what I have been able to cover. It would be useful to examine the culturally determined nature of heterotopias. Intercultural performance would be conducive to constructing heterotopias because new spaces of potentiality are likely to emerge from performative explorations of cultural difference. The concept extends beyond a western framework, but the cultural specificities and generic particularities of non-western theatre require more detailed attention than I have had room to investigate here. In addition, it would be worth scrutinizing whether particular theatre companies and/or creative styles provide more heterotopic opportunity than others. From a different perspective, heterotopia almost always incorporates time with space, just as the spatial structures that shape our culture are also temporally determined. For instance, what might be heterotopic in a production of, say, *King Lear* that lends itself to contemporary references in 2014 may not suit a production of the same play in a different cultural or temporal context from 2002 or one proposed for 2020. Yet heterotopias may also refer to times from the past that have relevance to the present: the effects (ideological, emotional, affective) that they produce move and shift in and through time. In this study, I have deliberately focused on the spatial aspects of performance over the temporal, not to discount the significant matter of time, but simply to narrow a large project. There is considerable scope for a heterotopic analysis that places much more attention on the communicating capacity of time in relation to spatiality.

The second, the gaps that heterotopia facilitates probing, suggests both the significance of heterotopia in theatre and the richness of what remains to be realized in performance analysis. Issues of gaps and absences emerged in many of the case studies. Paul Rae argues

the centrality of presence/absence in theatre and performance gener-
ally: 'it is more important that the theatre mark the ways in which
appearance and disappearance underwrite each other than that they
resolve the ensuing tensions' (2009, p. 69). The capacity to explore
how gaps, absences, and holes actually come, paradoxically, to take
up space on stage underscores the value of heterotopia: it is a means
of uncovering both physical and abstract places and states of mind
that frequently avoid exposure. Yet parallel to Rae's argument, while
a heterotopia can articulate gaps, it need not fill them to be success-
ful. This focus on the gaps and absences is one of the significant
achievements that theatre offers to heterotopic studies generally. As
a medium, it can present space as a concrete entity, an imaginary
location, as an absence that must be rendered visible in a metaphoric
form, as well as the connection of these spaces to the world beyond
a performance venue. The interrelations between such zones con-
tribute to the genre's operation, as do our noticing of the absence of
particular spaces or locations.[1]

As I outlined in the Introduction, the foundational place of space in
human society is as central as identity, and heterotopia is an effective
means to test how theatre enables an encounter with spatial struc-
tures beyond the stage. This is the politics that heterotopia explores:
the capacity to reconfigure space in performance in a way that may
be meaningful to remaking spatial structures beyond a performance
as well. Heterotopia augments the ability for theatre to step outside
of itself, reinforcing its position as a part of a wider community. If
theatre and performance are to be understood to help shape the cul-
tures of which they are a part, they must be grasped in the context of
what takes place beyond the performance venue. Likewise, this study
demonstrates the two-way relationship between what takes place *in*
performance and how that might affect how we interpret the work-
ings of social and political space *outside* the performance. Further, its
participatory nature reinforces the potential for effective transforma-
tion of aspects of spatial formation on stage, as my case studies illus-
trate. The enactment of heterotopia has the potential to make theatre
transportive and transgressive, as it re-evaluates spatial structures on
stage in a manner that can have implications for how we look at
the wider world. For Derek Hook, heterotopia 'is a *differential space*,
importantly related to, but always fundamentally different from, the
places which surround it' (2010, p. 182; original emphasis). As such,

heterotopia differs from the better known spatial trope of utopia. Erik Elm goes so far as to argue that '[u]topia is bad dramaturgy. [...] The good without interruption ceases to function [...]. We don't want development processes to "solve" our plays, we want them to remain unstable at the lip of creation' (2011, p. 95). One of the achievements of heterotopia is that it capitalizes on the socio-cultural instabilities that an awareness of spatiality reveals; it then explores how alternative spatial structures might be implemented off-stage. Like the best theatre, heterotopic theatre stops short of providing answers, instead raising alternatives to the status quo that may have traction in the actual world. Contrary to utopia, heterotopia is characterized by 'ambivalence and uncertainty, thresholds that symbolically mark not only the boundaries of a society but its values and beliefs as well' (Hetherington 1997, p. 49). Heterotopia, unlike utopia, holds a more specific spatial context in its capacity to provide the building blocks for creating something different, something better. Part of its appeal is its precariousness and impermanence.

At the conceptual level, heterotopia intersects with philosophy, architecture, cultural geography, as well as, in my application of it here, theatre. Following a brief summary of the book and a short return to the method, I look to the future of such an analytical framework. In terms of the theoretical contribution, I have intervened in the study of a cross-disciplinary heterotopia in several ways: through my reinterpreting of Foucault's use of the term to draw attention to how it 'unsettles' social and spatial processes, and developing Hetherington's modification of Foucault's concept to extend beyond 'just' the crucial 'alternate ordering' that Hetherington identified. In providing a background to the concept (well beyond the discipline of theatre), I found cause to modify the terms that describe the poles which frame heterotopia. These adapted components have helped me develop heterotopia into a theoretical model relevant for theatre and performance (as well as other disciplines). It is not only theatre studies that has failed to fully engage with the potential of heterotopia: its potential has not been fulfilled in most other disciplines, but I hope that this study will encourage critics to reassess its merits. My version extends beyond Foucault and Hetherington in a way that is transferable to other fields. This genealogy of heterotopia has highlighted an additional interdisciplinary term to the study, analysis, and production of theatre and performance.

Each of my case studies has interrogated a different aspect of theatre and highlighted a new dimension to heterotopia. Chapter 2 addressed site-specific performance, perhaps the easiest theatrical form to combine with heterotopia, given its central preoccupation with space through a multifunction and extra-theatrical context. The two examples illustrate heterotopia's capacity to provide a detailed and nuanced approach to investigating space in site-specific performance. Further, they clarify how space in performance can be linked directly to constructions of power, authority, and agency. Heterotopia facilitates an understanding of such performance well beyond narrative or appreciation of the site: it reconceptualizes the site itself in a larger context. To some extent, all the examples that I have addressed in this book perform site-specificity (if not in the purest sense of the term), since heterotopia is generated by a fuller essence of site and performance space than often appears in criticism. In Chapter 3's exploration of the National Theatre of Scotland, I examined the heterotopic implications of performing in an ever-changing range of venues, an analysis that isolated how fragmenting identity complements the spatial decisions the company has taken in performance. More importantly, like the shifting flat at the conclusion to *365* (the third case study in this chapter), the examples demonstrate how the National Theatre of Scotland has shifted the definition of 'space' and 'Scotland' from their traditional axes. Chapter 4's focus on Shakespeare's Globe Theatre tested whether heterotopia in performance could surmount the well-known venue's fixed, historical meanings. The three examples prove it possible to transcend the historicity embedded in the venue and to communicate with a contemporary London, as the original did. If this venue can generate heterotopia, amid the weight of cultural history, then it should be possible for just about any venue or performance context to produce a heterotopic interpretation. The final chapter investigated performance that intersects with other generic forms, and which is transformed by the encounter. Multimedia performance is a natural augmentation of theatre's spatial ordering, although the heterotopias elucidated an intensified form of spatial potential. The case studies – deliberately variant in form – illustrate that a heterotopic analysis can cover complex spatial arrangements in most forms of theatre and performance.[2] The examples across the book reinforce heterotopia's relevance for the field as a whole. Each

chapter productively modifies the conceptual development of heterotopia in theatre and performance, increasing the potentiality for our understanding of individual performances, theatre at large, and the concept itself.

While the book has focused mostly on analysing performance, there is considerable scope for examining text, and for the generation of performance. Its use in probing spatiality in text will be enhanced for those who can imagine a text in three-dimensional terms, not simply as words on a page. It may also reveal productive tensions between spatial arrangements in a text, say Chekhov's *Three Sisters*, and its manifestation on stage, if the latter shifts the interpretational potential beyond the latitude of the text. The method also has substantial capacity for practitioners: directors, designers, and devisers. After all, there is little scope for a heterotopic analysis without the creation of spatially adventurous productions. While designers are inherently aware of the communicating power of space, its specific articulation as heterotopia could present innumerable spatial directions (and challenges) to explore in production on stage. The careful deployment of space need not cost more money: it simply requires a creative team to understand the potential for theatre to intervene in and help shape its culture, and that space can assist in this venture. Creating devised theatre with a sense of the power of heterotopia could transform the impact of action, text, and other theatrical effects (and their intersections). Much further work can be conducted to investigate design practice from this perspective. I do not suggest that every company and production ought to follow the spatial plan that I seek, but I do propose that companies and productions attempt to be more thoughtful about how they deploy space, how they think about space, how they make valuable connections to spatiality on stage, and what that might mean for the world outside the theatre. As Hetherington remarks, 'the significance of heterotopia is that it is used in a way that unsettles the flow of meaning. [...] Heterotopic relationships unsettle because they have the effect of making things appear out of place' (1997, p. 50). Theatre, more than most other art forms, can capitalize on the enactment of things appearing out of place.

This Conclusion provides a suitable moment to return to the method of analysis that I have developed herein. The system may seem at first to be somewhat cumbersome in its three-part structure

(of constructed space/abstracted space/heterotopia). A heterotopic investigation may not need to articulate the full detail of the constructed space/abstracted space/heterotopia in exactly the format that I have outlined here; rather, I have explored each example in detail to demonstrate the potential depth of scrutiny that heterotopia facilitates. To recapitulate the process, I begin when I find a spatial aspect of a production that makes a connection to the world beyond the performance, and that offers a renewed or different way of thinking about how space might operate in the actual world. It may be as simple as a fleeting moment of the possibility of something different, or it may be a much more established spatial structure. If there is little connection to the actual world, I set the production aside as unlikely to engage with a heterotopia. Once I see some potential for heterotopia, I step back to analyse its spatial zones at large. To isolate zones of spatial significance in a production, I examine the literal, architectural locations and the differing elements of the imaginative landscapes, and/or psychic spaces that a production might introduce. Suggestive locations may also be apparent through the absence of space or the absence of locations that one might have anticipated being staged. Sometimes, a performance stages many locations, while another enacts just a few; if there are many, they may need to be grouped into larger categories. Then it is a matter of establishing which one (or ones) creates a constructed space and which an abstracted space.

The constructed space is often associated with the architecture of a performance venue, but not always. It is usually a conventional or anticipated aspect of spatiality, while the abstracted space often – but not always – opposes it. Sometimes these poles contrast each other but at other times they are more complementary. Either way, they must be read in relation to each other. The abstracted space is less likely to be architectural, but it is still anchored in physicality to at least some degree. Between them, the heterotopia (a zone of possibility, of trying out alternative spatial arrangements) often creates a space where the analysis of the production can be extended; from this extension, the perception of spatiality can be expanded. It is here that the connection between the theatre and the actual world might be located, although the relationship is not always apparent or direct. Heterotopia is somehow unsettling in that it challenges the way we understand the spatial parameters of the world at large – and

of theatre's potential. My draft notes often include diagrams and lists of spaces, as well as potential interpretations of them, many of which are linked by arrows. It sometimes requires time to see the connections between the various types of space; despite that, it is a more detailed and rewarding means of interpreting performance than others I have tried, and, therefore, worth the effort. It is, without doubt, a demanding way of thinking and working, but as should be clear from the case studies, I have been able to elicit more from these productions than I would have, had I used another method. Not every production will be heterotopic. A heterotopic zone may also only be apparent in a fleeting, fragmentary, or transient form, if it is even possible to perceive. It may take some thinking and rethinking to discern, but that does not diminish its value or the merits in exploring it.

This method demonstrates that the glimpses of heterotopia are easier to discern when spatial structures on the stage are enacted in a fragmentary manner. Theatre not only demonstrates such fragmentation visually, it also shows us how to break down larger spatial structures into more manageable aspects that can be understood, investigated, and rethought. Heterotopia reconfigures space in several other significant dimensions as well: it encourages researchers and critics to think of theatre in a more plastic and three-dimensional fashion. Reconceiving performance in three dimensions reshapes our understanding of a script and its narrative, of the potential of performance, and even of the world beyond performance. It recalibrates how to visualize theatre and performance. While most commentators assume that the visuality of theatre is a given, many accounts of both actual performances and reading strategies for describing performance often lack a sustained sense of that visuality. I hope that my version of heterotopia will fill that gap in its promotion of looking to space deeply, and in its advancing of the analysis of a broad spatiality that covers the full stage and beyond. Its conceptual leap in how we conduct analytical research in theatre and performance is a result partly of an activation of a fuller range of theatre's multidimensionality and visuality, and partly of the cross-disciplinary nature of heterotopia. It links visualization and conceptualization in a form that enhances both.

Theatre is, of course, not the only discipline that could benefit from a deeper engagement with a strong means of spatial analysis. My

study provides the opportunity for application to spatiality in other disciplines where a three-dimensional approach would enhance the form, content, and political impact of analysis. It is particularly useful for those disciplines which visualize culture's relationship to a wider socio-political context. The ability for heterotopia to shift to accommodate change (for instance, how constructed and abstracted spaces might alter according to broader cultural contexts) suggests its relevance to disciplines that embrace a potentiality of what else might be. This model should produce more comprehensive accounts of space's fundamental role in artistic expression such as film, literature, and art installations, to name just a few. Heterotopia can contribute to the ever-widening field of cultural identity, which has much to learn from a method that focuses on a larger cultural context and the spatial dynamics through which it is shaped. A cultural geography that responds to heterotopia might offer a more acute awareness of how cultural expression intervenes in and helps support and develop its social context. Heterotopia also offers the means to interrogate the crucial spatial aspects of our increasingly mediatized world. A further potential means of marking heterotopic spatiality is to heed Russell West-Pavlov's comment that heterotopias illustrate the fault-lines of social change (2009, p. 138), a point that I raised in Chapter 1. Heterotopia provides potential for the framing of urban geography and the marking of public space that also recognize fault-lines or unsettlement. Public protests and environmental interventions that explore resistance to the constructions of social space could benefit from heterotopic analysis. Heterotopia offers the means to shape the 'space' of protest more effectively. While heterotopia is a fluid form that needs to be imbricated in a contemporary context, it can also embrace a rich historicity that encompasses how spatiality has functioned in the past. Heterotopia's application must, however, have a specific political outcome: as David Harvey insists, heterotopia cannot simply note other worlds or realms (2009, p. 111). There must be some semblance of articulating alternate orderings in terms of some form of social change, or the concept holds no potency.

To return to theatre, I argued in the Introduction to this book that heterotopic theatre has the capacity to be world-making. If one thinks of theatre in the way that Howard Barker does, that '[t]heater is not a disseminator of truth but a provider of versions' (1993, p. 44), world-making is a matter of creating moments, however fleeting,

that enable us to imagine alternatives to the actual world. Despite the fact that the performances I see often fail to take spatial risks, I nevertheless remain hopeful that the next production I attend will engage in staging the gaps or the absences that facilitate connections between the potential of what happens on stage and matters beyond the theatre's walls. For Henry Giroux, '[w]hat hope offers is the belief, simply, that different futures are possible. In this way, hope can become a subversive force, pluralizing politics by opening up a space for dissent, contingency, indeterminacy' (2004, p. 63). This is the aim of heterotopia. I hope that I have demonstrated that performance – whether traditional theatrical productions or pieces that combine with the latest technological advances – is an excellent medium for its exploration.

Notes

Introduction: Theatre, Space, and World-making

1. This work is primarily focused on theatre studies but its argument also pertains to the broader field of performance studies.
2. For a fuller discussion of this text, the significance of land rights, the importance of simultaneous occupation, and the staging of landscape in Australia, see my *Unsettling Space* (2006, pp. 25–48).
3. Escolme describes the ways in which a similar design decision was used in a Royal Shakespeare Company production of *Richard II* with Sam West, directed by Steven Pimlott at The Other Place in 2000. Her interpretation of this moment takes the argument about the externalities in a different direction – she explores the 'violence done to conventions of inside and outside' (2006, p. 107) – but she recognizes this staging technique as a challenge to space, reality, and as a result, the politics of the play itself. A movie that mirrors this approach is Tim Robbins's 1999 *Cradle Will Rock* about the actual 1937 attempt to mount Marc Blitzstein's left-leaning musical of the same name. It depicts the power of theatre in the United States where the hunt for Communists among artistic communities destroyed lives and careers. Thanks to Fred D'Agostino for alerting me to this film.
4. Barker's argument may appear to be utopian rather than heterotopic but as I argue in Chapter 1, there are intersections between these terms. While heterotopia also has a utopian aspect, I regard it as more likely to be materialized than utopia.
5. Of course, analysing performance necessarily calls on a broad range of theatrical features.
6. Theatre is, of course, already distinguished from the world when it occurs in a purpose-built venue. Theatre that engages with heterotopia acknowledges more intensively than usual both the discreteness of its location(s) and the possibility for a closer connection with the world beyond the venue.
7. See Hetherington's argument that factories generally are not heterotopic but one particular factory (Josiah Wedgwood's) could be (2001, pp. 52–70).
8. The fleeting nature of insights in theatre can be frustrating for theatre researchers but it is also part of theatre's appeal. For accounts of elusive exchanges and meaning-making in theatre, see, in various contexts, Dolan 2005; Hodgdon 2012; Phelan 1997; Skantze 2013; and Sofer 2012.
9. See also Lefebvre's 'possible-impossible' 'U-topia' (2003, p. 39).
10. For an account of the history of space and place, see Casey's *The Fate of Place*. Unless otherwise specified, I follow Lefebvre's conclusions

187

regarding space as a chief determining factor in culture and his lead in referring to space as the larger entity, although Casey's theory of place is particularly helpful in my construction of heterotopia, as I outline in the next chapter.

11. Of the many studies that exist on theatre space, see Mackintosh's history of the western theatre through an analysis of its playhouses (1993). Others that address spatiality in theatre, at least to some extent, include: Carlson 1989; Chaudhuri 1995; Chaudhuri and Fuchs 2002; Dillon 2000; Garner 1994; McAuley 1999; McKinnie 2007; Sullivan 1998; Tompkins 2006; and Ubersfeld 1998.

12. I am not using 'possible worlds' in its narrative theory context.

13. This categorization assumes that the location of such performed spaces must also account for the (usually urban) geographical context. For more on this, see Carlson 1989 and McKinnie 2007.

14. See Carlson for an account of the 'haunting' of theatre venues (2003a, p. 140), whether in terms of previous productions that were housed in the same venue, the re-use of props or even set designs, among other echoes of productions past.

15. Among the commentators on site-specific performance (which I address in Chapter 2) see Birch and Tompkins 2012; Thomasson 2011; and Wilkie 2008.

16. McAuley extends this argument in her analysis of all the locations in a theatre venue (1999, pp. 24–32).

17. Certainly the connection between space and theatre design or scenography is essential, as Howard articulates: 'space is the first and most important challenge for a scenographer' (2002, p. 1). Most people who attend theatre don't have the skill to isolate a production's design elements (such as colour, composition, balance, line). A closer analytical relationship between design and theatre is clearly desirable but beyond the scope of this project.

18. I do not, however, insist that all performances make, or must make, such a connection but I often find more rewarding the performances that do.

1 Theatre and the Construction of Alternate Spaces

1. I am less well-equipped to articulate a methodology for a production tool than I am a reading strategy. Nevertheless, the two emerge strongly from my study of heterotopia. This project leaves scope for others to analyse exactly how heterotopias might enhance performance production.

2. Utopia has been deployed by so many different cultural sectors that Neville-Sington and Sington maintain it to be 'one of mankind's principal navigational instruments for at least five hundred years' (1993, p. 253).

3. See also Hetherington's outline of the term's anatomical origins: '[i]t is used to refer to parts of the body that are either out of place, missing, extra, or, like tumours, alien' (1997, p. 42).

4. For more on utopia, see those sources referenced above, and Bisk 2002; Bloch 1988; Gindin and Panitch 2002; Giroux 2004; Jestrovic 2013; Markus 2002; Schehr 1997; Wegner 2002; Wood 2002; and Yoran 2002.

5. See also Muñoz's *Cruising Utopia: The Then and There of Queer Futurity*, which takes a different approach to utopianism, although it is as hopeful as Dolan's book and my own. Like Dolan's, it is not fixed in space per se, but more in time.

6. As I explore later in this chapter, the other component of utopia – the 'good place' – is, for me, equally important. It operates as a unity in the context of 'utopia' but as a separate spatial field in 'heterotopia'.

7. Marin frames the 'place' of utopia differently, arguing '[i]t is often said that it [utopia] is an imaginary place. Rather, it is an indetermined place. Better yet, it is the very indetermination of place' (1984, p. 115).

8. Dolan suggests a fusion of the good no-place that is theatre but as I outline below, heterotopia occupies a space between these two structural components.

9. While I appreciate Dolan's project very much, it received some criticism, which Reinelt sums up as follows:

> [r]eaders will find her arguments variously persuasive or weak depending in part on whether or not they are prepared to accept some of her premises: that emotional experience might lead to social action, that performances can create a temporary community, that respect for difference does not interfere with experiencing an intersubjective sense of common humanity, that there is a spiritual dimension to extraordinary performances. (2007, p. 215)

My project will, I hope, sidestep similar criticism because of its somewhat 'firmer' grounding in spatiality.

10. There are other variants of the conventional topos of utopia: for instance, in a non-theatrical context, McGrath conjures 'simultopia' which, in the context of contemporary Bangkok, is 'a hyper-modern milieu of surfaces and signs without an authentic centre or origin over-occurring within the same space of ancient beliefs, practices and rituals' (2002, p. 204).

11. Dolan comments that dystopias and utopias are not mutually exclusive: 'spectators might draw a utopian performative from even the most dystopian theatrical universe' (2005, p. 8).

12. Lefebvre mentions heterotopias in the context of a topos grid: 'isotopias, heterotopias, utopias, or in other words analogous places, contrasting places, and the places of what has no place, or no longer has a place – the absolute, the divine, or the possible' (1991, p. 163). He briefly articulates heterotopias as mutually repellent spaces (1991, p. 366) and as inverted space: 'full space may be inverted over an almost heterotopic void at the same location (for instance, vaults, cupolas)' (1991, p. 224). He refers to the concept further, briefly, in *The Urban Revolution* (2003, p. 38 and pp. 128–32). See Johnson (2006, pp. 83–4) for a discussion of the potential relationship between Foucault's heterotopia and Lefebvre's urban

utopia. Harvey takes Lefebvre to task for suggesting that everything can be a heterotopia (2013, p. xvii).

13. See also Lefebvre (2003, p. 4) and Casey (1997, p. 301).

14. See also Casey (1997, p. 300). Relph is perhaps the most enthusiastic proponent of heterotopias as they directly connect with geography:

> [h]eterotopia is the geography that bears the stamp of our age and our thought – that is to say it is pluralistic, chaotic, designed in detail yet lacking universal foundations or principles, continually changing, linked by centreless flows of information; it is artificial, and marked by deep social inequalities. It renders doubtful most of the conventional ways of thinking about landscapes and geographical patterns. (1991, pp. 104–5)

> For others who write constructively on heterotopia, see Boyer 2008; Faubion 2008; Hook 2010; Johnson 2006; Kohn 2003; Pinder 2005; and Topinka 2010.

15. Among the theatre scholars who refer to heterotopia, Birringer uses the term in passing to describe Makrolab, a Project ATOL intervention in the notion of museum exhibitions (2000). Jestrovic mentions heterotopia in the context of theatre in Belgrade (2013, p. 71). Moser isolates heterotopia as useful for understanding two plays by the Canadian playwright, Margaret Hollingsworth. Moffat analyses the heterotopic woods in *A Midsummer Night's Dream* (2004). Meerzon uses the term to analyse Joseph Brodsky's work (2007, p. 187), Juffer to understand baseball (2006), and Chung on film and globally dispersed production sites (2012). Beyond this partial view, others deploy the term in contexts that seem questionable. See Defert's critique of Rella and Teyssot (1997, p. 280). Siebers's edited collection, *Heterotopia: Postmodern Utopia and the Body Politic*, refers to the word only twice (see p. 32).

16. It is possible that productions of these plays (versus the scripts themselves) could be heterotopic with sufficient spatial exploration.

17. In heterotopia one need not isolate utopian space; while the two are related, the existence of one does not depend on the presence of the other.

18. To locate a 'no place' in performance, one might turn to Augé's concept of a non-place (1998, p. 97), which is also able to be identified and situated in culture and, as I argued in *Unsettling Space*, on stage.

19. Hetherington outlines six ways in which heterotopia has been used (1997, p. 41) to contest our understandings of the 'real'. My study does not articulate specific types of heterotopia, preferring to address the concept as a whole and its productivity to theatre research.

20. I return to this production briefly in the analysis of another *Timon of Athens* in Chapter 4.

21. Lavender describes emancipation as 'not so much liberation as the possibility of disagreement. The "emancipated spectator" is not a looker-on but someone who is involved – which raises all sorts of questions for spectatorship, agency and participation' (2012, p. 308).

22. I stress that I am not insisting that all performance look forward or produce a spatially complex scenography. I do, however, find myself preferring those that do.
23. Linking Bachelard and Foucault, Casey coins the term 'heterotopoanalysis' (1997, p. 297).
24. On applied theatre, see Thompson 2009; and Prendergast and Saxton 2009.

2 Heterotopia and Site-Specificity

1. These productions also raise questions about distinctions between 'theatre', 'performance', and 'installation' (among other sub-genres), distinctions that are beyond the scope of this chapter. I admit that I use some terms somewhat interchangeably, when others would keep specific boundaries around them. I believe that my methodology applies equally to all these art forms. However they are termed, I have limited the case studies in this chapter to two so that I can analyse each in sufficient depth.
2. Not all site-specific performance has a narrative per se, but the examples that I explore in this chapter do. Site-specific performance that does not have a strong narrative structure can still demonstrate and build on heterotopia.
3. For fuller versions of the history of site-specific performance, see Wilkie 2008. She also argues a clear account of the types of site-specificity (2004, p. 54). See also Tompkins 2012a.
4. I experienced *And While London Burns* on 17 November 2008 and 14 September 2010. For reviews of the production, see Kimberley 2006; and Jonathon Brown, Crooks, Dunmall, Hopson, and Mason (all 2007). I use present tense in the description and analysis of this production since, at the time of writing, it is still possible to undertake the audio-tour. The next example, however, is specific to a particular day in 2008, so I use past tense in its description.
5. www.andwhilelondonburns.com. All further references to the dialogue and stage directions of this production are from the audio 'track' at this location.
6. See Tompkins 2011 for a detailed discussion of the effects of this production in the context of Deepwater Horizon, using a comparable analytical frame to explore psychogeography, a term that has connections to the operations of heterotopia.
7. The only cost is entry to the Monument, which was £2 in 2006; following the 2008 refurbishments, the fee rose to £3.
8. When the trader takes over the narrative later in the piece, he provides a few more street names than the guide and his instructions are a bit easier to follow. Both voices also provide instructions based on (relatively) stable landmarks, such as 'turn at the cash machines' or 'turn right at Caffè [sic] Nero'.
9. In this chapter only, I provide subheadings for each of the types of space in a heterotopic analysis to assist readers in understanding its method.

10. Further, participants are asked to stand facing the hot exhaust fans at Bank station for what feels like a very long time, long enough to hear about a nun who immolated herself to protest the Vietnam War, one of its many embedded sensory parallels. For Welton, this scene is central to the performance's affect,

> not just in the effect of the warm air but also in the process of its return to the atmosphere of the city at large, itself blown through by the westerly winds which move down the Thames valley, pushed there by the flow of the Atlantic gulf-stream. The condition of air is critical to investigating *And While London Burns*, not only because of the political interchange between atmospheres marked by the Bank station fans, but also because in this way it imbricates the listener in the atmosphere of the city itself. (2008)

11. See the Royal Exchange website.
12. The production does not engage with the people in buildings, one exception being the Deutsche Bank employees whom participants watch working, through a window on a pedestrian overpass.
13. According to *Heritage Key*'s 'The Ancient World in London' (2011),

> [t]he Temple of Mithras, or London's Mithraeum, is a large Roman temple, built between 307–310 AD, dedicated to Mithras, the Persian god of light and the sun [...]. Mithraism emerged as a serious rival to Christianity in the Roman Empire around the second century AD, and was a men-only cult in which those indoctrinated would be subject to fearsome initiation ceremonies.

14. A further limitation then was that the Monument was closed for refurbishment during 2008–09.
15. While the piece was designed in 2006, well before the Global Financial Crisis (GFC), it did predict the crash. The guide explains the 'skyscraper index': 'when large buildings are finished, there's a recession or other financial collapse'. The narrative reminds the participant that (in 2006) 'London's in the midst of a skyscraper frenzy', despite many of the towers being only half-occupied at the time. The collapse of large companies in 2008 meant that occupation rates were even lower. Further, if *And While London Burns* achieved an extension and intensification of Platform's message in 2008, its 2010 context took on a yet more historicized meaning with the deaths of the Deepwater Horizon rig workers and the oil leak in the Gulf of Mexico. The financial networks described in *And While London Burns* were put into stark perspective by the profits available to the players in the carbon web, notably BP's former CEO, Tony Hayward (see Orwall, Langley, and Herron 2010).
16. *Suitcase* has since had a second iteration in 2013 to commemorate the 75th anniversary of *Kindertransport*; this more recent production also

incorporated tours to train stations in other UK cities. For an earlier version of the argument in this section, see Tompkins 2012b.

17. Liverpool Street Station has another historical claim to fame that did not appear to have a direct bearing on *Suitcase*: from 1247 until 1676, it was the site of the original Bedlam, the Bethlem Royal Hospital (Whittaker 2010), which developed from the prior of St. Mary of Bethlehem and was 'first referred to as a hospital for "insane" patients in 1403, after which it has a continuous history of caring for people with mental distress' ('History' 2010). Much more recently, the station has been deployed in several cultural contexts, including T Mobile's 2009 flash mobbing advertisement, and it marks the end point for Janet Cardiff's 1999 audio-walk, *The Missing Voice (Case Study B)*. While these historical elements are in themselves not important to *Suitcase*, they may have intersected with some audience members' interpretation of the site.

18. See the story of John Berrys (born Hans Berlinsky) who, at 17, 'joined the British army, feeling "a sense of obligation toward the country that had given me refuge when others wouldn't"' (Berrys qtd in Gooderham 2008).

19. The production also relied on volunteers to lead the groups of about ten audience members each.

20. Brooks (2008) quotes Richard Attenborough, whose family took in two *kinder*: 'I will never forget when Helga and Irene first arrived at our home. [...] Two pale waifs with their pathetic little suitcases.' For Brooks, 'it would be hard to find a more appropriate and evocative name' for the play than *Suitcase*.

21. Such gender issues returned less comically in a scene with Stephan (who had been assumed to be 'Stephanie') who did not meet his adoptive family's gender expectations. A family with five girls just managing financially agreed to take one more girl, only to meet Stephan. Whereas the humour of the 'wrong' child was played up in the scene described above, the generosity of Stephan's foster family did not (could not) extend to Stephan's desperate requests for them to help save his mother; I return to this scene in subsequent pages.

22. The audience was constructed in other roles as well: commuters, foster parents, and volunteers.

23. In the 2013 iteration of *Suitcase*, volunteer guides explained that any donations made by audiences would go to a contemporary charity, thus extending connections well beyond 'just' *Kindertransport*. I am grateful to Sarah Thomasson, who attended the 2013 production, for this point.

24. I inadvertently contributed a further dimension to this 'watching': some fellow audience members were curious (possibly suspicious) about my note-taking, several asking me what my notes were for.

25. The production also causes one to recall examples of the failure to provide compassion. In Australia, for instance, the children of asylum-seekers are locked in detention centres. I am grateful to Sarah Thomasson for this connection.

26. Flor Kent was commissioned to create the original statue, which included a glass case containing some memorabilia from the time, donated by *kinder*. The case was damaged by moisture so the items were moved to a safer location and Meisler's statue replaced Kent's.

3 Heterotopia, the National Theatre of Scotland, and 'Theatre without Walls'

1. The National Theatre of Scotland is not the first such theatre: Toronto's Theatre Passe Muraille has used this ethos (if within the confines of a building) since 1968 (see McKinnie 2007, pp. 75–6). I interviewed Caroline Newall in 2008 when she was NTS's Workshop Director (she is now Director of Artistic Development). She noted pragmatically that at one level, having a building 'would be easier because you wouldn't be having three shows opening in the same week so your staff wouldn't be split all over the country [...] but the idea of having one building just seems so repulsive [... and] bogged down in conversations about leaking rooms and maintenance'.
2. NTS's fundraising arm is the 'Theatre Without Walls Fund'. For the intentions of the new NTS Artistic Director, Laurie Sansom, to pursue this ethos, see Sansom 2013.
3. See Field 2009 for an account of how the National Theatre Wales has explored this format since its 2010 inception.
4. Even rehearsals have to this point been in multiple locations across Glasgow but the company moved to a consolidated office and rehearsal space in 2014 so that all its operations – except performance itself – could be under one roof in the Spiers Lock area of Glasgow ('Scottish' 2008).
5. All the productions are outlined on the NTS's extensively archived homepage. See also Reid 2007 for an outline of each *Home* production.
6. See DiCenzo (1996, pp. 83–7), Harvie (2005, p. 34), Trousdell (1996, p. 4), and Reid (2013). See Reid for a comparison of the development of NTS and the Scottish parliament (2007, p. 196).
7. See also 'Wha's [sic] like us... National Theatre of Scotland', published during the 2008 Edinburgh Festival:

 > [t]ake a bow, the National Theatre of Scotland. If drama were an Olympic event, this outfit would win gold. [...] [I]t has achieved global fame at lightning speed. Its lack of a home – initially controversial – has helped the company to reach a wide audience. [...] The company is truly a jewel in Scotland's cultural crown. (2008, p. 16)

8. While I saw *365* in Scotland, my experience of this company has been mostly through tours, which invariably inflects my interpretation of its relationship to the 'space' of Scottish identity, both inside and outside Scotland. I do not explore NTS productions on the basis of their

engagement with Scottish heritage or diasporic communities inter-
nationally per se, even though there is scope for both analyses. For a
critical account of *Black Watch*'s connection to Scottish heritage and
nationalism, see Zerdy 2013.

9. Archibald claims that *Black Watch* 'is one of the most successful Scottish
 theatre productions of all time' (2008a, p. 279). I saw *Black Watch* in
 Perth, Australia in 2008, when it toured as a feature in both the Perth
 International Arts Festival and the Sydney Festival. In addition to the
 international tours, it was published in 2007; a production was filmed for
 a BBC Scotland broadcast (2007) and released as a DVD (2008). In 2012
 Black Watch toured to China and Korea and, in 2013, to the US again.

10. The Black Watch is now '3rd Battalion, Royal Regiment of Scotland
 (3 SCOTS)' (Archibald 2008b, p. 9). A promotional slogan in the NTS
 brochure suggests that *Black Watch* is 'an unauthorised biography of the
 legendary Scottish regiment' (*Summer-Autumn Brochure* 2006, p. 5) and
 the *Black Watch* site links to the homepage of the regiment.

11. The stage was used particularly well in the last scene in which the soldiers
 talk to the writer, this time about the deaths of their colleagues. The
 soldiers, clearly wishing not to discuss this, sat at one end of the traverse
 playing space, the writer character at the other. The setting that had been
 shaped earlier to provide a more intimate pub context was no longer in
 play, this scene's evocation of loss and the inability to explain it being
 now more significant.

12. See Robinson for an account of how tours of the play were, initially,
 planned to be performed only in drill halls (2012, p. 397). *Black Watch*'s
 phenomenal success prevented this plan from being implemented. It has
 been performed in arenas, football academies, and, in Perth, an exhibition
 centre, all of which are flexible enough to suggest a drill hall, in an attempt
 to maintain some sense of the traverse stage and original site-specificity.

13. All quotations from *Black Watch* are to this edition and indicated in the
 text with the appropriate page reference.

14. Two of Archibald's arguments against *Black Watch* are the omission in
 Cammy's history of the regiment's involvement in Ireland (2008b, p. 9) and,
 in the context of the current battle, the Iraqis themselves (2008b, p. 11).

15. For a contemporary example, see *Tuntematon Sotilas* (*Unknown Soldier*),
 produced at the Finnish National Theatre between 2007 and 2009 and
 directed by Kristian Smeds. Its ironic view of the novel of the same
 name that has national treasure status in Finland enacts an anti-war mes-
 sage. Thanks to Hanna Korsberg (with whom I saw this production) for this
 insight. In his analysis of *Black Watch*, Steve Wilmer notes the material value
 of this production is such that Alex Salmond, the First Minister of Scotland,
 'takes great pride in the production and [...] [h]e has used the play "not once
 but three times to celebrate the opening of the Scottish Parliament and the
 Scottish National Party's first crack at government"' (2009, p. 82).

16. Burke notes, 'we never had a soldier [who attended *Black Watch*] who
 said, "That's untrue". Everybody who's seen it, whether they're Black

Watch or American soldiers, has said: "That's what it's like. You've got it spot-on"' (qtd. in Logan 2008, p. 18).

17. See Letts 2008 on the differences between the performance in Edinburgh and London.

18. Heyvaert and Verhulst wrote the play for the Belgian theatre company, Victoria, and it toured Europe and Canada in 2005; see the introduction to McLean's published script (2007a, p. iv).

19. Young notes critiques of the play for 'not signpost[ing] what is actually documented and what is invented' (2009, p. 76).

20. Michael Delaney tried to blame everything on 'the system' but the Voice rejected this position (McLean 2007b, p. 40). Further quotations from *Aalst* are to this edition and indicated in the text by the appropriate page reference.

21. Even those audience members who knew nothing about the play learned the premise quickly from context.

22. This exchange was the only time the actors looked at each other in the play.

23. Many of the venues in which *Aalst* was performed were larger venues, not the intimate spaces that may have originally seemed appropriate to a production with only two live actors and few set constraints.

24. See Grehan for a discussion of the audience response to the performance's 'reveal' in this final scene (2010, p. 7).

25. See also Young (2009, p. 80); Grehan (2010, p. 14); and M. Brown (2007).

26. My analysis of *365* takes its lead primarily from the Edinburgh International Arts Festival production, which I saw on 25 August 2008. It is supported by the performance I saw on 11 September 2008 at the Lyric Theatre in Hammersmith, London. *365* premiered at Eden Court, Inverness just before its Edinburgh Festival run.

27. This explosion provided a counterpoint to the explosion and dismembering of the Black Watch soldiers. In both cases, literal and symbolic explosions provide a slow, careful construction of unity, albeit fragmented and incomplete. I am grateful to Joanne Zerdy for this observation.

28. The rest of the cast interacted with the set of J's constructed space in various ways, sharing the fantasy. They appeared comfortable, although they may still have been in their own flats: perhaps only J was in this forest.

29. Featherstone relates that '[i]n theatre, people are desperate for stories. So what happens when a character comes on stage who does not have one, or does not know it, or does not want to tell it? What does that mean for an audience?' (qtd. in Phelan 2008, p. xxiv). C's creation of a family photo for himself is a poignant attempt to deal with the holes in his story.

30. Not surprisingly, the young people became very angry at times. The many movement pieces tended to evoke their emotions, positive and negative. In one example, the dance of restraint, the entire cast performed the actions of an out-of-control teen being restrained by a social worker or police officer. The synchronized movement suggested that the intensified feelings they demonstrated were much the same for any child in this situation. *365* relied on affect through, among other features, the song written for it by Paul Buchanan of the Glasgow band, the Blue Nile.

31. The play also staged how desperate the teens were for love and affection. At one point, one boy showed C how to hug in a moving, non-erotic scene of managing basic emotions.

32. Andrew Dawson, a child psychotherapist, explains in further detail in *365*'s program:

> independent living is not only about material resources and social and domestic skills but also about the emotional journey towards a sense of self. Central to this is being able to care for oneself, to tolerate the needs of others and to have relationships in which care may be sought with a sense of security. Imagine the immensity of this task for young people who do not have any good parental figures with whom to relate. (2008, p. xxvi)

33. For instance, I assume that V (played by Simone James), a teen whose preoccupation was setting fires, died in a fire that she ignited. The scene in which she burned her pillow saw the entire flat consumed in flames. After escaping, V returned inside the burning building and failed to re-emerge. She did not seem to appear in the final scene of the play that took place shortly thereafter.

34. The NTS website offers *vox populi* responses to the Edinburgh season of *365*, and on YouTube, to the Lyric season. Admittedly the NTS uses such a website function to illustrate positive reactions, but nevertheless, this anonymous comment seemed indicative of the audience response the night I saw the production: 'I thought it was extraordinary. I thought it was emotionally devastating and a relentless picture of what's probably the reality of kids' lives. I'm trying to watch and think about how we translate that into something that makes a difference' ('Audience Reactions *365*' 2008).

35. The 2012 end-of-year figures had increased to over 91,000 children in care ('Statistics' 2014). Statistics for 2013 are harder to source since the National Society for the Prevention of Cruelty to Children (NSPCC) has begun keeping them differently, according to separate areas and types of care, rather than for the UK as a whole. The flyer distributed after *365* provided details of websites to learn more and/or offer assistance.

36. While the production used the full Playhouse stage well, it tried to make the auditorium more intimate by not selling the stalls seats under the balcony, and curtained off this temporary 'dark' space. The Edinburgh audience had a more casual feel, and many were young people. I attended the London production on press night, which had a more official feel.

4 Re-establishing Heterotopic Relationships at Shakespeare's Globe Theatre

1. Of course, I do not imply that the focus of the Globe in its first decade has been either problematic or uniform.

2. To illustrate his argument, West notes that 'gallants stole lines from the plays to be used when dining out' while in his turn Ben Jonson 'merely lifted dramatic dialogue from what he heard in their company' (2002, p. 42).

3. For more on the debates about the venue, see Prescott (2005) and Worthen (2003). For more on 'original practices', see Gurr (1989) and, in a different context, Conkie (2006).

4. Worthen's project examines the ways in which text moves to performance. Both his project and mine focus on the power and effect of the venue, although they differ in that he argues that the world influences the production of the text, questioning any claims to historical authenticity, whereas I demonstrate how theatre might influence contemporary culture.

5. The effect of the building is somewhat ironic, however, when the layers of history that structured the Globe may not necessarily communicate clearly to audiences today: as Wiles comments, 'Shakespeare's cosmological terms of reference, for example, belong to a culture that has vanished' (2003, p. 193).

6. Shakespeare repeatedly reminds audiences that 'worlds' can be conjured on stage to articulate matters related to the outside world and to rehearse solutions to those problems. See Jaques in *As You Like It*, 2.7.140–167; Prospero in *The Tempest* 4.1.146–158; Macbeth in *Macbeth*, 5.5.25–29; the prologue in *Henry V*; and Antonio in *Merchant of Venice*, 1.1.77–79. These references to the relationship between theatre and the world echo Foucault's construction of heterotopia, but my analysis builds on them to also take performance into account.

7. Given the enormity of the topic, I have room to focus only on a few. I set aside Weimann's analysis (2000) of *locus* and *platea* which, while useful in analysing spatial contexts in scripts, is less helpful in the more spatially detailed sphere of performance. See also Poole's account of Shakespearean theatre being interpreted spatially through *trompe l'œil*, anamorphosis, and palimpsest (2011, pp. 133–4).

8. For a detailed study of this era's 'production' of the city, see Dillon 2000; Grantley 2008; Hopkins 2008; Mullaney 1988; Sullivan 1998; Weimann 2000; and West 2002.

9. Hopkins provides extensive examples of London being compared to a stage (2008, pp. 25–31), even isolating the theatrical origins (through John Lyly) of space on stage 'not only being "here" but also being "elsewhere"' (2008, pp. 60–3), a concept that is now, of course, a fundamental component of theatre practice and interpretation. Sanders isolates how Richard Brome's *The Antipodes* also 'collapse[s] the spatial difference between "here" and "there" in unsettling ways [...] responding not only to the massive expansion of England's capital city, but simultaneously to the emergence of a new colonial identity, and, with it, a new world geography' (2011, p. 235).

10. See also West (2002, pp. 50–6) who argues for a *liminoid* relationship (as opposed to a marginal association) between the city and the theatres in

the Liberties, which permits further interpenetration of ideas and con-
structions of space.

11. While the analysis of a production on video inevitably alters the effects of
a performance, the opportunity to compare more productions than were
in season when I could visit outweighed liveness as a sole criterion. To
counteract the limitations of analysing recordings, I watched at least two
different performances, paying particular attention to audience response
and to what reviewers noted about those responses. The readings of
Pericles and *Timon* are also informed by extensive reading of textual
criticism.

12. Many reviews were unfavourable, perhaps because this production pre-
sented a radical departure from the kind of work that had, to then, been
performed at the Globe. Almost all, however, praised the theatricality of
the shipwreck scenes.

13. Pericles the Elder was played in very early performances by Corin
Redgrave, but illness forced him to withdraw. This role was covered for
the rest of the run by John McEnery. Pericles the Younger was played by
Robert Lucskay.

14. Nightingale's review points (disapprovingly) to another act of highlight-
ing 'performance' and what it can be, even in the Globe: 'the pretend
quarrel between Pericles and Thaisa's father, Simonides, becomes a spoof
wrestling match, with prince kicking king, king twisting prince's nipples,
and so on' (2005). Billington's review notes the aerialists' turning 'the
tournament at Pentapolis into a spectacular modern Olympics as they
hang upside down from ropes or dangle dangerously from circus hoops'
(2005, p. 24). This irreverence that Nightingale questions and the acro-
batics that Billington praises fit entirely with Gower's role and one part
of what he appeared to be trying to achieve as Chorus in this production.

15. All quotations to this production were transcribed from the archival
production I watched at Shakespeare's Globe archives.

16. Designer Liz Cooke created most locations very simply: at times bits
of driftwood around one of the columns signified a land that bordered
the sea. An exception was the doors at the back of the stage for the
scene in Antioch. These metal elevator doors removed the activity from
Shakespeare's day, placing it squarely in a contemporary world.

17. See Office for National Statistics, Annual Population Survey 2007.

18. In 2005 Bob Geldof's television series, *Geldof in Africa*, aired about the
regions of Africa that remain particularly poverty stricken, twenty years
after the 1986 Live Aid movement. That year he also spearheaded the
Live 8 concerts in G8 countries and in South Africa to end third world
debt; these concerts were held in conjunction with the UK's Make
Poverty History campaign and the Global Call for Action Against Poverty.
These extra-textual comments were integrated well with the action and
with Gower's character.

19. To cite just two examples, at one point, Pericles was handed a WWI
pilot's jacket, while the tournament at Pentapolis through which Pericles

won the hand of Thaisa included contestants wearing costumes recognizably associated with the Olympics, shortly after the announcement that London had been awarded the 2012 Games. Further indications of the 'extension' of the global spatial reach in this production include Gower's 'cosmic' powers: briefly taking the part of Cerimon, he exhibited the restorative magic to revive Thaisa from the dead. In addition to freezing action, he could appear to be invisible to all except the audience and Pericles the Elder, who could not be rid of him. Gower's Prospero-like authority was most clearly demonstrated by means of the storms that appeared to arise at his behest. Gower's music also became the music of the spheres. Finally, after the performance's conclusion, the actors threw magic dust to the audience, reinforcing the other-worldliness of the production.

20. The multicultural nature of this production was not simply inspired by the British Empire: young Pericles (Lucskay) was Hungarian, while the Italian actor, Marcello Magni, played several characters (and assisted in the choreography). Gower drew attention to the cultural heritage of all actors on stage (see Dachel 2006, p. 498).

21. Dean's analysis of *Pericles* suggests that this interpretation is not too far from the original: romance's 'art is the means of psychological and spiritual metamorphosis, a route to, rather than a diversion from, truth and reality' (2000, p. 128).

22. The historical layers of this production are yet deeper. The parallel between Naiambana's Gower and the 'original' Gower is worth drawing out: the remains of the historical poet, Gower, lay only a few hundred metres from the Globe, in Southwark Cathedral. Cochrane notes the disjunction of their having been there for some two hundred years when Shakespeare's play was first performed, something that the original audiences would have known, even if contemporary audiences may not recognize the name of Gower (2013, p. 127).

23. In her review of *Pericles* and several other productions, Dachel interrogates a different relationship to the world outside, that of the 2003 tsunami (2006, p. 497). While I could not make this connection, it is possible to pursue a heterotopic analysis via other such real-world frames.

24. The Globe has a policy of working closely with its community as this note on their website outlines:

> **Do you live, work or learn in Southwark? Then Shakespeare's Globe is here for you.**
> We work with the local community to deliver a huge range of projects every year. These range from Youth Theatre groups for local children, to annual productions when Southwark residents come together to perform on the Globe stage.
> The borough is constantly evolving and is now home to hundreds of diverse communities. Our commitment to reaching beyond our building and into the schools, streets and homes of Southwark remains at the heart of our mission.

Each year, we seek to create new partnerships with Southwark schools and the wider community. We are also committed to finding new partners to support the extension of our work in Southwark.

'It has always been the policy for the Globe to be an integral part for [sic] *Southwark and its people'* – *Sam Wanamaker.* ('Southwark' 2013; original emphasis)

25. William Dudley, *Timon's* designer, notes in the programme that Bosch's paintings were also influential in set and costume development (2008, p. 7).
26. Minton comments that it is relatively commonplace to stage *Timon of Athens* in times of economic downturn: '[p]roductions set during the stock market crash of 1929, the oil crisis of the 1970s, and the bursting of the dot.com bubble in the 1990s have resonated strongly with audiences, proving that the symbolic nature of *Timon* can give us a lens through which we can look at the follies of our own society' (2009, p. 344). In 2012, the National Theatre's production of *Timon*, with Simon Russell Beale in the title role, focused much more directly on the GFC and the Occupy Movement. Its heterotopic potential is also considerable, drawing as it did on the actuality of London locations, but there is not room in this analysis to explore it here.
27. See Cartelli: 'what finally distinguishes *Timon* from Shakespeare's other tragedies is not its failure but its refusal to be complementary' (1991, p. 183). That is, the play provides no alternative discourse for its audience to emulate. Further, he argues, '*Timon* may, admittedly, be demanding more than audiences are normally accustomed to give; it may require playgoers to break critical habits of mind that are ineluctably tied to their psychological need for defences against precisely the kinds of denial with which *Timon* is preoccupied' (1991, p. 184). The authorship of *Timon of Athens* has come under question; there is agreement now that Thomas Middleton contributed sufficient scenes to *Timon* that it be credited to both Shakespeare and Middleton (Vickers 2004). See also Jowett, *Shakespeare and Text* regarding Middleton's mark on *Timon* (2007, pp. 24–5).
28. Allfree's review draws attention to the religious connotations in the costuming of Timon, played by Simon Paisley Day: '[d]ressed in white, he first appears blessed with a Christ-like munificence, initially blind to the fact that such naivety is sheer folly in an anti-Christian world intent instead on confirming man's base nature' (2008). The production did not push this interpretation since the birds dominated so heavily. Costuming generally contributed greatly to the delineation of different worlds within this play, beyond that which depicted Timon's wealth and subsequent destitution: while Timon and his servants were clothed in white, beige, and gold, his debtors who became creditors wore dark costumes that were adorned with feather trim and wing effects; dark, opalescent colours resembled bird plumage. Animal references also abounded, with the prostitutes wearing animal print leotards while the Athenian senators sported different types of fur trim on their costumes.

29. For Jowett, the script of *Timon* argues its point by combining perfor-mance and architecture at the Globe:

> [i]n Sc. 14 Timon calls on the 'blessèd breeding sun' (14.10), the earth, the gods, and the 'clear heavens' (14.28), and the 'Common mother' earth again (14.178). To translate this statement into theatrical terms appropriate to the Globe, the actor, alone on stage, gestures towards the structure of the theatre building: not now to the wall at the rear of the stage and the door in it through which he has entered, but to the 'wooden O' through which daylight pours into the amphitheatre, and to the platform of the stage on which he stands. (2007, p. 14)

This production expands on the possibilities Jowett articulates.

30. The actors stood in this recessed space but the aesthetic suggested that they were 'seated' at the banquet.

31. In his review, Taylor introduces another interpretation for this perme-able sphere: 'a mordant anus' (2008) since, once Timon was exiled, he exploited his faeces to torment the Poet and Painter, placing the value of gold to him on a par with his defecations. The anus metaphor served a comparable purpose to the menacing aviary. Other unpleasant locations were also established: the nets also formed a prison, emphasized by two large spiked wagon wheels which topped the central columns. A pris-oner's throat was slit here, his body left to hang upside down from this 'perch' for most of Scene 10.

32. Allfree describes the birds as 'harbingers of death and avenging furies; they are bloodthirsty carrion and the stuff of nightmares; and in the lit-eral world of the play they are venal Athenians, devouring Timon's riches before casting him out to die' (2008).

33. *Timon* previewed in early August 2008. Talk of financial insecurity was in the press at this time, but it was September 2008 before the reality of what became the GFC was clear.

34. Timon's pit, which was ultimately also his grave, continued to stretch the reach of the stage space even further in its enhancement of both vertical and horizontal planes, beyond this circle in its alluding to the location of 'hell' that the trap also generally implies.

35. Cartelli argues the 'outcome' of the play in detail:

> Alcibiades' alternative clearly promises the audience a smoother return to reality than does a continuing imaginative alliance with Timon's misanthropy. But it fails to offer the audience the final (and fleeting) luxury of feeling superior to a gesture playgoers must soon perform in an analogous way of their own, as they re-accommodate themselves to the values and standards of behaviour that obtain outside the theater. Once it has sufficiently distanced itself from the affective range of the-atrical experience, the audience will, presumably, come to acknowledge its essential resemblance to the normative Alcibiades, and recognize the inescapable otherness of the abnormative Timon. But until the play ends, Alcibiades and the senators who attempt to appease him

seem intended to serve as embodiments of what the audience imagines itself to be cured of, not as the welcome agents of a mutually desired reconciliation. (1991, p. 198)

36. Timon appeared unable to perceive that his own base-line for humanity was flawed. His blindness was emphasized in the production when three lords appeared through holes in the netting, perching above the pit just before the first feast: they spoke their lines while they were suspended half way, eventually abseiling all the way down into the pit. Then three musicians stood in the trap so that only half their bodies were visible. Presenting 'partial' or inverted views of actors challenged the audience's perception of the moral base of the play: was it where Timon stood centrally, or below, where the musicians were positioned (and indeed at the same level of some of the guests in the trough at the stage's edge), or where the lords were suspended, above the pit or even where the audience themselves were positioned?

37. This analysis refers to video productions from 28 July and 21 August 2007. The printed script does not include the exclamation mark in the title but the production did, so I have retained it in this analysis.

38. See, to varying degrees, Billington; Loveridge; Quirke; Shore; and Thaxter (all 2007), and Taylor 2007a. One reviewer even notes of the production, 'this open-air venue has possibly never been put to better use' ('A Global Success' 2007). Only JP critiques the play's use of the venue: 'Mark Rosenblatt's production tries heroically to create a sense of continuity, but neither he nor Shepherd can quite handle the Globe's space: the action is too complex for the bare simplicity of this stage' (2007, p. 24).

39. All quotations from the script are to this edition and will be indicated in the text with the appropriate page reference.

40. In his review, Freed takes the potential for a connection between theatre and the actual world in a different direction of contemporary space and politics: '[t]he fight for ordinary people to have the right to vote and participate in a form of democracy mean that the play's Victorian context has strong resonances with Iraq and that in many ways the battle still continues' (2007).

41. Dickens had a long association with Southwark, even after the discharge of his father's debts which forced the family to relocate there to the prison ('Dickens' Southwark' 2013).

42. Logan quotes Jack Shepherd who comments on 'the irony that Lovett fought tooth and nail to get people first an education, then the vote. And nowadays, people don't vote, and it's cool to reject education' and that 'wealth is being held by a smaller and smaller percentage of people, as it was at the time of this play' (2007).

5 Heterotopia and Multimedia

1. Some of the groups to experiment earlier with video and other media include Japan's Dumb Type, since 1984, not to mention the Wooster Group in New York since the late 1970s.

2. Dixon writes here of digital performance which, in being generated (almost) entirely through a computer screen, differs from at least the first example that I examine in this chapter. His point applies equally to multimedia performance, though. This raises a question about terminology: while I call the case studies in this chapter multimedia performance, rather than theatre, it is necessary to refer to their 'theatrical' elements at times. Nevertheless, I have endeavoured not to make 'theatre' and 'performance' synonymous.

3. For much more detailed considerations of these forms of performance, the definitions of the various terms, perspectives on the Auslander/ Phelan liveness debate (which structured much early thinking about this subgenre), and a history of the field, see Bay-Cheng, Kattenbelt, Lavender, and Nelson 2010; Causey 2006; Dixon 2007; and Klich and Scheer 2012.

4. See Carlson who writes about Frank Castorf and other European theatre directors who explore ways to mobilize and stage the locations in and around the theatre through both live and pre-recorded video (2003b).

5. For an analysis of both productions, see Klich 2013.

6. For some exceptions, see Klich 2013 and Wiens 2010, and, on the virtual, Giannachi 2004. See Causey (2006, p. 51) on the need to combine all these aspects of theatricality.

7. Klich continues, arguing that in such performance, '[t]here is no movement of events from a beginning point to an end point; there is only movement through space' (2013, p. 428).

8. The mathematician who advised Complicite in the creation of *A Disappearing Number*, Professor Marcus du Sautoy, remarks that '[t]his tension between east and west is one that runs throughout much of mathematical history' (2009, p. 14).

9. All further quotations from this play are to this edition and included in the text with the appropriate page reference.

10. The patterns were not just illustrated: they were heard as well through the tabla music composed for this production, 'based on Ramanujan's work' (Abdulla 2007, p. 25). Taylor describes it thus: 'Nitin Sawhney's score, with its hypnotic chanting, demonstrates that music is mathematics made audible' (2007b).

11. Aninda's research into string theory investigates 'how everything in the universe is linked [...] like it says in the Upanishads all those millennia ago, [that] everything is connected to everything else' (p. 37).

12. In *A Mathematician's Apology*, Hardy differentiates between pure and applied mathematics (2005, pp. 33–7). Mathematics is, of course, not abstract, even if I have located it in abstracted space.

13. He says: 'please choose a simple number. (*Beat.*) Now multiply that number by two. (*Beat.*) Now add fourteen. [...] Now divide this new number by two. (*Beat.*) Finally, take away your original number' (pp. 24–5). This leaves the number seven.

14. Patterns are not always immediately discernible: as Ruth notes, '[t]o find the hidden pattern you sometimes need to look at them in a new way' (p. 21).

15. Both Aninda Rao and Al went to India to bury someone, and there were the untimely deaths of Ramanujan and Ruth, as well as numerous other connections and intersections. Al and Aninda compare notes on India and the Indian diaspora, as the traditions of the past blend with the numbers of the present and even the future. The characters do not discern many of the extensive interconnections that emerge: it is up to the audience to derive the patterned meaning from them.

16. This is the kernel of the play, something that Hardy expounds upon in *A Mathematician's Apology*: '[a] mathematician, like a painter or a poet, is a maker of patterns' (2005, p. 13). But making patterns is not enough: '[t]he mathematician's patterns, like the painter's or the poet's must be *beautiful*; the ideas like the colours or the words, must fit together in a harmonious way. [...] [T]here is no permanent place in the world for ugly mathematics' (Hardy 2005, p. 14; original emphasis).

17. Charges that this play is anti-semitic have been levelled at Churchill, as outlined in explorations of the play by Clements 2013 and Grehan 2014. See also Kushner and Solomon for a carefully argued defence of the play, even as they express alarm at what some lines mean for the authors, who identify as Jewish (2009).

18. Both Israel and the Hamas have been accused 'of committing war crimes and failing to distinguish between military and civilian targets' (Clements 2013, p. 357).

19. *Seven Jewish Children* was performed after *The Stone* for a separate audience, and for free, not a usual format for the Royal Court.

20. Churchill's only stipulation in how the play is performed is the following:

 [n]o children appear in the play. The speakers are adults, the parents and if you like other relations of the children. The lines can be shared out in any way you like among those characters. The characters are different in each small scene as the time and child are different. (*Seven Jewish Children* 2009a)

21. See Kushner and Solomon 2009, and Felton-Dansky 2011 for accounts of some iterations of this play.

22. My analysis is also informed by research into the Royal Court production and watching a range of productions uploaded on YouTube, some made directly for that medium, others not.

23. Bernard-Donals uses Nancy's work to explain why it is not possible or appropriate for the characters to be named (2011, p. 411).

24. Kritzer quotes Churchill who notes that Scene 1 was 'some time of persecution, which could be nineteenth-century Russia' but it was construed as 'thirties Germany' in the Royal Court production (2010, p. 613). The absence of certainty of which historical events each scene discusses confirms that the play introduces particular historical inflections, rather than being a documentary account of Jews and Israel.

25. Quoting Churchill, Kritzer writes that Scene 6 'shows adults answering the questions of a child' visiting Israel (2010, p. 614). Kritzer also isolates

shifts in the dialogue from 'the emergence of Jewish certainty in military dominance and the power of ownership' in Scene 5 to the 'moral turning point of the piece, as the adults actively deceive the child' in Scene 6 to a 'silencing of moderate dialogue as militaristic viewpoints have come to control Israeli decision-making' in Scene 7 (2010, p. 614).

26. There is scope for far more detailed analysis of the craft with which the text is written. Note: the script eliminates most apostrophes, even in 'Dont', and avoids most punctuation, including full stops at the end of sentences. I have reproduced words and lines as they appear in the downloaded script.

27. This interpretation changes somewhat if multiple actors participate (playing different family members), creating an argument or expressing disagreement among different personalities. Various YouTube versions of Churchill's script with multiple cast members demonstrate a slightly different dynamic that is not counter to this analysis.

28. Grehan argues that the audience response can be understood through Levinas wherein '[t]he call of the other constantly interrupts the subject and she has no option but to respond' (2014, p. 105).

29. Grehan notes that it is, of course, possible to subvert the gaze by doing something else at the same time or refusing to engage (2014, p. 103).

30. For Kushner and Solomon, the all-important outcome of this imaginative leap is, as they articulate hopefully, '[p]erhaps this girl [from Scene 7] will grow up to work for justice' (2009).

31. Not every spectator will respond this way, not least because of the controversy the play has generated.

32. See Felton-Dansky (2011, p. 160) and Kritzer (2010, p. 616) for more on several of these iterations.

33. While Ortelia's design and spatial management of venues and exhibitions/performances in the contemporary world is a commercial venture, the historical aspect, which is the focus of this section, is planned for open access release. In the contemporary theatre space, users can create their own venue and generate theatre sets there, complete with a full range of theatre lighting, all of which interact with the set to throw accurate shadowing. Ortelia is comprised of three people: me, and Lazaros Kastanis and Darren Pack who are VR environment modellers. It also makes use of motion-capture technology through the skills of Matthew Delbridge.

34. While the plot of *Dr Faustus* is well known, the other two plays are seldom performed. Briefly, in *A Looking Glass for London and England*, incest, murder, adultery, fraud, and exploitation characterize all levels of society in eighth-century BC Nineveh. The prophet Oseas plays a choric role, comparing the evils of Nineveh to those of London and promising dire consequences should Londoners not reform their ways. In *Friar Bacon and Friar Bungay*, Edward, the Prince of Wales, falls in love with Margaret, the Fair Maid of Fressingfield, but his seduction-by-proxy fails and he accepts his father's choice for him (Eleanor of Castile). The action is interwoven with the magic antics of Bacon and Bungay but Bacon's magic leads to

death and disaster and he resigns from his craft: overall, magic is seen to cause trouble where love can lead to resolution.

35. Hayles notes that this work prompted the creation of 'the London Charter for the Use of 3-Dimensional Visualization in the Research and Communication of Cultural Heritage, a document setting out standards for projects of this kind' (2012, p. 49). Ortelia follows the principles set out in this Charter.

36. The short video clips of these moments are available at: http://ortelia.com/new/portfolio/ (Pack and Kastanis 2014a; 2014b) and also on YouTube.

37. The avatar was created by Matthew Delbridge (see Delbridge and Kastanis 2014).

38. Butterworth speculates about other possibilities for flame effects (1998, p. 41). In each case, we explored many options to realize these effects, deciding on those that could be generated easily enough mechanically while still being impressive theatrically.

39. This dragon can be managed in the tiring house without too much interference to or from other stage traffic: the rope can be secured at the gallery level before the performance begins, with a stage anchor point over the tiring house door on the inside, ready to be moved to a hook and screw-eye at the back of the tiring house, when the dragon's cue comes.

40. The mechanism is even simpler than the rope pulley system that would have been used to rig sails on ships; that is an option as well.

41. For more on the (re-)construction dilemmas and access questions that the theatre has uncovered, see Tompkins and Delbridge 2009, and Delbridge and Tompkins 2012.

42. See Klich and Scheer for the difference between cognitive and sensory immersion (2012, p. 132), as well as their definition of hyperreality (2012, p. 91).

43. The ergodic is especially useful for recreating venues or works that no longer exist. I am grateful to Bernadette Cochrane and Alan Lawrence for their assistance with this argument.

Conclusion: Gaps, Absences, and Alternate Orderings

1. Heterotopia reveals absences, but it also has the capacity to indicate excess as well. As my examples in Chapter 5 demonstrated, heterotopia might exceed the conventional theatrical frame.

2. In Chapter 1, I pointed out that productions looking entirely to the past would be unlikely to generate heterotopia; other types of performance that are unlikely to shape heterotopias comprise re-enactments of historic events, and adaptations or productions of classic texts concerned solely with a connection to an 'original'.

Bibliography

365. (2008). National Theatre of Scotland. http://www.nationaltheatrescotland.
com/content/default.asp?page=home_365, accessed 9 October 2008.

Aarseth, E. (1997). *Cybertext: Perspectives on Ergodic Literature* (Baltimore, MD:
The Johns Hopkins University Press).

Abdulla, S. (2007). 'An Act of Communal Imagination', *Nature*, 449.6, 25–6,
Proquest database, accessed 1 February 2011.

A History of Everything (2013). By Ontroerend Goed and D. Eagleman,
A. Devriendt (director), S. De Somere (designer). Performed Perth, State
Theatre Centre of Western Australia: Ontroerend Goed, and Sydney Theatre
Company. (Viewed 15 February).

Alexander, A. (2011). 'Heroes, martyrs and the rise of modern mathematics',
Late Night Live with Philip Adams, radio broadcast, Australian Broadcasting
Corporation Radio National, 27 September.

Allfree, C. (2008). 'Aviary of Avarice with *Timon of Athens*', *Metro*, 10 August,
http://metro.co.uk/2008/08/10/aviary-of-avarice-with-timon-of-athens-
358535/, accessed 17 November 2011.

Allison, T. (2008). '"Text and Texture": Responses to *Black Watch*', *Contemporary
Theatre Review*, 18.2, 274–5.

'The Ancient World in London' (2011). Heritage Key, http://heritage-key.com/
site/temple-mithras-london, accessed 21 March 2011.

'Annual Population Survey January–December 2007, 2010 weights' (2012).
Office for National Statistics UK, http:www.ons.gov.uk, accessed 2 October
2013.

Archibald, D. (2008a). '"The Scottish Play?" Responses to *Black Watch*',
Contemporary Theatre Review, 18.2, 279.

Archibald, D. (2008b). '"We're just big bullies ...": Gregory Burke's *Black
Watch*', *Drouth*, 26, 8–13.

Aronson, A. (2005). *Looking into the Abyss: Essays on Scenography* (Ann Arbor,
MI: University of Michigan Press).

'Audience Reactions *365*' (2008). National Theatre of Scotland, www.national
theatrescotland.com/content/default.asp?page=s428, accessed 9 October 2008.

Augé, M. (1998). *A Sense for the Other: The Timeliness and Relevance of Anthropology*,
trans. A. Jacobs (Stanford, CA: Stanford University Press; first published 1994).

Bachelard, G. (1964). *The Poetics of Space*, trans. M. Jolas (Boston, MA: Beacon
Press; first published 1958).

Bailey, L. (dir) (2008). *Timon of Athens*, by W. Shakespeare and T. Middleton,
W. Dudley (designer). Performed London, Shakespeare's Globe: Shakespeare's
Globe. (Viewed 30 September).

Bammer, A. (1991). *Partial Visions: Feminism and Utopianism in the 1970s*
(New York, NY: Routledge).

Barker, H. (1993). *Arguments for a Theatre*, 2nd edn (Manchester, UK: Manchester University Press).

Bay-Cheng S., C. Kattenbelt, A. Lavender & R. Nelson (eds) (2010). *Mapping Intermediality in Performance* (Amsterdam: Amsterdam University Press).

Bennett, S. (2013). *Theatre & Museums* (Basingstoke, UK: Palgrave Macmillan).

Bergner, B.A. (2013). *Poetics of Stage Space: The Theory and Practice of Theatre Scene Design* (Jefferson, NC: McFarland).

Bernard-Donals, M. (2011). 'The Call of the Sacred and the Language of Deterritorialization', *Rhetoric Society Quarterly*, 41.5, 397–415.

Bharucha, R. (1993). *Theatre and the World: Performance and the Politics of Culture*, 2nd edn (London: Routledge).

Billington, M. (2007). 'Holding Fire! Shakespeare's Globe, London', *The Guardian*, 7 August, *Factiva* database, accessed 18 January 2010.

Billington, M. (2005). 'Review: The Main Event', *The Guardian*, 6 June, *Factiva* database, accessed 28 January 2011.

Birch, A. & J. Tompkins (eds) (2012). *Performing Site-Specific Theatre: Politics, Place, Practice* (Basingstoke, UK: Palgrave Macmillan).

Birringer, J. (2000). *Performance on the Edge: Transformations of Culture* (London: Athlone Press).

Bishop, C. (2012). *Artificial Hells: Participatory Art and the Politics of Spectatorship* (London: Verso).

Bisk, T. (2002). 'Towards a Practical Utopianism: Utopian Thinking Needs to Be Rescued from Fantasy and Fanaticism', *The Futurist*, 36.3, 22–5.

Black Watch. (2008). DVD, John Williams Productions Limited U.K. Directed by J. Tiffany.

Black Watch. (2007). National Theatre of Scotland, http://www.national theatrescotland.com/content/default.asp?page=home_BlackWatch2012, accessed 10 August 2014.

Black Watch Regiment. (2007). http://www.theblackwatch.co.uk/newsite/index.html, accessed 20 November 2010.

Bloch, E. (1988). *The Utopian Function of Art and Literature: Selected Essays*, trans. J. Zipes and F. Mecklenburg (Cambridge, MA: MIT Press).

Bowsher, J. (1998). *The Rose Theatre: An Archaeological Discovery* (London: Museum of London).

Boyer, C.M. (2008). 'The Many Mirrors of Foucault and their Architectural Reflections', in M. Dahaene & L. De Cauter (eds), *Heterotopia and the City: Public Space in a Postcivil Society* (London: Routledge).

Brenton, H. (2006). *In Extremis* (London: Nick Hern Books).

Brenton, H. (2007). 'Playing to the crowd', *The Guardian*, 12 May, http://www.guardian.co.uk, accessed 17 November 2011.

Brome, R. (2000). *The Antipodes*, D. S. Kastan & R. Proudfoot (eds) (London: Nick Hern Books; first published 1640).

Brooks, R. (2008). 'The Attenborough Sisters Who Escaped Hitler', *The Sunday Times*, 30 November, *Factiva* database, accessed 16 April 2010.

Brown, J. (2007). 'The City's a Stage in this Musical with a Message', *The Independent*, 5 January, *Factiva* database, accessed 27 January 2010.

Brown, M. (2007). 'Staccato Descent into Murder', *The Daily Telegraph*, 26 March, p. 29.

Brown, M. (2008). 'Edinburgh Festival: *365*', *The Telegraph*, 8 August, http://www.telegraph.co.uk/culture/theatre/3558046/Edinburgh-Festival-365.html, accessed 17 November 2011.

Brown, P. (2007). *'Holding Fire!' London Theatre Guide*, 6 August (London: Shakespeare's Globe Archives).

Burke, G. (2007). *Black Watch* (London: Faber and Faber).

Burke, G. (2008). 'Author's Note' in programme for *Black Watch* (Glasgow: National Theatre of Scotland).

Butterworth, P. (1998). *Theatre of Fire: Special Effects in Early English and Scottish Theatre* (London: Society for Theatre Research).

Campos, L. (2007). 'Searching for Resonance: Scientific Patterns in Complicite's *Mnemonic* and *A Disappearing Number*', *Interdisciplinary Science Reviews*, 32.4, 326–44, *Proquest* database, accessed 1 February 2001.

Carlson, M. (1989). *Places of Performance* (Ithaca, NY: Cornell University Press).

Carlson, M. (2003a). *The Haunted Stage: The Theatre as Memory Machine* (Ann Arbor, MI: University of Michigan Press).

Carlson, M. (2003b). 'Video and Stage Space: Some European Perspectives', *Modern Drama*, 46.4, 614–28.

Carson, C. & F. Karim-Cooper (2008). *Shakespeare's Globe: A Theatrical Experiment* (Cambridge, UK: Cambridge University Press).

Cartelli, T. (1991). *Marlowe, Shakespeare, and the Economy of Theatrical Experience* (Philadelphia, PA: University of Pennsylvania Press).

Casey, E.S. (1997). *The Fate of Place: A Philosophical History* (Berkeley, CA: University of California Press).

Causey, M. (2002). 'A Theatre of Monsters: Live Performance in the Age of Digital Media', in M.M. Delgado & C. Svich (eds) *Theatre in Crisis? Performance Manifestos for a New Century* (Manchester, UK: Manchester University Press).

Causey, M. (2006). *Theatre and Performance in Digital Culture: From Simulation to Embeddedness* (London; New York, NY: Routledge).

Chapple, F. & C. Kattenbelt (2006). *Intermediality in Theatre and Performance* (Amsterdam: Rodopi).

Chaudhuri, U. (1995). *Staging Place: The Geography of Modern Drama* (Ann Arbor, MI: University of Michigan Press).

Chaudhuri, U. & E. Fuchs (eds) (2002). *Land/Scape/Theater* (Ann Arbor, MI: University of Michigan Press).

Chekhov, A. (2002). *Three Sisters* in P. Carson (ed.) *Plays*, trans. P. Carson, rev. edn (London: Penguin; first published 1901).

Chung, H.J. (2012). 'Media Heterotopia and Transnational Filmmaking: Mapping Real and Virtual Worlds', *Cinema Journal*, 51.4, 87–109.

Churchill, C. (2009). *Seven Jewish Children: A Play for Gaza*, playtext, http://www.map-uk.org/get-involved/fundraise-for-us/7-jewish-children.aspx, accessed 8 November 2013.

Clements, R. (2013). 'Framing War, Staging Precarity: Caryl Churchill's *Seven Jewish Children* and the Spectres of Vulnerability', *Contemporary Theatre Review*, 23.3, 357–67.

Cochrane, B. (2013). 'Dramaturgy, Playtext, Structure', PhD thesis, University of Queensland, Brisbane.

Complicite (2008). *A Disappearing Number* (London: Oberon Modern Plays).

Conkie, R. (2006). *The Globe Theatre Project: Shakespeare and Authenticity* (Lewiston, NY: Edwin Mellen Press).

Craddock, S. (1998). 'Force Field: The Work of Heather Ackroyd and Daniel Harvey', in N. Childs & J. Walwin (eds), *A Split Second of Paradise* (London: Rivers Oram Press).

Crooks, E. (2007). 'Guided Tour that Exposes the Heart and Soul of the City', *Financial Times*, 6 January, *Factiva* database, accessed 27 January 2010.

Dachel, K. (2006). '*Pericles, Prince of Tyre* by William Shakespeare; Kathryn Hunter; *Children of the Sea* by Toby Gough', *Theatre Journal*, 58.3, 495–8.

Dawson, A. (2008). 'Emotional Journeys' in programme for *365* (Glasgow: National Theatre of Scotland).

Dean, P. (2000). '*Pericles'* Pilgrimage', *Essays in Criticism*, 50, 125–44.

Defert, D. (1997). 'Foucault, Space and the Architects', in C. David & J. Chevrier (eds), *Documenta X – The Book: Politics Poetics* (Ostfildern, Germany: Cantz).

Delbridge, M. & J. Tompkins (2012). 'Reproduction, Mediation, and Experience: Virtual Reality, Motion Capture and Early Modern Theatre', *Space–Event–Agency–Experience: Open Access Epublication of the DREX Project Centre for Practice as Research in Theatre* (Tampere, Finland: University of Tampere).

Delbridge, M. & L. Kastanis (2014). 'Motion capture scene of *Dr Faustus*', *OrteliaInteractive*, http://www.youtube.com/watch?v=S3YTKkRb3NQ&feature=youtu.be, accessed 13 March 2014.

DiCenzo, M. (1996). *The Politics of Alternative Theatre in Britain, 1968–1990: The Case of 7:84 (Scotland)* (New York, NY: Cambridge University Press).

Dickens, C. (1986). *Little Dorrit*, ed. H.M. Page (Harmondsworth, UK: Penguin; first published 1855–7).

'Dickens' Southwark' (2013). Southwark Council, http://www.southwark.gov.uk/info/200159/history_of_southwark/1020/dickens_southwark/1, accessed 30 September 2013.

Dillon, J. (2000). *Theatre, Court and City 1595–1610: Drama and Social Space in London* (Cambridge, UK: Cambridge University Press).

Dixon, S. (2007). *Digital Performance: A History of New Media in Theater, Dance, Performance Art, and Installation* (Cambridge, MA: MIT Press).

Dolan, J. (2005). *Utopia in Performance: Finding Hope at the Theater* (Ann Arbor, MI: University of Michigan Press).

Doran, G. (dir) (2012). *Julius Caesar* by W. Shakespeare, M. Vale (designer). Performed London, Noel Coward Theatre: Royal Shakespeare Company. (Viewed 15 September).

Dudley, W. (2008). '*Timon of Athens*' in programme for *Timon of Athens* (London: Shakespeare's Globe).

Dunmall, G. (2007). 'London Walking: The Carbon Web that Entangles us all', *Plenty Magazine*, 12 February, http://www.plentymag.com, accessed 27 January 2010.

Eaket, C. (2008). 'Project [murmur] and the Performativity of Space', *Theatre Research in Canada /Recherches théâtrales au Canada*, 29.1, 29–50.

Eckersall, P., H. Grehan & E. Scheer (2014). 'New Media Dramaturgy', in M. Romanska (ed.), *The Routledge Companion to Dramaturgy* (Abingdon, UK: Routledge).

Elm, E. (2011). 'Utopia in the Shadow of Disaster', *Contemporary Theatre Review*, 21.1, 95–8.

Escolme, B. (2006). *Talking to the Audience: Shakespeare, Performance, Self* (London: Routledge).

Faubion, J.D. (2008). 'Heterotopia: An Ecology', in M. Dahaene & L. de Cauter (eds), *Heterotopia and the City: Public Space in a Postcivil Society* (London: Routledge).

Featherstone, V. (2007). *Summer–Autumn Brochure* (2007) (Glasgow: National Theatre of Scotland).

Featherstone, V. (dir) (2008). *365*, by D. Harrower, G. McGuinness (designer). Performed Edinburgh, Edinburgh Playhouse: National Theatre of Scotland. (Viewed 25 August).

Felton-Dansky, M. (2011). 'Clamorous Voices: *Seven Jewish Children* and its Proliferating Publics', *TDR: The Drama Review*, 55.3, 156–64.

Ferns, C. (1999). *Narrating Utopia: Ideology, Gender, Form in Utopian Literature* (Liverpool, UK: Liverpool University Press).

Field, A. (2009). 'The National Theatre of Wales wants You', *The Guardian*, Theatre blog, http://www.guardian.co.uk/stage/theatreblog/2009/may/26/national-theatre-wales, accessed 2 June 2009.

Fisher, M. (2007). 'Review: *Aalst*', *Variety*, 26 April, http://variety.com/2007/legit/reviews/aalst-1200509399/, accessed 10 November 2009.

Foucault, M. (1986). 'Of Other Spaces', *Diacritics*, 16.1, 22–7.

Foucault, M. (2002). *The Order of Things: An Archaeology of the Human Sciences* (London: Routledge).

Freed, M.J. (2007). '*Holding Fire!* Review', *Something Jewish*, 28 August, http://www.somethingjewish.co.uk, accessed 19 January 2010.

Garner, Jr., S.B. (1994). *Bodied Spaces: Phenomenology and Performance in Contemporary Drama* (Ithaca, NY: Cornell University Press).

Genocchio, B. (1995). 'Discourse, Discontinuity, Difference: The Question of "Other" Spaces', in S. Watson & K. Gibson (eds), *Postmodern Cities and Spaces* (Oxford, UK: Blackwell).

Giannachi, G. (2004). *Virtual Theatres: An Introduction* (London: Routledge).

Gindin, S. & L. Panitch (2002). 'Rekindling Socialist Imagination: Utopian Vision and Working-Class Capacities', *Monthly Review*, March, 36–52.

Giroux, H. (2004). 'When Hope Is Subversive', *Tikkun*, 19.6, 62–4.

Glass, R. (2007). 'An Introduction to *Aalst*', National Theatre of Scotland, http://www.nationaltheatrescotland.com/content/default.asp?page=s278_2, accessed 9 October 2008.

'A Global Success' (2007). *The Jewish Chronicle*, 24 August, *Factiva* database, accessed 18 January 2010.

'The Globe Gets Tossed Out to Sea' (2005). *The Independent* (Features), 12 June, *Factiva* database, accessed 18 January 2010.

Gooderham, M. (2008). 'Germany: Night of the Broken Glass', *The Globe and Mail* (F5), 8 November, *Factiva* database, accessed 16 April 2010.

Goold, R. & B. Power (dirs.) (2008). *Six Characters in Search of an Author* by L. Pirandello. M. Buether (designer). Performed London, Gielgud Theatre: Headlong and Chichester Festival. (Viewed 7 October).

Gorman, M. (2008). '365 by the National Theatre of Scotland', Gibberish blog, http://markgorman.wordpress.com/2008/08/, accessed 23 August 2009.

Gould, R. (2008). 'Review: *365* at the Lyric, Hammersmith' *Broadwayworld*, 16 September, http://w.broadwayworld.com/emailcolumn.cfm?id=32381, accessed 29 August 2009.

Grantley, D. (2008). *London in Early Modern English Drama: Representing the Built Environment* (Basingstoke, UK: Palgrave Macmillan).

Greene, R. (1969). *Friar Bacon and Friar Bungay*, ed. by D. Seltzer (Lincoln, NE: University of Nebraska Press; first published 1594).

Grehan, H. (2010). '*Aalst*: Acts of Evil, Ambivalence and Responsibility', *Theatre Research International*, 35.1, 4–16.

Grehan, H. (2014). 'Responsibility and the Dangers of Proximity: Responding to Caryl Churchill's *Seven Jewish Children*', in B. Trezise & C. Wake (eds), *Visions and Revisions: Performance, Memory, Trauma*, e-book (Copenhagen: Museum Tusculanum Press – In Between States).

Griffiths, A. (2008). *Shivers Down Your Spine: Cinema, Museums, and the Immersive View* (New York, NY: Columbia University Press).

Gurr, A. with J. Orrell (1989). *Rebuilding Shakespeare's Globe* (New York, NY: Routledge).

Hardy, G.H. (2005). *A Mathematician's Apology*, e-book (Edmonton, AL, Canada: University of Alberta Mathematical Sciences Society; first published 1940).

Harrop, S. (2008). '*365*' London Theatre Blog, 12 September, http://www.london theatreblog.co.uk/365/, accessed 17 August 2010.

Hart, C. (2008). 'Fighting a Great Fight: *Black Watch*', *The Sunday Times* (London), 29 June, p. 19.

Harvey, D. (1989). *The Condition of Postmodernity: An Enquiry into the Origins of Cultural Change* (Oxford, UK: Blackwell).

Harvey, D. (2006). *Spaces of Global Capitalism: Towards a Theory of Uneven Geographical Development* (London: Verso).

Harvey, D. (2009). *Cosmopolitanism and the Geographies of Freedom* (New York, NY: Columbia University Press).

Harvey, D. (2013). *Rebel Cities: From the Right to the City to the Urban Revolution* (London: Verso).

Harvie, J. (2005). *Staging the UK* (Manchester, UK: Manchester University Press).

Harvie, J. (2009). *Theatre & the City* (Basingstoke, UK: Palgrave Macmillan).

Hassell, G. (2007). '*Holding Fire!* Shakespeare Globe' [sic]. *The Financial Times*, 11 August, *Factiva* database, accessed 18 January 2010.

Hayles, N.K. (2010). *How We Became Posthuman: Virtual Bodies in Cybernetics, Literature, and Informatics* (Chicago, IL: University of Chicago Press).

Hayles, N.K. (2012). *How We Think: Digital Media and Contemporary Technogenesis* (Chicago, IL: University of Chicago Press).

Hemming, S. (2006). 'All the Land's a Stage for Scotland's Theatre', *The Financial Times*, 21 February, http://www.ft.com/cms/s/0/c5389168-a27f-11da-9096-0000779e2340.html #axzz2vMknEiem, accessed 17 August 2009.

Hemming, S. (2008). '*Black Watch*, Barbican Theatre, London', *The Financial Times*, 28 June, http://www.ft.com/cms/s/0/d1ac4d78-43e9-11dd-842e-0000779fd2ac.html #axzz2vMiNdp15, accessed 17 August 2009.

Hemming, S. (2005). '*Pericles* Shakespeare's Globe Theatre', *The Financial Times* (Arts and Ideas), 8 June, *Factiva* database, accessed 18 January 2010.

'Heterotopia' (1994). *Concise Medical Dictionary* (Oxford, UK: Oxford University Press).

Hetherington, K. (1997). *The Badlands of Modernity: Heterotopia and Social Ordering* (London: Routledge).

Hetherington, K. (2001). 'Moderns as Ancients: Time, Space and the Discourse of Improvement', in J. May & N. Thrift (eds), *TimeSpace: Geographies of Temporality* (London: Routledge), 49–72.

Heyvaert, P. (dir) (2007). *Aalst*, by P. Heyvaert and D. Verhulst; adapt. D. McLean, P. Heyvaert (designer). Performed Brisbane, Brisbane Powerhouse: National Theatre of Scotland. (Viewed 3 February 2008).

'A History of South London and Maudsley NHS Foundation Trust' (2010). South London and Maudsley NHS Foundation Trust, http://www.slam.nhs.uk/about/history.aspx, accessed 8 May 2010.

Hodgdon, B. (2012). 'Material Remains at Play', *Theatre Journal*, 64.3, 373–88.

Hook, D. (2010). *Foucault, Psychology and the Analytics of Power* (Basingstoke, UK: Palgrave Macmillan).

Hopkins, D.J. (2008). *City/Stage/Globe: Performance and Space in Shakespeare's London* (London: Routledge).

Hopson, C. (2007). 'Climate Change in Your Face on London Opera Tour', *Upstream*, 5 January, http://www.upstreamonline.com/hardcopy/cuttings/article1134274.ece, accessed 10 January 2010.

Howard, P. (2002). *What Is Scenography?* (London: Routledge).

Hunter, K. (dir) 2005. *Pericles*, by W. Shakespeare, L. Cook (designer). Performed London, Shakespeare's Globe: Shakespeare's Globe. (Viewed archive video Shakespeare's Globe, 1 October).

Hurley, K. (2008). '"Uncomfortably Spectacular": Responses to *Black Watch*', *Contemporary Theatre Review*, 18.2, 275.

Hytner, N. (dir) (2012). *Timon of Athens* by W. Shakespeare, T. Hatley (designer). Performed London, Olivier Theatre: National Theatre of Great Britain. (Viewed 10 July).

Imre, Z. (2008). 'Staging the Nation: Changing Concepts of a National Theatre in Europe', *New Theatre Quarterly*, 24.1, 75–94.

Jackson, S. (2011). *Social Works: Performing Art, Supporting Publics*, e-book (New York, NY: Routledge).

Jameson, F. (2005). *Archaeologies of the Future: The Desire Called Utopia and Other Science Fictions* (London: Verso).

Jestrovic, S. (2013). *Performance, Space, Utopia: Cities of War, Cities of Exile* (Basingstoke, UK: Palgrave Macmillan).

JP. (2007). '*Holding Fire!*' *The Sunday Times* (Culture), 12 August, p. 24 (accessed Shakespeare's Globe Archives).

Johnson, D. (2012). *Theatre & the Visual* (Basingstoke, UK: Palgrave Macmillan).

Johnson, P. (2006). 'Unravelling Foucault's "Different Spaces"', *History of the Human Sciences*, 19.4, 75–90.

Jordan, J. & J. Marriott (dirs.) (2006). *And While London Burns* by J. Jordan and J. Marriott. Performed London, London City: Platform. www.andwhile londonburns.com.

Jowett, J. (2007). *Shakespeare and Text* (Oxford, UK: Oxford University Press).

Juffer, J. (2006). 'Why We Like to Lose: On Being a Cubs Fan in the Heterotopia of Wrigley Field', *South Atlantic Quarterly*, 105.2, 289–301.

Kahya, D. (2010). 'Can I Take My Money Out of Oil?', *BBC News*, 7 June, http://www.bbc.co.uk/news/10258508, accessed 7 June 2010.

Kaplan, E.A. (2008). 'Global Trauma and Public Feelings: Viewing Images of Catastrophe', *Consumption Markets and Culture*, 11.1, 3–24.

Kaye, N. (2009). 'Disjunction: Performing Media Space', in S.R. Riley & L. Hunter (eds), *Mapping Landscapes for Performance as Research: Scholarly Acts and Creative Cartographies* (Basingstoke, UK: Palgrave Macmillan).

Kaye, N. (2000). *Site-Specific Art: Performance, Place and Documentation* (London: Routledge).

Kimberley, N. (2006). 'Stage is Set for Download Drama', *London Evening Standard*. 11 December, http://www.standard.co.uk/goingout/theatre/stage-is-set-for-download-drama-7391282.html, accessed 27 January 2010.

'Kindertransport, 1938–1940' (2013). United States Holocaust Memorial Museum, http://www.ushmm.org/wlc/article.php?ModuleId=10005260, accessed 15 May 2013.

King, G. & T. Krzywinska (2002). *ScreenPlay: Cinema/Videogrames/Interfaces* (London: Wallflower Press).

Klaić, D. (1991). *The Plot of the Future: Utopia and Dystopia in Modern Drama* (Ann Arbor, MI: University of Michigan Press).

Klich, R. (2013). 'Performing the Postnarrative Text in the Theatre of New Media', *Contemporary Theatre Review*, 23.3, 421–31.

Klich, R. & E. Scheer (2012). *Multimedia Performance* (Basingstoke, UK: Palgrave Macmillan).

Knapper, S. (2010). 'Simon McBurney: Shifting Under/Soaring over the Boundaries of Europe', in M.M. Delgado & D. Rebellato (eds), *Contemporary European Theatre Directors* (Abingdon, UK: Routledge).

Knowles, R. (2004). *Reading the Material Theatre* (Cambridge, UK: Cambridge University Press).

Kobialka, M. (ed. and trans.) (1993). *A Journey through Other Spaces: Essays and Manifestos 1944–1990 by Tadeusz Kantor with a Critical Study of Tadeusz Kantor's Theatre* (Berkeley, CA: University of California Press).

Kohn, M. (2003). *Radical Space: Building the House of the People* (Ithaca, NY: Cornell University Press).

Kritzer, A.H. (2010). 'Enough! Women Playwrights Confront the Israeli-Palestinian Conflict', *Theatre Journal*, 62.4, 611–26.

Krotosky, L. (2008). 'All Aboard for the Kinder', *Totally Jewish*, 27 November, http://www.totallyjewish.com/entertainment/features_and_reviews/?content_id=10638, accessed 16 April 2010.

Kushner, T. & A. Solomon (2009). '"Tell Her the Truth": On Caryl Churchill's *Seven Jewish Children: A Play for Gaza*', *The Nation*, April 13, http://www.thenation.com/article/tell-her-truth?page=0,0, accessed 17 October 2010.

Kwon, M. (2002). *One Place after Another: Site-Specific Art and Locational Identity* (Cambridge, MA: MIT Press).

Lancashire, A. (1970). '*Timon of Athens*: Shakespeare's *Dr Faustus*', *Shakespeare Quarterly*, 21.2, 35–44.

Langley, M. (2010). 'BP Responded As Best It Could: Hayward', *The Weekend Australian*, 31 July–1 August, p. 18.

Lavender, A. (2012). 'Viewing and Acting (and Points in Between): The Trouble with Spectating after Rancière', *Contemporary Theatre Review*, 22.3, 307–26.

Leach, R. (2007). 'The Short, Astonishing History of the National Theatre of Scotland', *New Theatre Quarterly*, 23.2, 171–83.

Lefebvre, H. (1991). *The Production of Space*, trans. D. Nicholson-Smith (Oxford, UK: Blackwell; first published 1974).

Lefebvre, H. (2003). *The Urban Revolution*, trans. R. Bononno (Minneapolis, MN: University of Minnesota Press).

Letts, Q. (2008). 'Explosive! (And That's Just The Language)', *Daily Mail*, 27 June, p. 64.

Lodge, T. & R. Greene (1932). *A Looking Glass for London and England* (New York, NY: AMS Press; first published 1594).

Logan, B. (2007). 'Playing with Fire', *Time Out*, 1 August, *Factiva* database, accessed 18 January 2010.

Logan, B. (2008). 'The Spoils of War', *The Times* (Supplement Section 2), 9 June, pp. 17–18.

Loveridge, L. (2007). 'A Curtain Up London Review: *Holding Fire!*' *CurtainUp: The Internet Theater Magazine of Reviews, Features, Annotated Listings*. http://www.curtainup.com/holdingfirelond.html, accessed 1 October 2013.

Lunney, R. (2002). *Marlowe and the Popular Tradition: Innovation in the English Drama Before 1595* (Manchester, UK: Manchester University Press).

MacDonald, C. (2002). 'Critical Path', in M.M. Delgado and C. Svich (eds), *Theatre in Crisis? Performance Manifestos for a New Century* (Manchester, UK: Manchester University Press), 57–64.

MacDonald, F. (2007). 'We're All a Bit Wild At Art', *Metro*, 19 February, http://www.metro.co.uk/news/37973-were-all-a-bit-wild-at-art.

Macintyre, B. (2008). 'The British Rescue Mission that Saved a Boy from Almost Certain Death in Nazi Germany', *The Times*, 22 November, *Factiva* database, accessed 16 April 2010.

Mackey, S. (2007). 'Performance, Place and Allotments: *Feast* or Famine?', *Contemporary Theatre Review*, 17.2, 181–91.

Mackintosh, I. (1993). *Architecture, Actor, and Audience* (London: Routledge).

Manovich, L. (2013). *Software Takes Command* (London: Bloomsbury).

Marin, L. (1984). *Utopics: The Semiological Play of Textual Spaces*, trans. R.A. Vollrath (New York, NY: Humanity Books; first published 1973).

Markus, T.A. (2002). 'Is There a Built Form of Non-Patriarchal Utopias?', in A. Bingaman, L. Sanders, and R. Zorach (eds), *Embodied Utopias: Gender, Social Change and the Modern Metropolis* (London: Routledge).

Marlowe, C. (1993). *Doctor Faustus: A- and B- Texts 1604: A-and B-texts (1604, 1616)*, D. Bevington and E. Rasmussen (eds) (Manchester, UK: Manchester University Press).

Marlowe, S. (2007). '*Holding Fire!*', *The Times*, 8 August, *Factiva* database, accessed 18 January 2010.

Marshall, C. (2000). 'Sight and Sound: Two Models of Shakespearean Subjectivity on the British Stage', *Shakespeare Quarterly*, 51.3, 353–61.

Mason, M. (2007). '*And While London Burns*', *The Independent*, 3 January, p. 3.

McAuley, G. (1999). *Space in Performance* (Ann Arbor, MI: University of Michigan Press).

McBurney, S. (dir) (2007). *A Disappearing Number* by Complicite, M. Levine (designer). Performed London, The Barbican: Complicite. (Viewed 15 October 2008).

McBurney, S. (2009). 'Introduction', in *A Disappearing Number* by Complicite (London: Oberon).

McGrath, B.P. (2002). 'Bangkok Simultopia', in A. Bingaman, L. Sanders & R. Zorach (eds), *Embodied Utopias: Gender, Social Change and the Modern Metropolis* (London: Routledge).

McKinnie, M. (2007). *City Stages: Theatre and Urban Space in a Global City* (Toronto, ON: University of Toronto Press).

McKinnie, M. (2012). 'Rethinking Site-Specificity', in A. Birch & J. Tompkins (eds), *Performing Site-Specific Theatre: Politics, Place, Practice* (Basingstoke, UK: Palgrave Macmillan), 21–33.

McLean, D. (2007a). 'Introduction', in D. McLean (adapt), *Aalst* (London: Methuen Drama, original work by P. Hayvaert & D. Verhulst).

McLean, D. (adapt) (2007b). *Aalst* (London: Methuen Drama, original work by P. Hayvaert & D. Verhulst).

McMillan, J. (2008). 'Theatre Review: *365*', *The Scotsman*, 25 August, p. 35.

Meerzon, Y. (2007). 'The Ideal City: Heterotopia or Panopticon? On Joseph Brodsky's Play *Marbles* and Its Fictional Spaces', *Modern Drama*, 50.2, 184–209.

Merkin, R. (dir) (2008). *Suitcase*, adapted by R. Merkin, R. Merkin (designer). Performed London, Liverpool Street Station: Hope Street Limited. (Viewed 2 December).

Merkin, R. (2011). 'Personal correspondence'. Email. 12 September.

Millard, R. (2007). 'The Phoney Revolution', *New Statesman*, 3 September, *Factiva* database, accessed 18 January 2010.

Minton, A. (2007). 'Down to a Fine Art', *The Guardian* (Society Pages), 10 January, *Factiva* database, accessed 27 January 2010.

Minton, G.E. (2009). Review of *Timon of Athens*. Dir. Lucy Bailey. Shakespeare's Globe, London. *Shakespeare Bulletin*, 27.2, 344–8.

Mitchell, K. (dir) (2006). *The Waves* by Virginia Woolf, V. Mortimer (designer). Performed London, Cottesloe Theatre: National Theatre of Great Britain. (Viewed 10 January 2007).

Moffatt, L. (2004). 'The Woods as Heterotopia in *A Midsummer Night's Dream*', *Studia Neophilologica*, 76, 182–7.

Monahan, J. (2005). '*Pericles*', *Around the Globe*, 31 August, pp. 6–7.

More, T. (1992). *Utopia* (London: Everyman's Library; first published 1516).

Moser, M. (2002). 'Reconfiguring Home: Geopathology and Heterotopia in Margaret Hollingsworth's *The House that Jack Built* and *It's Only Hot for Two Months in Kapuskasing*'. *Theatre Research in Canada/Recherches théâtrales au Canada* 23.1-2, 1–18.

Mullaney, S. (1988). *The Place of the Stage: License, Play, and Power in Renaissance England* (Chicago, IL: University of Chicago Press).

Mulryne, J.R. & M. Shewring (eds) (1997). *Shakespeare's Globe Rebuilt* (Cambridge, UK: Cambridge University Press).

Muñoz, J.E. (2009). *Cruising Utopia: The Then and There of Queer Futurity* (New York, NY: New York University Press).

'National Theatre of Scotland'. (2014). National Theatre of Scotland, http://www.nationaltheatrescotland.com/content/default.asp, accessed 2 January 2014.

Neville-Sington, P. & D. Sington (1993). *Paradise Dreamed: How Utopian Thinkers Have Changed the Modern World* (London: Bloomsbury).

Newall, C. (2008). 'Personal Interview', National Theatre of Scotland, 27 August.

Nightingale, B. (2005). 'Old Seadogs, New Tricks', *The Times* (Features), 6 June, *Factiva* database, accessed 18 January 2010.

Ortelia. (2014). http://www.ortelia.com, accessed 3 January 2014.

Orwall, B., M. Langley & J. Herron (2010). 'Embattled BP Chief to Exit: American Robert Dudley to Succeed Tony Hayward as Head of British Oil Giant', *The Wall Street Journal*, 26 July, *Factiva* database, accessed 3 April 2011.

Packer, R. & K. Jordan (eds) (2002). *Multimedia: from Wagner to Virtual Reality* (New York, NY: Norton).

Pack, D. & L. Kastanis (2014a). 'Man being consumed by flames in *A Looking Glass for London and England*', *OrteliaInteractive*, http://www.youtube.com/watch?v=sa_nzHpcHD4&feature=youtu.be, accessed 13 March 2014.

Pack, D. & L. Kastanis (2014b). 'The Dragon in a play such as Robert Greene's *Friar Bacon and Friar Bungay* (1589–90)', *OrteliaInteractive*, http://www.youtube.com/watch?v=6xWzC73gVNQ&feature=youtu.be, accessed 13 March 2014.

Pearson, M. & M. Shanks (2001). *Theatre/Archaeology* (London: Routledge).

Petralia, P.S. (2010). 'Headspace: Architectural Space in the Brain', *Contemporary Theatre Review*, 20.1, 96–108.

Phelan, P. (1997). *Mourning Sex: Performing Public Memories* (London; New York, NY: Routledge).

Phelan, S. (2008). 'Untold Stories' in programme for *365* (Glasgow: National Theatre of Scotland).

Phillips, S. (dir) (2013). *Otello* by G. Verdi, D. Ferguson (designer). Performed Brisbane, Lyric Theatre: Opera Queensland. (Viewed 2 November).

Pinder, D. (2005). *Visions of the City: Utopianism, Power and Politics in Twentieth-Century Urbanism* (Edinburgh: Edinburgh University Press).

Poole, K. (2011). *Supernatural Environments in Shakespeare's England: Spaces of Demonism, Divinity, and Drama* (Cambridge, UK; New York, NY: Cambridge University Press).

Prendergast, M. & J. Saxton (eds) (2009). *Applied Theatre: International Case Studies and Challenges for Practice* (Bristol, UK: Intellect).

Prescott, P. (2005). 'Inheriting the Globe: The Reception of Shakespearean Space and Audience in Contemporary Reviewing', in B. Hodgdon & W.B. Worthen (eds), *A Companion to Shakespeare and Performance* (Malden, MA: Blackwell).

Punday, D. (2011). 'From Synesthesia to Multimedia: How to Talk About New Media Narrative', in R. Page & B. Thomas (eds), *New Narratives: Stories and Storytelling in the Digital Age* (Lincoln, NE; London: University of Nebraska Press).

Quirke, K. (2007). 'A Glorious Epic Struggle', *The Evening Standard*, 7 August, *Factiva* database, accessed 18 January 2010.

Rae, P. (2009). *Theatre & Human Rights* (Basingstoke, UK: Palgrave Macmillan).

Rancière, J. (2009). *The Emancipated Spectator*, trans. Gregory Elliott (London: Verso).

Rayner, A. (2002). 'E-Scapes: Performance in the Time of Cyberspace', in E. Fuchs & U. Chaudhuri (eds), *Land/Scape/Theater* (Ann Arbor, MI: University of Michigan Press).

Rebellato, D. (2007). 'National Theatre of Scotland: The First Year', Interview with N. Murray and J. Tiffany, *Contemporary Theatre Review*, 17.2, 213–18.

Reid, T. (2007). '"From scenes like these old Scotia's grandeur springs": The New National of Scotland', *Contemporary Theatre Review*, 17.2, 192–201.

Reid, T. (2013). *Theatre & Scotland* (Basingstoke, UK: Palgrave Macmillan).

Reinelt, J. (2007). 'Review of *Utopia in Performance: Finding Hope at the Theater*. By Jill Dolan', *Theatre Survey*, 48.1, 215–17.

Relph, E. (1991). 'Post-modern Geography', *The Canadian Geographer*, 35.1, 98–105.

Rice, E. (dir) (2008). *Brief Encounter*, adapt E. Rice, N. Murray (designer). Performed London, Haymarket Cinema: Kneehigh. (Viewed 26 September).

Robbins, T. (dir) (1999). *Cradle Will Rock*. Motion Picture. Touchstone Pictures, Cannes.

Robinson, R. (2012). 'The National Theatre of Scotland's *Black Watch*', *Contemporary Theatre Review*, 22.3, 392–9.

Rocamora, C. (2008). 'McBurney Meets Miller', *American Theatre*, 25.10, 32–5; 87–9, *Proquest* database, accessed 1 February 2011.

Rosenblatt, M. (dir) (2007). *Holding Fire!* by J. Shepherd, J. Bird (designer). Performed London, Shakespeare's Globe: Shakespeare's Globe. (Viewed archive video Shakespeare's Globe, 1 October).

Rothberg, M. (2011). 'From Gaza to Warsaw: Mapping Multidirectional Memory', *Criticism*, 53.4, 523–48.

Royal Exchange. (2013). The Royal Exchange, http://www.theroyalexchange.co.uk, accessed 17 October 2011.

Saco, D. (2002). *Cybering Democracy: Public Space and the Internet* (Minneapolis, MN: University of Minnesota Press).

Sanders, J. (2011). *The Cultural Geography of Early Modern Drama, 1620–1650* (Cambridge, UK; New York, NY: Cambridge University Press).

Sansom, L. (2013). National Theatre of Scotland, http://nationaltheatrescotland. wordpress.com/2013/07/01/profile-laurie-sansom/, accessed 27 June 2013.

Sargisson, L. (2000). *Utopian Bodies and the Politics of Transgression* (London: Routledge).

du Sautoy, M. (2009). 'A Most Romantic Collaboration', in *A Disappearing Number* by Complicite (London: Oberon).

Scottish Government News. (2008), http://www.scotland.gov.uk/News/News-Extras/156, accessed 17 April 2008.

Schehr, R.C. (1997). *Dynamic Utopia: Establishing Intentional Communities as a New Social Movement* (Westport, CT: Bergin & Garvey).

Seven Jewish Children: A Play for Gaza (2012). By C. Churchill, uploaded by jd9329996, Performed: Taiwan. http://www.youtube.com/watch?v=wRd0gvW3sjg, accessed 17 September 2013.

Seven Jewish Children: A Play for Gaza (2009a). By C. Churchill. *The Guardian*. http://www.theguardian.com/stage/video/2009/apr/25/seven-jewish-children-caryl-churchill, accessed 17 September 2013.

Seven Jewish Children: A Play for Gaza (2009b). By C. Churchill, S. Jabbarin (director), http://www.youtube.com/watch?v=eoyDYJIz-tI, accessed 29 July 2010.

Seven Jewish Children: A Play for Gaza (Part One). (2009c1). By C. Churchill, *Rooms Productions*, http://www.youtube.com/watch?v=1OBA30Ax51s, accessed 17 September 2013.

Seven Jewish Children: A Play for Gaza (Part Two). (2009c2). By C. Churchill, *Rooms Productions*, http://www.youtube.com/watch?v=gV3iASkzQkg&feature=related, accessed 17 September 2013.

Seven Jewish Children: A Play for Gaza (2009d). By C. Churchill, in 'Songs for Israel'. Performed Catford, Lewisham Town Hall: Lewisham Stop the War Coalition, 18 February.

Seven Jewish Children: A Play for Gaza (2011). By C. Churchill, J. Wadell (director), Performed Wellington, NZ, St. Andrew on the Terrace: NZ Actors without Borders Collective, 21–25 February.

Seven Jewish Children: A Play for Gaza (2010). By C. Churchill, Warwick Student Drama, C. Verkerk & C. McLeod (dirs), http://www.youtube.com/watch?v=8JFpMH963sk, accessed 29 July 2010.

Shaffer, P. (1988). *Black Comedy* (London: Samuel French; first production 1965).

Shakespeare, W. (2005). *As You Like It* in S. Wells et al. (eds), *The Oxford Shakespeare: The Complete Works*. 2nd edn (Oxford, UK: Oxford University Press; first published 1623).

Shakespeare, W. (2005). *Antony and Cleopatra* in S. Wells et al. (eds), *The Oxford Shakespeare: The Complete Works*. 2nd edn (Oxford, UK: Oxford University Press; first published 1623).

Shakespeare, W. (2005). *Coriolanus* in S. Wells et al. (eds), *The Oxford Shakespeare: The Complete Works*. 2nd edn (Oxford, UK: Oxford University Press; first published 1623).

Shakespeare, W. (2005). *Henry V* in S. Wells et al. (eds), *The Oxford Shakespeare: The Complete Works*. 2nd edn (Oxford, UK: Oxford University Press; first published 1600).

Shakespeare, W. (2005). *Julius Caesar* in S. Wells et al. (eds), *The Oxford Shakespeare: The Complete Works*. 2nd edn (Oxford, UK: Oxford University Press; first published 1623).

Shakespeare, W. (2005). *King Lear* in S. Wells et al. (eds), *The Oxford Shakespeare: The Complete Works*. 2nd edn (Oxford, UK: Oxford University Press; first published 1623).

Shakespeare, W. and G. Wilkins (2005). *Pericles* in S. Wells et al. (eds), *The Oxford Shakespeare: The Complete Works*. 2nd edn (Oxford, UK: Oxford University Press; first published 1609).

Shakespeare, W. & T. Middleton (2005). *Macbeth* in S. Wells et al. (eds), *The Oxford Shakespeare: The Complete Works*. 2nd edn (Oxford, UK: Oxford University Press; first published 1623).

Shakespeare, W. (2005). *Merchant of Venice* in S. Wells et al. (eds), *The Oxford Shakespeare: The Complete Works*. 2nd edn (Oxford, UK: Oxford University Press; first published 1600).

Shakespeare, W. & T. Middleton (2005). *Timon of Athens* in S. Wells et al. (eds), *The Oxford Shakespeare: The Complete Works*. 2nd edn (Oxford:, UK Oxford University Press; first published 1623).

Shakespeare, W. (2005). *The Tempest*. in S. Wells et al. (eds), *The Oxford Shakespeare: The Complete Works*. 2nd edn (Oxford, UK: Oxford University Press; first published 1623).

Shepherd, J. (2008). *Holding Fire* (London: Nick Hern Books).

Shore, R. (2007). Review of *Holding Fire! London Evening Standard* (Metro Life), 8 August, p. 23.

Siebers, T. (1994). 'What Does Postmodernism Want? Utopia', in T. Siebers (ed.), *Heterotopia: Postmodern Utopia and the Body Politic* (Ann Arbor, MI: University of Michigan Press).

Skantze, P.A. (2003). *Stillness in Motion in the Seventeenth-Century Theatre* (London: Routledge).

Smout, C. (2009). 'Review of Shakespeare's *King Lear* (Directed by Dominic Dromgoole) at Shakespeare's Globe, London, April–August 2008, and *Timon of Athens* (Directed by Lucy Bailey) at Shakespeare's Globe, London July–October 2008', *Shakespeare*, 5.1, 82–9.

Sofer, A. (2012). 'Spectral Readings', *Theatre Journal*, 64.3, 323–36.

Soja, E.W. (1989). *Postmodern Geographies* (London: Verso).

Soja, E.W. (1996). *Thirdspace: Journeys to Los Angeles and Other Real-and-Imagined Places* (Oxford, UK: Blackwell).

'Southwark' (2013). Shakespeare's Globe, http://www.shakespearesglobe.com/education/southwark, accessed 19 September 2013.

'Statistics on looked after children' (2014). National Society for the Protection of Cruelty to Children. http://www.nspcc.org.uk/Inform/resources forprofessionals/lookedafterchildren/statistics_wda88009.html, accessed 4 January 2014.

Stevenson, T. (2006). 'Investment Column: But Would the Dean Find Value in Dresdner Outlook?', *The Telegraph*, 12 December, http://www.telegraph.co.uk/finance/2952272/Investment-column-But-would-the-Dean-find-value-in-Dresdner-outlook.html, accessed 27 January 2010.

Stern, S. (2008). 'A Moving Story of Escape and Survival', *Financial Times* (Notebook), 21 November, *Factiva* database, accessed 16 April 2010.

Sullivan, Jr., G. (1998). *The Drama of Landscape: Land, Property, and Social Relations on the Early Modern Stage* (Stanford, CA: Stanford University Press).

Summer–Autumn Brochure (2006). (Glasgow: National Theatre of Scotland).

Summer–Autumn Brochure (2007). (Glasgow: National Theatre of Scotland).

Taylor, H. (2004). 'Deep Dramaturgy: Excavating the Architecture of the Site-Specific Performance', *Canadian Theatre Review*, 119, 16–19.

Taylor, P. (2005). 'Pain, Pedantry and Mysticism', *The Independent*, 6 June, http://www.independent.co.uk/arts-entertainment/theatre-dance/reviews/pericles-shakespeares-globe-london-6144730.html, accessed 31 January 2010.

Taylor, P. (2007a). 'Review of *Holding Fire!*', *The Independent* (Extra), 7 August, *Factiva* database, accessed 18 January 2010.

Taylor, P. (2007b). 'Maths, Mortality and Mysticism', *The Independent*, 13 September, *Factiva* database, accessed 28 January 2001.

Taylor, P. (2008). '*Timon of Athens*, Shakespeare's Globe, London', *The Independent*, 13 August, http://www.independent.co.uk/arts-entertainment/theatre-dance/reviews/timon-of-athens-shakespeares-globe-london-892697.html, accessed 31 January 2010.

Thaxter, C. (2007). '*Holding Fire!*' *The Stage* (Reviews), 6 August, http://www.thestage.co.uk/reviews/review.php/17623/holding-fire-, accessed 1 October 2013.

'Theatre without Walls' (2013). National Theatre of Scotland, http://www.theatrewithoutwallsfund.com, accessed 17 November 2013.

Thomasson, S. (2011). 'Carving Out a Space: Founding Performance Space in the City', MPhil Thesis, The University of Queensland, Brisbane.

Thompson, J. (2009). *Performance Affects: Applied Theatre and the End of Effect* (Basingstoke, UK: Palgrave Macmillan).

Thompson, J. (2010). 'The Stinking Hot Summer', *Theatre Journal*, 62.4, 505–10.

Thomson, K. (2004). *Wonderlands* (Sydney: Currency Press).

Tiffany, J. (dir) (2008). *Black Watch* by G. Burke, L. Hopkins (designer). Performed Perth, Perth Convention and Exhibition Centre: National Theatre of Scotland. (Viewed 9 February).

Till, N. (2010). 'Oh, to Make the Boardes to Speak!', in J. Collins and A. Nisbet (eds), *Theatre and Performance Design: A Reader in Scenography* (Abingdon, UK: Routledge).

Tompkins, J. (2006). *Unsettling Space: Contestations in Contemporary Australian Theatre* (Basingstoke, UK: Palgrave Macmillan).

Tompkins, J. (2011). 'Site-Specific Theatre and Political Engagement across Space and Time: The Psychogeographic Mapping of British Petroleum in Platform's *And While London Burns*', *Theatre Journal*, 63.2, 225–43.

Tompkins, J. (2012a). 'The "Place" and Practice of Site-Specific Theatre and Performance', in A. Birch & J. Tompkins (eds), *Performing Site-specific Theatre: Politics, Place, Practice* (Basingstoke, UK: Palgrave Macmillan).

Tompkins, J. (2012b). 'Theatre's Heterotopia and the Site-Specific Production of *Suitcase*', *TDR: The Drama Review*, 56.2, 101–12.

Tompkins, J. & M. Delbridge (2009). 'Using Virtual Reality Modelling in Cultural Management, Archiving and Research', in A. Seal, S. Keene & J. Bowen (eds), *Proceedings of EVA* [Electronic Visualisation and the Arts] *London 2009* (London: British Computing Society).

Topinka, R.J. (2010). 'Foucault, Borges, Heterotopia: Producing Knowledge in Other Spaces', *Foucault Studies*, 9, 54–70.

Trezise, B. (2008). 'A Quiet Kind of Terror', *RealTime*, 83, February-March, http://realtimearts.net/article/issue83/8861, accessed 20 June 2010.

Trousdell, R. (1996). 'Crossing Boundaries: Directing Gay, Lesbian and Working Class Theatre in Scotland', in J.L. Oliva (ed.), *New Theatre Vistas: Modern Movements in International Theatre* (New York, NY; London: Garland Publishing).

Tuan, Y. (1977). *Space and Place: The Perspective of Experience* (Minneapolis, MN: University of Minnesota Press).

Turner, C. (2004). 'Palimpsest or Potential Space? Finding a Vocabulary for Site-Specific Performance', *New Theatre Quarterly*, 20.4, 373–90.

Turpin, A. (2007). 'Northern Lights', *Financial Times* (Financial Times Magazine), http://www.ft.com/cms/s/0/04d4c2a2-bbf6-11db-9cbc-0000779e2340.html#axzz2rVve1aud, accessed 17 August 2009.

Ubersfeld, A. (1998). *Reading Theatre* (Toronto, ON: University Toronto Press).

Valentine, G. (1999). 'Imagined Geographies: Geographical Knowledge of Self and Other in Everyday Life', in D. Massey, J. Allen & P. Sarre (eds), *Human Geography Today* (Cambridge, UK: Polity Press).

Vanhoutte, K. (2010). 'Embodiment', in S. Bay-Cheng, C. Kattenbelt, A. Lavender & R. Nelson (eds), *Mapping Intermediality in Performance* (Amsterdam: Amsterdam University Press).

Vickers, B. (2004). *Shakespeare, Co-author: A Historical Study of Five Collaborative Plays* (Oxford, UK: Oxford University Press).

Waites, J. (2008). '*Aalst*: National Theatre of Scotland', *Australian Stage Online*, 19 January, http://www.australianstage.com.au/200801191042/reviews/sydney-festival/aalst-|-national-theatre-of-scotland.html, accessed 19 March 2009.

Wegner, P.E. (2002). *Imaginary Communities: Utopia, the Nation, and the Spatial Histories of Modernity* (Berkeley, CA: University of California Press).

Weimann, R. (2000). *Author's Pen and Actor's Voice: Playing and Writing in Shakespeare's Theatre* (Cambridge, UK: Cambridge University Press).

Welton, M. (2008). '*And While London Burns*', paper presented to the *Performance Studies international* conference, Copenhagen, 22 August.

West, R. (2002). *Spatial Representations and the Jacobean Stage: From Shakespeare to Webster* (Basingstoke, UK: Palgrave Macmillan).

West-Pavlov, R. (2009). *Space in Theory: Kristeva, Foucault, Deleuze* (Amsterdam: Rodopi).

'Wha's [sic] like us ... National Theatre of Scotland'. (2008). *Scotland on Sunday* (Editorial), 24 August, p. 16.

Whittaker, R. (2010). 'General Historical Information', *Bethlem Royal Hospital Archives and Museum Service*, http://www.bethlemheritage.org.uk/aboutus. asp, accessed 8 May 2010.

Wiens, B. (2010). 'Spatiality', in S. Bay-Cheng, C. Kattenbelt, A. Lavender & R. Nelson (eds), *Mapping Intermediality in Performance* (Amsterdam: Amsterdam University Press).

Wiles, D. (2003). *A Short History of Western Performance Space* (Cambridge, UK: Cambridge University Press).

Wiles, D. (1997). *Tragedy in Athens: Performance Space and Theatrical Meaning* (Cambridge, UK: Cambridge University Press).

Wilkinson, C. (2008). '(Black) Watch again', *The Guardian* (Theatre Blog with Lyn Gardner), 27 June, http://www.theguardian.com/stage/theatre-blog/2008/jun/27/blackwatchagain, accessed 21 July 2008.

Williams, T. (2000). *The Glass Menagerie* in *A Streetcar Named Desire and Other Plays* (London: Penguin).

Wilkie, F. (2008). 'The Production of "Site": Site-Specific Theatre', in N. Holdsworth & M. Luckhurst (eds), *A Concise Companion to Contemporary British and Irish Drama* (Oxford, UK: Blackwell).

Wilkie, F. (2004). 'Out of Place: The Negotiation of Space in Site-Specific Performance', PhD Thesis, University of Surrey, Guildford.

Wilmer, S. (2009). 'Theatrical Nationalism: Exposing the "Obscene Superego" of the System', *Journal of Dramatic Criticism* 23.2, 77–87.

Woddis, C. (2007). 'Same Rules, Different Personnel', *GlobeLink: Globe Education's Online Resource Centre*. http://www.globelink.org/resourcecentre/ otherplays/holdingfire/shepherd, accessed 19 January 2010.

Wood, A. (2002). 'Re-Reading Disney's Celebration: Gendered Topography in a Heterotopian Pleasure Garden', in A. Bingaman, L. Sanders & R. Zorach (eds), *Embodied Utopias: Gender, Social Change and the Modern Metropolis* (London: Routledge).

Worthen, W.B. (2003). *Shakespeare and the Force of Modern Performance* (Cambridge, UK: Cambridge University Press).

Yoran, H. (2002). 'The Humanist Critique of Metaphysics and the Foundation of the Political Order', *Utopian Studies*, Spring 13.3, 1–20.

Young, S. (2009). 'Playing with Documentary Theatre: *Aalst* and *Taking Care of Baby*', *New Theatre Quarterly*, 25.1, 72–87.

Zerdy, J. (2011). 'Stages of Governance: The Scottish Parliament's Festival of Politics and National Subjects in Performance', *Contemporary Theatre Review*, 21.2, 171–88.

Zerdy, J. (2013). 'Fashioning a Scottish Operative: *Black Watch* and Banal Theatrical Nationalism on Tour in the US', *Theatre Research International*, 38.3, 181–95.

Index

Printed and bound by CPI Group (UK) Ltd, Croydon, CR0 4YY